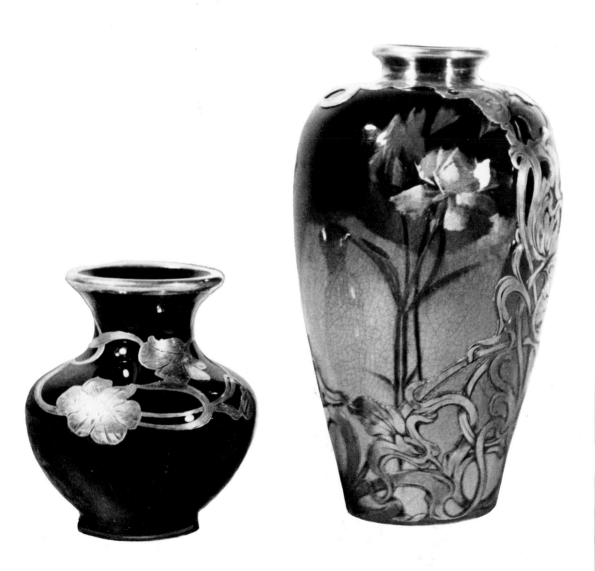

Silver overlay. *Left to right:* Marked "Rozane" (Roseville), 4½ in. high; marked "Louwelsa Weller," 8 in. high, shades of dark brown and yellow; marked "Owens-Utopian," 5 in. high. *Collection of Frances and Don Hall; Fox photo*

AMERICAN ART POTTERY

Lucile Henzke

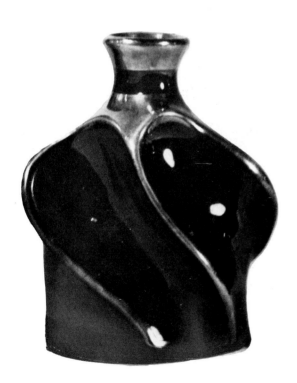

THOMAS NELSON INC.

Camden New York

All rights reserved. Published in Camden, New Jersey, by Thomas Nelson Inc. and simultaneously in Don Mills, Ontario, by Thomas Nelson & Sons (Canada) Limited.

Library of Congress Catalog Card Number 70-113171

ISBN-0-8407-4301-7

PRINTED IN THE UNITED STATES OF AMERICA

To Jerry, my husband
and best friend,
who assisted me
every step of the way.

Also
to my parents,
Professor Claude L. Clements
Winnie Hammond Clements

Acknowledgments

The author expresses her sincere thanks to everyone who contributed to this collection of facts and permitted examination of their collections and other materials. To the following she owes deepest gratitude:

Norris F. Schneider Catherine W. Smither
Dr. and Mrs. Gordon Gifford John Frank
Arthur (Art) Wagner Stangl Pottery
Ohio Historical Society E. Stanley Wires

Thanks are also extended to museums and libraries that so generously assisted along the way.

Special acknowledgment is made to Mr. Albert Christian Revi for his constant encouragement, guidance, and tolerance and to *Spinning Wheel Magazine* for permitting use of material appearing in its publications.

Heartfelt thanks are given to Oma Anderson for permission to scan through her vast library of information to obtain a portion of pertinent data for this treatise.

A very special credit is due a young and talented artist friend, David Thompson, for his generous contribution of some of the sketches appearing in this book.

To Frances Hall, the author gives many, many thanks for her immense assistance and patience, without which this book would not be as complete.

Black and white photos by

Wade H. Knight, Dallas, Texas
Jesse Johnson, Fort Worth, Texas
Raymon Orren, Fort Worth, Texas

Color photos by

Wade H. Knight, Dallas, Texas

CONTENTS

Introduction

This story of American art pottery is a chronology of events from the beginning days to the time the potteries closed their doors. Nothing has been included that did not seem a reasonable assumption from the records and research. In writing about this fascinating art, the author had but one idea in mind, and that was to influence her readers to enjoy what they collect.

Through the years much has been written in the form of books, magazine articles, and pamphlets about all types of antiques and collectibles, but very little about art pottery. This book is primarily concerned with the vessels modeled of clay, then decorated with slip and covered with a glaze. Pottery is almost always heavy, thick, and opaque. However, there are exceptions. It is often referred to as "earthenware." The art wares exhibit the maker's own skill and individuality, in line and in decoration. Pottery must have some type of glaze to make it waterproof; without a glaze it will absorb water, and the vessel will leak.

The glazes developed by individual art potteries in America are peculiar to each product; it is impossible to duplicate them except under the exact conditions, using the identical ingredients. Hence, each successful glaze is something to be studied and admired. In this treatise, we are dealing with hand-decorated and -modeled pottery as opposed to porcelain or just plain crockery.

In fashioning a piece of pottery in a mold, the clay is first pulverized and then completely washed, filtered, and mixed with water to a certain consistency. It is then pressed into a plaster of Paris mold, either by hand or machine. The plaster of Paris absorbs the water, making a body of clay next to the inner surface of the mold. After a few minutes, what

liquid remains is poured out. The shell that is left becomes the future vessel or object. It is then sponged and all defects are smoothed off by a finisher. This makes the piece devoid of surface roughness and it is now ready to be placed in the kiln. Some of the kilns were huge, being twenty feet high on the inside. The men packing the kiln had to use ladders to put the top on the tall columns of saggers (boxes) that held the wares.

From time to time we will speak of "under-the-glaze slip decoration" or "slip painting." Slip is a mixture of clay and water, to which color is added. It is applied while the vessel is still damp so that the body and decoration can contract evenly while drying in the "dry room," where it is left until all the water has evaporated. The slip paintings are done in the manner of oil paintings. After the vessel or ware is dried, it is covered with a pulverized enamel, then fired. We now have the finished product. At times, the colors ran slightly; then again, they almost burned out. The glaze did not always contract with the body, thereby causing much of it to be crazed. On some pottery, the glaze and decoration is fired at the same time, a method further discussed in this book. Most potteries allowed their artists to experiment in the manufacturing of this art ware; consequently, different processes were used to obtain different results.

Each artist-chemist developed his own mixture for glazing and often achieved extraordinary results. Furthermore, these were usually carefully guarded secrets. A simple type of glaze, readily available to all, was the lead glaze, in which process powdered lead was dusted onto the article. When fired, the lead melted and fused with the silica in the clay to form a hard, transparent glaze.

The salt glaze was the most common type used on crockery and utility ware and was the most simple of all. Just plain ordinary salt was shoveled into the fire of the kiln and the vapors from the salt condensed on the ware to form a hard, smooth, acid-resisting surface.

The smear glaze is the slip with other ingredients added, then swiped or smeared onto the surface of the article and then fired.

Dates are given as accurately as possible, although some are only approximate; to determine an exact date is almost an impossibility. Some of the potteries marked most of their wares; however, some of their wares bore no mark at all, even though they were made during

the same period. The workers seemingly at one time or another grew rather careless.

Collectors of early American art are beginning to understand art pottery more, and it is appearing in collections where heretofore only art glass and porcelains have had a place. Art pottery was made in competition with Victorian art glass and art nouveau, and you will find pieces similar in shape and appearance. Tiffany realized the importance of art pottery and made a very limited amount during this era.* Tiffany's New York store was also an outlet for the better lines from other potteries.

Readers of this book who live in the vicinity of the potteries will, no doubt, have additional information. The author would be most appreciative of any further data on art pottery that readers could supply.

The following is an excerpt taken from an article written in December, 1905, by Lura Milburn Cobb, after she had visited several of the potteries in Zanesville, Ohio. We feel it is quite a tribute to the creators of American art pottery.

> In this lovely spot, art is truly the child of nature. The genius of the artist here calls together the primeval elements from beneath his feet to do his bidding. Earth, water and fire bend to the task, and to him bring the product of their united labors. He clothes the varied shapes of beauty in the soft rich colors that please him best, and then across each shining bosom he lays, with exquisite grace, a nodding iris, a spray of apple blossoms, or a rosy thistle bloom, and in their fadeless, triumphant beauty sends them forth to adorn and bless the homes and lives of the children of men.

* For a comprehensive study of Tiffany pottery, see *American Art Nouveau Glass* by Albert Christian Revi.

FULPER POTTERY

1805 — 1929

STANGL POTTERY

1929 —

The Fulper Pottery was founded in 1805 by the Fulper Brothers in Flemington, New Jersey. The earliest Fulper ware was fashioned from the fine rich clay found in Hunterdon County. Many other potteries were also located in this section, where these rich clays were readily at hand. This area became the original American home of those potteries that are often referred to as "Bennington" type, such as Rockingham, yellow ware, and the salt glazes. "Bennington" is the name taken from the wares made by Captain John Norton at Bennington, Vermont. This type of ware duplicated those being imported from England that were glazed with the most common glazes. This was prior to the manufacturing of American art pottery. "Bennington" is more or less a utility ware and not considered an art-type ware.

At the very beginning the Fulper Company primarily manufactured drain tiles. Later other articles were added, such as drinking vessels for poultry. After 1860 beer mugs and bottles, water and vinegar jugs, butter churns, and pickling jars were added to the line. These were the typical lines created by the Fulper Pottery until 1910.

As stated in a brochure issued by the Stangl Pottery in 1965:

> One of the most unusual products created by the Fulper Company was a set of stoneware jars to provide clean, cool water. From the upper section the water passed through a specially-made "filter stone" into the lower container, inside of which was a smaller jar to hold ice. The

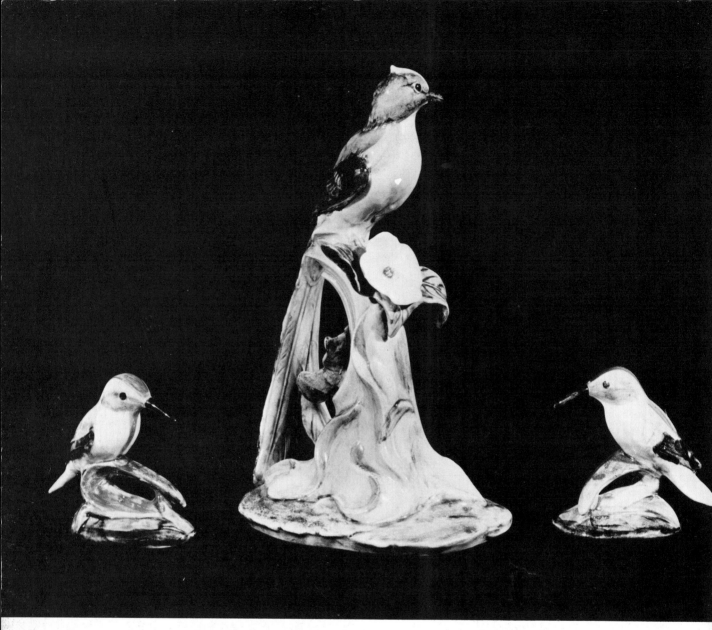

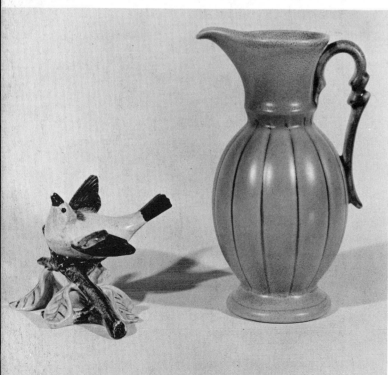

Stangl pottery. *Above, left and right:* Allen hummingbirds, vivid coloring, ink-stamped "Stangl," original tag has title and no. 3634, 3½ in. high. *Above, center:* Audubon warbler, vivid colors, primarily green, pink, and yellow, marked, original tag has no. 3757, 10 in. high. *Left:* Bird, bright pink, yellow, and blue, marked, 4½ in. high; early Stangl pitcher, shades from blue to green, marked, 10 in. high. *Author's collection; Knight photos*

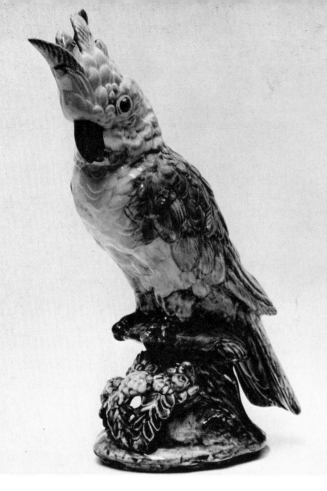 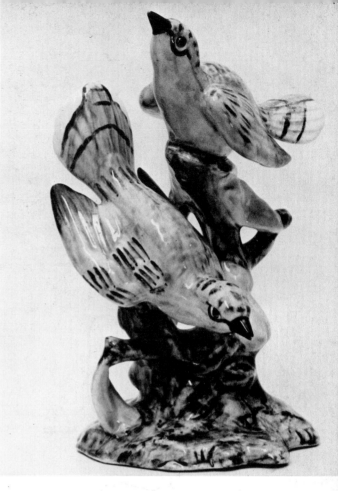

Top left: Marked cockatoo with brilliant plumage, signed with artist's signature, "Jacob," 12 in. high. *Top right:* Marked bluebirds, 7½ in. high. *Bottom left:* Marked Stangl, dark blue bird with light yellow, 5 in. high. *Bottom right:* Fulper parrot perfume lamp, brilliant natural coloring, impressed mark, artist signature, 9 in. high. *Author's collection; Knight photos*

 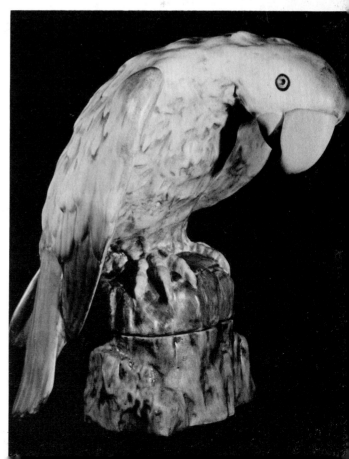

surrounding water, cooled by this "ice-chamber," was drawn off through a spigot. This was the forerunner of today's water-cooler. So great was the demand for the "Fulper Germ-Proof Filter," as it was called, that other potteries were often contracted to help make enough to fill the orders. These "water-coolers" were to be found in every railroad station from coast to coast and in office buildings and stores throughout the nation. They were also exported in large quantities to various South American and West Indian countries.

In 1910 J. M. Stangl was given the position of ceramic engineer at the Fulper Pottery. The company was entering the art-pottery field, and all the inherent problems of launching a new product were delegated to Mr. Stangl. The first art ware was sent to stores around the country as exhibit pieces only, and some were valued as high as several hundred dollars each.

During the World War I period, when imports were cut to a minimum, a large American doll manufacturer solicited Fulper to make doll heads. Mr. Stangl created what is now known as the famous "Fulper" doll heads, which are highly prized by today's doll collectors.

By 1920 the Fulper Pottery, now headed by Mr. Stangl, was designing and producing many beautiful art lines, as well as an attractive line of monochrome dinnerware. At first this dinnerware was made in solid green, but by 1930 other colors were added. Incidentally, Fulper was the first American pottery to introduce dinnerware in glazed solid colors in this country. Fulper also produced some articles of fine bisque and porcelain, fashioned of the identical clay they used in making the doll heads.

From the early 1920s the Pottery grew steadily; by 1929 two locations were operating in Flemington. Fulper had also taken over the Anchor Pottery of Trenton, New Jersey, in 1926. The Anchor Pottery had been operated by the Grand Union Tea Company to manufacture premium items that were given away to their customers.

On the morning of September 19, 1929, disaster struck: the main Fulper plant at Flemington burned to the ground. The news of this catastrophe was broadcast by radio and newspapers throughout the United States. The townspeople were greatly concerned since Fulper was one of the largest employers in this area. All employees were given the opportunity of transfering to the Trenton plant, where the name was immediately changed from Fulper Pottery to Stangl Pottery.

Fulper continued to manufacture art ware on a limited scale in the smaller pottery on Mine Street in Flemington. This operation lasted until 1935, when all facilities were transferred to the Trenton plant. The building on Mine Street is still standing and is utilized to display to the public all the products of the Stangl Pottery, consisting of their art ware and dinnerware.

In 1940 Stangl introduced a finer grade of dinnerware. This ware was, and continues to be, hand crafted and hand decorated in many beautiful designs—always in good taste. Stangl is the only large producer of fine dinnerware to use the carving process for their pattern designs. Trained artists use a specially designed sharp tool for the carving of the patterns. A certain amount of pressure is applied to the white

Marked Fulper ware. *Left to right:* Bisque covered box, artist signed; green vase, 6 in. high; vase, 12 in. high, paper label with line name "Yellow Flambe"; green bowl, slightly iridescent, with frog, 8 in. diameter. *Author's collection; Johnson photo*

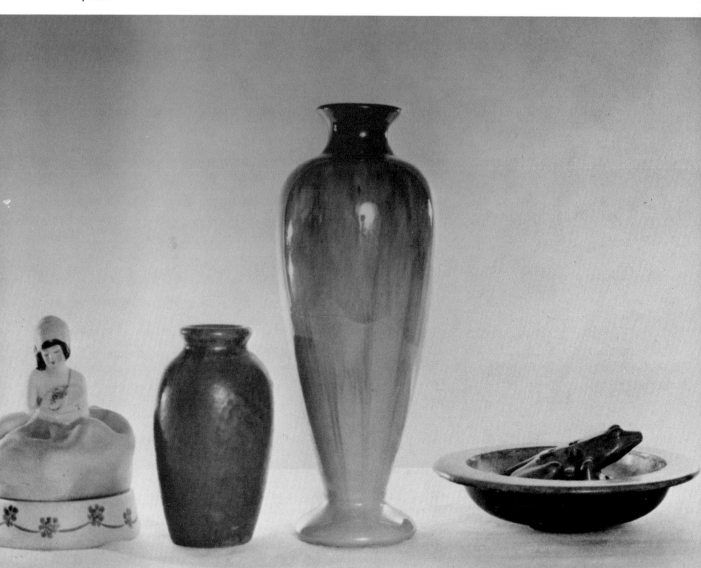

engobe (slip) with the tool, which cuts through and discloses the red clay—a Stangl trademark for many years. Between the carved lines, the artists then hand decorate the dinnerware with various bright underglaze colors.

In 1941, when World War II curtailed imports, Stangl, always progressive, was one of the first to create authentic Audubon reproductions of hundreds of different birds. These were done in exquisite detail and unexcelled quality. The high-gloss glazes on them have never crazed. In addition to the line of pottery birds, Stangl created twelve different birds in a "porcelain" body. These were made in limited numbers, less than fifty of each being produced. Both the pottery birds and the porcelain birds, which were made in the 1940s, are eagerly sought after by today's collectors.

As did other potteries at the turn of the century, Fulper created exotic names for its wares. In the early catalogs the names were highly imaginative. For example, "mouse gray with blue of the sky flambe," "mouse gray with cat's eye and black flambe," "cucumber green," or "elephant's breath," denoting a rather gray shade, were all color descriptions.

Fulper ware was made in a variety of forms and shapes, including ashtrays, cigarette boxes, trinket boxes, bowls, vases, pitchers, and all types of table accessories, as well as exquisite dinnerware.

Many different glazes were developed to add tone and texture to the art lines. Some pieces were matt finished and some were high-gloss glazed. Some Fulper items are artist signed; however, no records were kept of the artists' names or their monograms.

Stangl is still creating beautiful lines of gift ware and dozens of stunning lines of versatile dinnerware, as well as an attractive line of juvenile ware, called "Kiddie Set." When these sets were introduced in the 1920s they immediately became an all-time favorite. One of Stangl's leading art-line sellers is their "Antique Gold," a ware produced by brushing on 22-karat gold over a matt green glaze.

From the outset the Fulper Pottery marked their wares, and Stangl continues the custom of back stamping every article with the oval trade mark and pattern name. The wares are sold in thousands of fine stores all over the country.

Fulper-Stangl pottery marks:

FULPER BROS.
FLEMINGTON, N.J.

Impressed

Kenneth

Impressed

Impressed

Impressed

Impressed

Impressed

F U L P E R	F U L P E R	F U L P E R
Impressed or stamped	Impressed or stamped	Impressed or stamped

Impressed

Stamped

Paper Label:
Includes number,
pattern name, and
price

STANGL

U S A

Used after 1929
Impressed

STANGL

"STANGL," impressed; the
oval mark, ink stamped

Stangl company current marks (1969):

Ink stamped, dinnerware

Ink stamped, gift ware

CHELSEA KERAMIC
ART WORKS
1868—1894
DEDHAM POTTERY
1895—1943

In 1866 Alexander W. Robertson established the Chelsea Keramic Art Works at Chelsea, Massachusetts. He was joined by his brother, Hugh Cornwall Robertson, in 1868. Their production consisted mainly of flowerpots, bean pots, and simple vases. James Robertson, who had already gained recognition as an experienced potter in England and Scotland, joined his sons in 1872. Almost immediately the firm began to produce a more decorative type of pottery, for example, the "Redware" (terra cotta), which was quite ornate. The company name of Robertson and Sons was adopted, but the initials C K A W (Chelsea Keramic Art Works) were also used.

Hugh Robertson was one of the artists, along with Maria Longworth of Rookwood fame, who was inspired by the Oriental art works that were displayed at the Philadelphia Centennial Exposition in 1876. He devoted several years to perfecting the "Oxblood" (Sang de Bouef) and craquelle glazes, which to that time had been peculiar to the Orient. Other color glazes emerging from experiments were dark yellow (mustard color), turquoise, purple, maroon, sea green, and apple green. Several awards were won by this ware, including a gold medal at the St. Louis World's Fair and awards at the Paris and San Francisco World's Fairs.

James Robertson died in 1880 and Alexander Robertson migrated to California in 1884. Hugh Robertson remained at the Chelsea plant, where he continued his work in perfecting the Oriental secrets of glazing. However, in 1889, after twenty years of hard work with practically no profits because of costs of production, he closed the Chelsea Pottery and took a position with the Low Art Tile Company, where he stayed for only a brief period of time. During his twenty years at the Chelsea plant, many fine pieces of pottery were produced but were not well received by the public. In 1890 he assisted his brother, George W., in establishing the Robertson Art Tile Company at Morrisville, Pennsylvania, where he did the modeling for the embossed-tile designs.

In 1891 Hugh Robertson was engaged by a group of Boston businessmen, who reopened the pottery, to manage the Chelsea Keramic Art Works. In 1895 the operation was moved to Dedham, Massachusetts, and the name was changed to Dedham Pottery. This move from Chelsea was made because the damp climate was not inducive to pottery making. It was at Dedham where Hugh Robertson was to gain fame and recognition for his many years of hard work. Perhaps one could consider him a genius in his profession. He was successful in practically all

Dedham pottery plate. Two marks appear on base—the impressed rabbit and the regular stamped mark; 8 in. diameter. *Collection of Irma and Bill Runyon; Johnson photo*

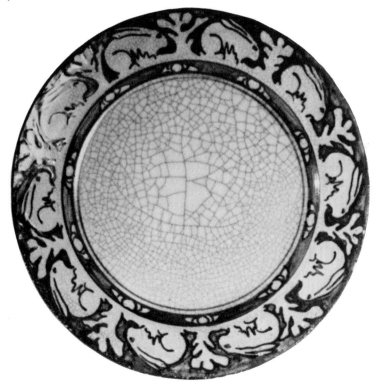

his undertakings, his main objective being a devotion to strict detail. He used simple lines and nothing was added that might detract from the beauty of the color. At the Dedham plant, the craquelle glaze was perfected and used extensively on the wares. This glaze was first used on tall pieces, such as vases. The Chinese-like crackle stoneware, with the blue-in-glaze border decoration, had flowers and animals as motifs. These included iris, clover, magnolia, grape, poppy, waterlily, azalea, polar bear, elephant, swan, lion, crab, turtle, owl, duck, turkey, butterfly, bird, and rabbit. The most popular pattern was the rabbit, designed by Joseph L. Smith, a teacher at the Boston Museum of Fine Arts School (1889-93). This pattern was adopted as the company trade mark. At first a raised rabbit was used, but this was soon discontinued because of the loss of many pieces due to cracking in the molds. During the early period, between 1891 and 1894, the rabbit decor went counterclockwise, and this is perhaps the rarest of the crackleware. After 1894 the design was changed to run clockwise. Some of the previously mentioned patterns were made on special order only. The forms were mostly tableware although, on occasion, odd pieces were produced.

Charles Davenport, a talented artist and decorator who spent thirty-five years with Dedham Pottery making the intriguing borders on the Dedham ware, is living in retirement on beautiful Cape Cod. He relates that one day, a certain Republican, who had just learned that the elephant was to become the party's official symbol, came to the factory and commissioned a set of tableware with elephant borders. This freehand type of decoration required a superb sense of spacing, since there is just so much room for a certain number which should be spaced evenly. Mr. Davenport states that this was the only profitable mistake he had ever made when it came to judging distance. The border was to consist of thirteen elephants, but when he got down to the last elephant, he found there wasn't enough room left for a repeat pattern. Rather than discard the entire plate, he filled in the small space with a baby elephant. The person who had ordered the pattern was quite delighted with the design and, apparently, so was the general public. Consequently, the elephant became the second most popular pattern among the forty-eight patterns created over the years. Mr. Davenport's initials will be found hidden in the blue borders of some of these pieces.

One important glaze improved upon at Dedham was the Chinese red glaze (Sang de Boeuf) and the other slow-flowing type glazes that were used by the old Japanese. One rather extraordinary glaze was produced by the use of two glazes, one running down over the other. This process was called "Volcanic Ware," which was rather heavy and not too popular. Dedham Pottery was completely handmade ware, although it does appear to be stencil work. Each piece of this pottery always carries a company mark on the base.

The gray clay used at Dedham came from Kentucky and the kiln that was in operation was very large, capable of holding more than two thousand pieces at one time. As previously stated, no stencils or decals were used—only free-hand work, painted by artists, decorated this ware. From the outset, Dedham pottery was expensive, as it was the only American-made craquelle ware. It was sold from coast to coast by many fine dealers, including Paul Elder of San Francisco, who also was an outlet for the fine Newcomb pottery.

Hugh Robertson died in 1908 and was succeeded as head of the company by his son, William Robertson, who had contributed a great deal to the successful development of the craquelle process. After William Robertson's death in 1929, his son, J. Milton Robertson, supervised operations until 1943, when the Dedham Pottery closed.

J. Milton Robertson died on May 17, 1966, taking with him the formula for the unique Dedham glaze.

Dedham Pottery "patterns":

Bird in Orange Tree

Water Lily

Azalea

Horse Chestnut

Swan

Magnolia

Turkey

Duck

Polar Bear

Grape

Iris

Butterfly

Dedham Platter
Pattern denotes the use of two motifs for decoration
On display at the Smithsonian Institution

Chelsea-Dedham pottery marks:
Impressed or stamped:

A.W. & H.C.
ROBERTSON

1868-72

1872-89

CHELSEA KERAMIC
ART WORKS
ROBERTSON & SONS

1872-89

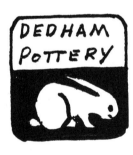

1891-94
(CPUS) Chelsea Pottery U.S.

1895
Limited use
of this mark
after 1895,
on plates

DEDHAM
POTTERY

1896-1929

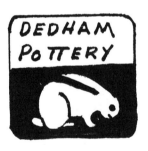

Registered
1929-43

 Monogram of Hugh C. Robertson

WELLER POTTERY

1872—1948

From just plain paint-covered clay flowerpots, which Samuel A. Weller made and sold from house to house, grew one of the largest potteries in America. Weller was a poor country boy who was born in Muskingum County, Ohio. His life could be considered a "rags to riches" story. During his boyhood he worked at the Bluebird Potteries, near his home, where he learned the art of "throwing a pot" on the potter's wheel. In 1872 he set up his own small, unpretentious shop in Fultonham, Ohio, and there worked every minute until he could get a wagonload of his paint-covered flowerpots ready for market. The same horse that helped furnish power to run the machinery used in making the stoneware and flowerpots also drew the wagon in which these wares were hauled to the purchaser.

Weller was a supersalesman and a still better businessman, for he had advanced far enough by 1882 to open his first factory, on Pierce Street in Zanesville. Numerous potteries thrived in Zanesville, which was often referred to as "Clay City." Weller continued to prosper. In 1890 he built a three-story building at Putnam commons, on Cemetery Drive, which was thereafter referred to as the Putnam Plant. Here, some sixty workers were employed.

In 1895 Weller purchased the Lonhuda Pottery in Steubenville, Ohio; with the purchase came W. A. Long and his process for making "Lonhuda," an under-the-glaze slip-decorated ware. Weller immediately entered the art-pottery field and began making the hand-decorated Lonhuda-type pottery. Since the name "Lonhuda" belonged to Mr. Long and could not be used by Weller, the new ware was called

33

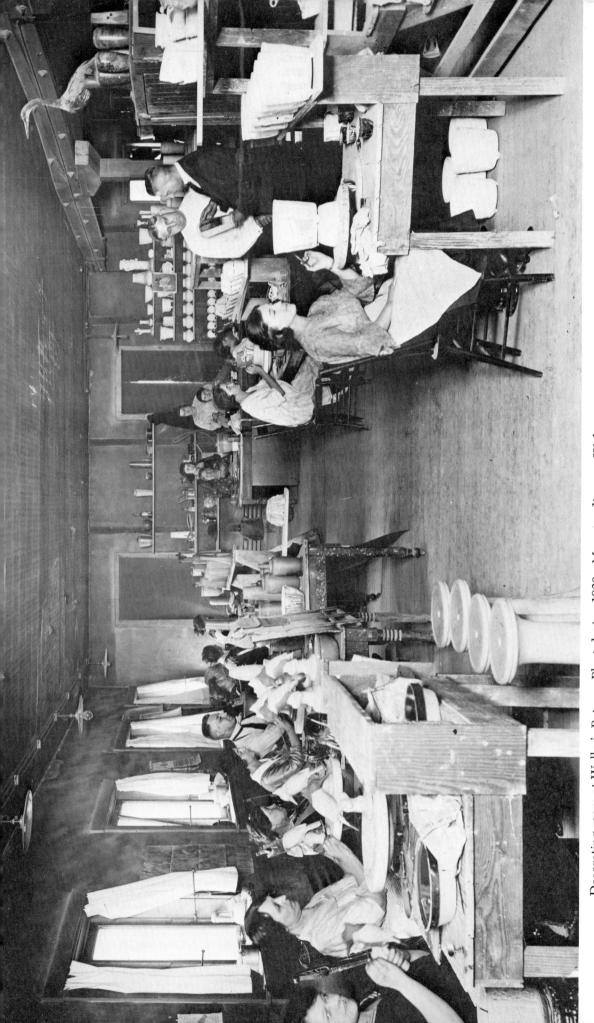

Decorating room at Weller's Putnam Plant during 1920s. Men standing are Walter Gitter in white, Ed Pickens in dark coat, holding a "Pictorial" vase.

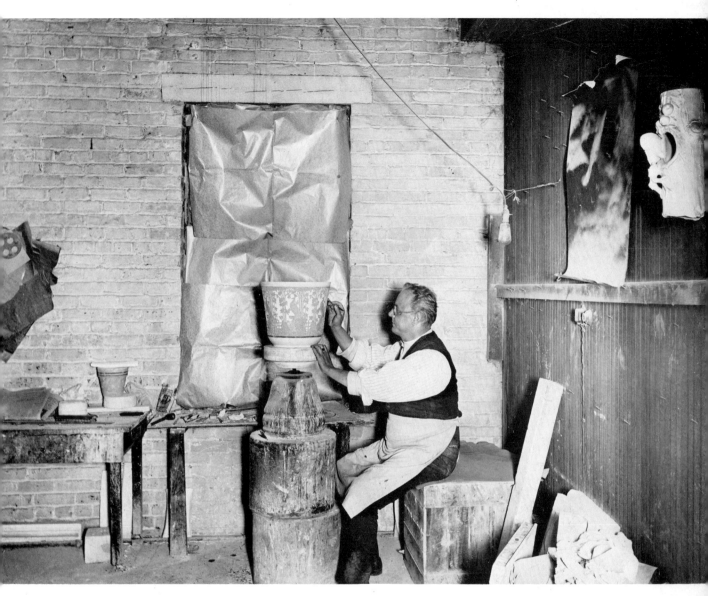

Rudolph Lorber, modeler for Weller Pottery, ca. 1920.

"Louwelsa," incorporating Weller's name with that of his daughter, Louise—"Lou" from Louise and "wel" from Weller, and "sa," Weller's initials. Louwelsa is a beautiful ware in delicate harmonizing shades of brown and yellow, with velvety shadows and shimmering highlights. It was very popular in the twenty-three years it was made (1895-1918), and over five hundred different items were produced during these years. The rarest and most sought-after pieces of Louwelsa are portraits and pictures of birds, fish, and animals. Other rarities are pieces trimmed with silver overlay and silver deposit. These were extremely scarce in the early days, and even more so today. Louwelsa ware can also be found in a shaded royal blue, which is indeed a rarity.

W. A. Long remained less than a year at the Weller Pottery and was succeeded as art director by Charles Babcock Upjohn. Upjohn worked for Weller for about a decade (1895-1905), and then retired. Later he became Professor of Art at Columbia University, a post he occupied for twenty-five years.

During his tenure with Weller potteries, Upjohn created the now-famous "Dickens Ware." In the late 1800s Doulton of England was

"Louwelsa" pottery. *Left to right:* Vase, shades from light yellow to dark brown, glaze contains aventurine crystals deep within the glaze similar to Rookwood "Tiger Eye," marked "Louwelsa Weller," signed by Elizabeth Blake, 6¼ in. high; pitcher, dark brown with hint of yellow under the spout, yellow pansies, marked, 5 in. high; vase, reddish brown at base shaded to dark brown at top with red rose, marked, 7 in. high. *Author's collection; Knight photo*

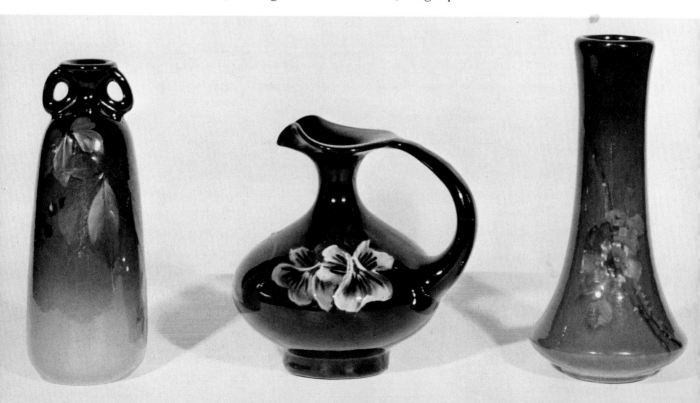

Weller "Louwelsa" electric lamp
base. White birds on brown and yellow
background, marked "Louwelsa Weller,"
signed "A. Haubrich 1901," 19 in. high.
Author's collection; Knight photo

Marked "Louwelsa Weller," brown
and yellow with silver overlay, 3 in. high.
Author's collection; Knight photo

"Louwelsa." *Left to right:* Vase, shaded brown to yellow with red flowers, marked
"Louwelsa" in circle, 4½ in. high; vase, shaded brown to yellow with red flowers,
marked, 3½ in. high; shaded from brown to green to yellow with yellow flowers,
2½ in. to top of handles; ash tray, shaded from brown to yellow, decorated with
one live match and one burnt one, marked "Louwelsa," 1½ in. high; ewer, shades
from yellow to brown, yellow and red flowers, marked "Louwelsa," signed "H. S.,"
6 in. high. *Author's collection; Knight photo*

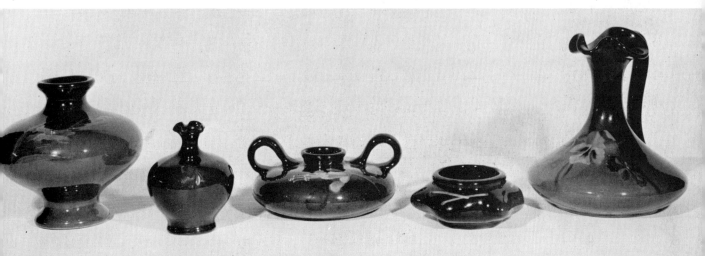

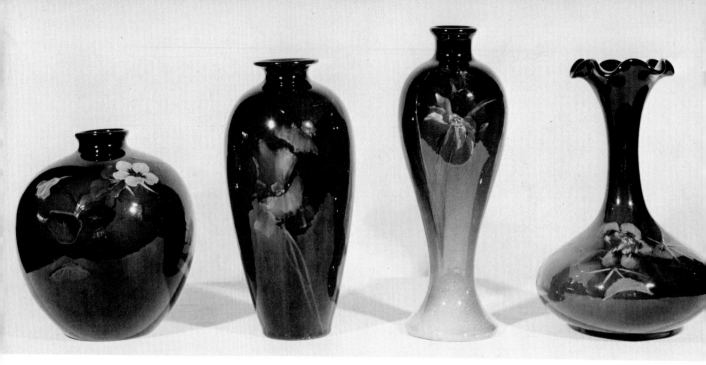

"Louwelsa" vases. *Left to right:* Brown and yellow shading with yellow flowers, marked, signed "S. Reid McLaughlin," 7 in. high; shaded from brown to green to yellow, red poppies, marked, 9¼ in. high; shades from pale yellow at base to dark brown at top, yellow flowers, marked, 10¼ in. high; shades from brown to green to yellow, red flowers, marked, 9¼ in. high. *Author's collection; Knight photo*

making an exquisite line of figurines, tableware, and accessories depicting characters from the Charles Dickens stories. These lines were selling well in England and also in America. Weller, being an alert businessman, decided to "hop on the bandwagon" and commissioned Upjohn to create a line called "Dickens Ware." Weller jokingly said, "If Dickens can create a character named Sam Weller, the least I can do is name a line after him." Upjohn immediately began experimenting to find a suitable ware to bear this name. He changed the background color on the Louwelsa-type lines to solid colors of dark blue, dark green, and a light chocolate brown; on some pieces the colors were shaded from dark to light. Some of these first-line items will be found with "Trial-D" incised on the inside.

In a matter of months Upjohn introduced the "second-line" Dickens Ware, which was destined to become the most sought after by collectors of American art pottery today. Pieces signed by Upjohn are highly treasured. Much of his work was very well executed and gave the effect of being three dimensional. This ware was decorated by the sgraffito method, being incised with a sharp tool by hand, with the background sprayed or brushed, and the colors blended together in beautiful shadow work. The subjects were slip painted with natural

colors, then covered with a glaze. The glazes used on the second line varied from a soft matt to a high-gloss finish. The soft matt and semi-gloss are the glazes most often encountered. The pieces with the high-gloss finish are indeed very rare. A dark, reddish brown clay was usually used in the second-line Dickens Ware; however, on occasion, a light-colored clay was used.

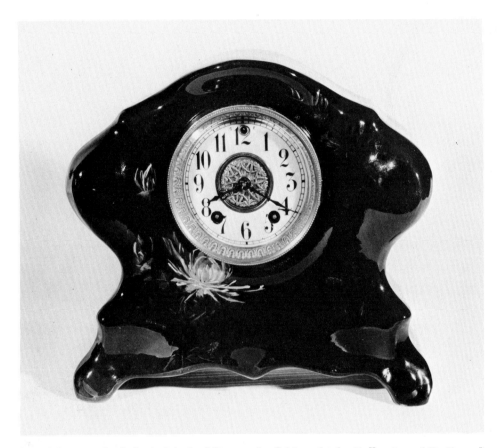

Weller "Louwelsa" clock. Marked "Louwelsa," 10 in. high. *Collection of R. E. and F. G. O'Brien, Jr.; Knight photo*

The colors most often seen in the second-line Dickens Ware are rich chocolate browns shaded to a blue-green or turquoise. Oftentimes the rich brown alone was used, and sometimes the blue-green or turquoise was used alone, blended from dark to light. It was also made in other colors, such as a beautiful true royal blue, shaded from light to dark. One of the rarest colors is the pink, a peach pink with shadings of bluish gray. Another rare color is the white. It is quite possible that other colors were used, but these are all the author has seen. The exact

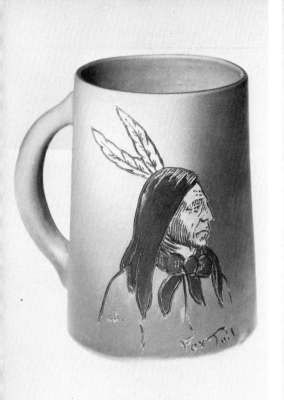
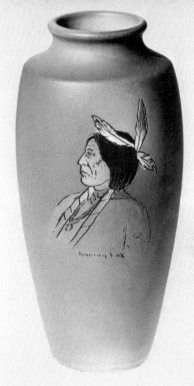

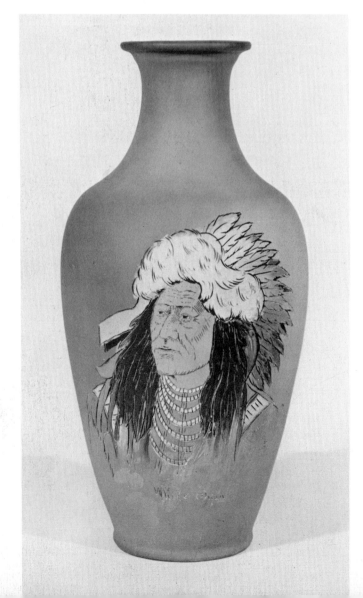

Weller "Dickens Ware" (2nd line).
Top left: "Fox Tail" mug shaded from blue-green to brown, matt finish, signed "Anna Dautherty," ca. 1902, 5½ in. high. *Center:* "Daring Fox" vase, shaded blue-green to chocolate brown, matt finish, signed "J. B.," ca. 1902, 7½ in. high. *Top right:* Three-cornered vase, all chocolate brown, semi-matt glaze, signed "Hattie Mitchell," ca. 1902, 6½ in. high. *Author's collection; Orren photos.*
Left: "White Swan" vase, tan at the bottom shading to turquoise at the top, white headdress and beads, impressed mark "Dickensware," signed by A. Dunlavy, dated 1901, 13½ in. high. *Collection of Oma and Andy Anderson; Knight photo*

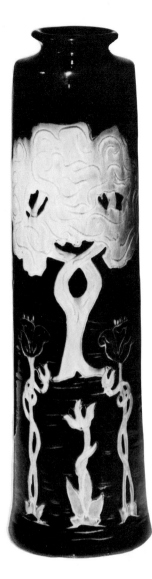

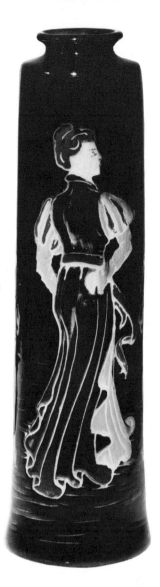

"Dickens Ware" (2nd line) vase. Deep cobalt blue with trees, in sgraffito, in brown and light blue, rare glossy finish, ca. 1901, 14 in. high. Note Chinese influence. *Author's collection; Orren photo*

"Dickens Ware" (2nd line) vase. Rare high-gloss glaze, deep cobalt blue with figure, in sgraffito, wearing a long blue and brown dress, ca. 1901, 14 in. high. *Author's collection; Orren photo*

Weller vases. *Left to right:* "Ethel," cream background with charcoal trim, block "Weller" mark, 9 in. high; "Alvin," light tan, paper label with line name, 8¾ in. high; "Glendale," rustic colors, marked with block "Weller," signed by Hester W. Pillsbury, 6½ in. high; "Knifewood," rustic colors, unmarked, 10½ in. high. *Collection of Oma and Andy Anderson; Knight photo*

number of years the second line was made has not yet been established; a good estimate might be a decade.

The third-line Dickens Ware, which was introduced about 1904 or 1905, was a high-glaze pottery with under-the-glaze slip painting. The background is dark, shading to light, very similar to Weller's "Eocean." The glaze on this line is clear. This is, by and large, the rarest of the Dickens Ware by Weller. The obverse has a Dickens character slip painted under a high-gloss glaze. On the reverse side is a raised disk bearing the name of the character and the story in which he appeared. The disks were molded by Gordon Mull and applied to various pieces. When these disks appear alone, the ware is sometimes referred to as "Cameo" Dickens; however, it is part of the third-line Dickens Ware. At times two disks will appear on the reverse side of a slip-decorated piece; one with the Charles Dickens cameo and the other with the title.

The subjects appearing on Dickens Ware are not always taken from the Charles Dickens tales. Some are portraits of Indians, with the

"Dickens Ware" (1st line) pillow-shaded vase. Dark green shading to light green, clear glaze, flowers in white, orange, and brown, signed "C. G.," ca. 1900, 7 in. high. *Author's collection; Orren photo*

Weller "Dickens Ware" (1st line) vases. *Top:* Light impressed mark "Dickens-ware," incised "Trial-D" on bottom inside, 6¾ in. high. *Bottom:* Light brown lined in yellow, orange flowers and green leaves applied in heavy slip, impressed mark, 7½ in. high. *Author's collection; Knight photos*

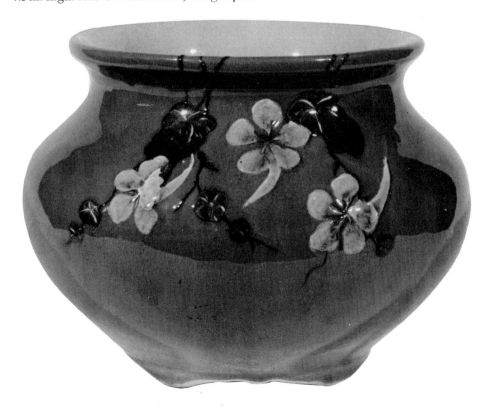

Indian's name, such as "Fox Tail," "Daring Fox," or "White Cloud," appearing on the piece. Some are people at play, such as golfers or men playing checkers, garbed in costumes of the period. Tavern scenes are found on many pieces. One of the most common subjects is a monk, either in full figure or bust. Birds, fish, and other natural subjects can be added to this list. It was rumored that one artist, Levi Burgess, was paid one dollar for each Indian portrait he created on Dickens Ware pieces. Other Weller artists also created very fine Indian portraits, and these too are eagerly sought after by collectors.

"Dickens Ware" (2nd line) vases. *Left and right:* Dark green and brown; *center:* royal blue with vicious dragon in yellow, 16 in. high. *Author's collection; Johnson photo*

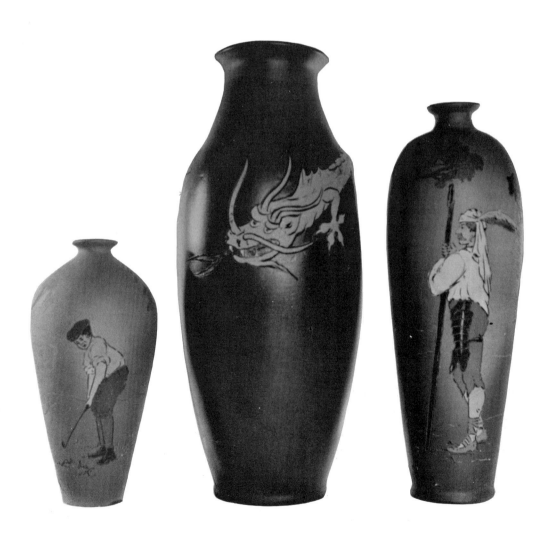

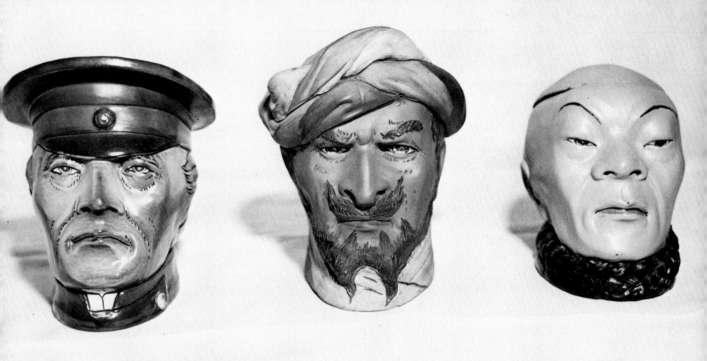

Weller "Dickens Ware" tobacco jars. *Left to right:* Admiral, natural color face, blue collar and hat, trimmed with red, 7 in. high; Turk, dark brown face, turban green, red, and brown, 7 in. high; Chinaman, natural color face, brown color, 7 in. high. *Collection of Dr. and Mrs. Gordon Gifford; Mesre photo*

The name "Dickens Ware" appears on almost all pieces of the first and second lines; however, the third line is marked only "Weller" on the base.

Most collectors of American art pottery are generally concerned with the ornate hand-decorated ware of the art nouveau and post-art nouveau periods (1890 to the early 1930s). A pamphlet published by the Weller Pottery in 1905 contained this statement. "Our factory has increased in size until today it stands the largest pottery in the world, covering over 300,000 feet of floor space." At this time, Weller had originated more than twenty different styles of ware, including the "Sicardo." Mr. Weller, who was always searching for new talent and new ideas, imported two Frenchmen to create a line of iridescent pottery. Jacques Sicard and his assistant, Henri Gellie, were making a beautiful metallic lusterware for the Clement Massier Pottery at Golfe Juan, France. Weller induced them to come to America to fashion a line of similar ware for his company. Arriving in this country sometime during 1901, they began making a metallic luster pottery with floral and geometric designs developed within the glaze.

Weller "Sicardo" line. *Top left:* Wine red vase with green, silver sheen, 7 in. high. *Center:* Green candlestick with highlights of wine red and blue, 8½ in. high. *Top right:* Vase, dark red at top, brilliant green at bottom, 5½ in. high. Note scratched signature "Sicard Weller." *Left:* Green and blue vase with silver sheen, 5 in. high. *Author's collection; Orren photos*

"Sicardo" vases. *Top left:* Peacock blue with purple highlights and gold thistles, 10 in. high. *Top right:* Green, 4¼ in. high. *Below:* Peacock blue, 6½ in. high. *Author's collection; Orren photos*

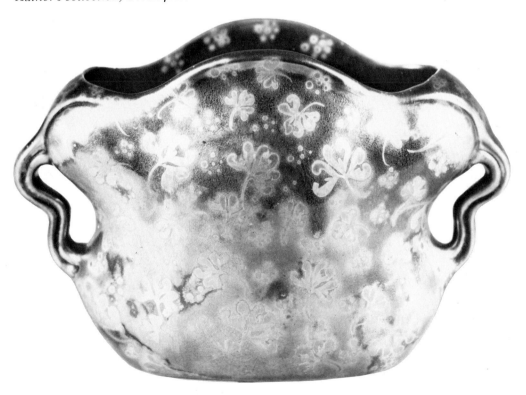

The colors for the most part are beautiful dark rich hues, blending from one shade to another. They consist of dark rich wine red, bright green, and peacock blue. Occasionally the reds and blues are used one over the other, giving an illusion of vivid purple. Each piece is highlighted with a gold or silver sheen. The inside shows a deep rose, evidently the first coat of glaze used on Sicardo. Sicardo follows closely in form the elegant classic shapes of the iridescent glass of the art nouveau period. Some items have molded designs in the body and some are reticulated. Sicardo was made mostly in ornamental vessels—vases, bowls, bonbon dishes, candlesticks, umbrella stands, jardinieres, plaques, and jewel boxes. The sizes in Sicardo ware are varied, some are as small as two inches, while others are as much as thirty inches in height.

This excellent line of art pottery was named after its creator by adding the letter "O" to his surname. Sicardo was a sensation from the very beginning and added prestige to the Weller art wares. It was very costly to produce, and due to the high cost of production, Weller claimed this line never made his factory any money. Some pieces reportedly were priced for upwards of three hundred dollars, being sold in exclusive jewelry stores, including Tiffany's.

The method used in making Sicardo was a laborious and time-consuming process. It was a difficult ware to produce and many pieces were damaged in the process or in the kiln and hence had to be dis-

"Darsie" bowl and candlesticks. Turquoise, marked in script; bowl 5½ in. high, 16 in. long; candlesticks 3½ in. high. *Author's collection; Knight photo*

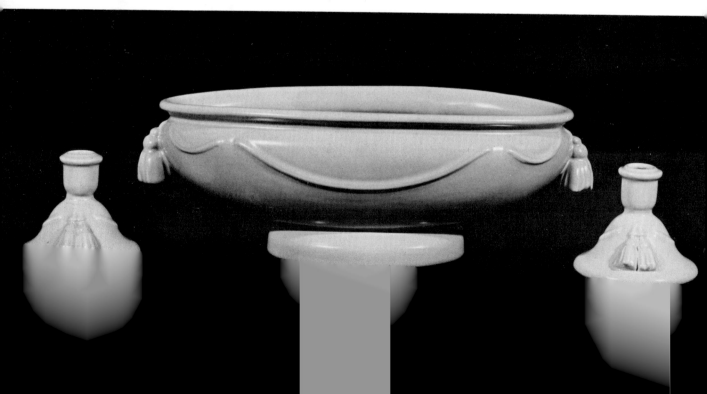

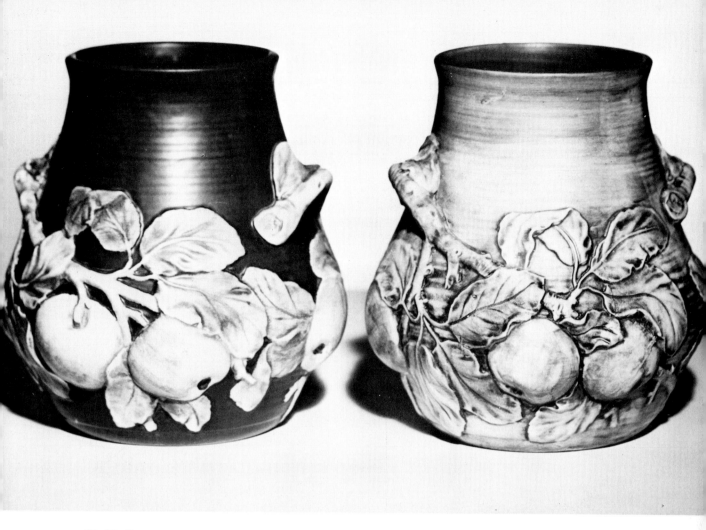

"Baldin" vases. No. 11 in catalog, natural apples on dark blue background *(left)* and rustic brown background *(right)*, 10 in. high. *Author's collection, Orren photo*

carded. The glaze was heavy and ran badly. There are pinpoint holes, craters, and thick spots (called bubbles) on many pieces. There is also evidence that the "stilts," on the base, had to be broken off on some articles. ("Stilts" are small pins or fins made of clay used to raise the wares from the floor of the saggers, thus preventing the glaze from sticking to the shelves. The stilts were usually in groups of three. If they happened to stick to the ware, they were removed with a gentle tap. The scars are often visible on pieces with a heavy glaze.) The excess glaze on the bottoms was then polished down on a grinding wheel to make smooth resting surfaces for the vessels. The glaze was a difficult one to fire as the colors seem to have burned out easily. The surface on some Sicardo pieces that were not exposed to the heat evenly have light spots and streaks, while others have a rather sickly

green appearance and seem to have lost all of their vivid colors completely.

Sicard and Gellie created an air of secrecy and mystery about the making of Sicardo, and it was rumored they worked behind locked doors conversing in a French-Swiss dialect so that no one could understand what they were saying, if they were overheard by someone who understood the French language. It was also rumored that Weller requested his other artists to obtain the formula for the making of Sicardo, by unorthodox means if necessary. However, the artists were unable to discover any of the processes. Sicard and Gellie managed to be convincing and imparted an air of secrecy about Sicardo which continues to intrigue people today. Although these two men endeavored to keep it a secret the process was not a complete mystery, since a similar line was developed by other potteries, including Tiffany, Roseville, and Owens. It must be understood that these other potteries did not use the exact process for the making of this lusterware, but that the end results were almost a duplication.

Sicard was proud of his product and claimed that every piece was signed. The signature consists of the name "Sicard" or "Sicardo," along with the name "Weller," no matter how insignificant the item. Most pieces are signed on the surface of the vessels near the bottom; some others were signed near the center, with "Sicard" or "Sicardo" on one side and "Weller" on the other side. Occasionally a piece will be marked with the impressed "Weller," or just "W" on the base. Pieces made by Sicard on special order were signed "J. Sicard," without the name Weller. Two techniques were used in the signing: in one method, the signature was worked in with the predetermined design and became part of the decoration; in the other method, the name was scratched in over the design before the final firing. On close observation the iridescence in the scratched signature is clearly visible.

The clay used in Sicardo was usually light in color; however, some of the earlier pieces are made of a dark reddish brown clay of the same type used on the second-line Dickens Ware.

Sicard, a bachelor, returned to his native France in 1907, where he operated a small pottery until his death in 1923. Gellie remained in America for a longer period of time; then he also returned, with his wife and two sons, to his homeland. He died in 1917, after being

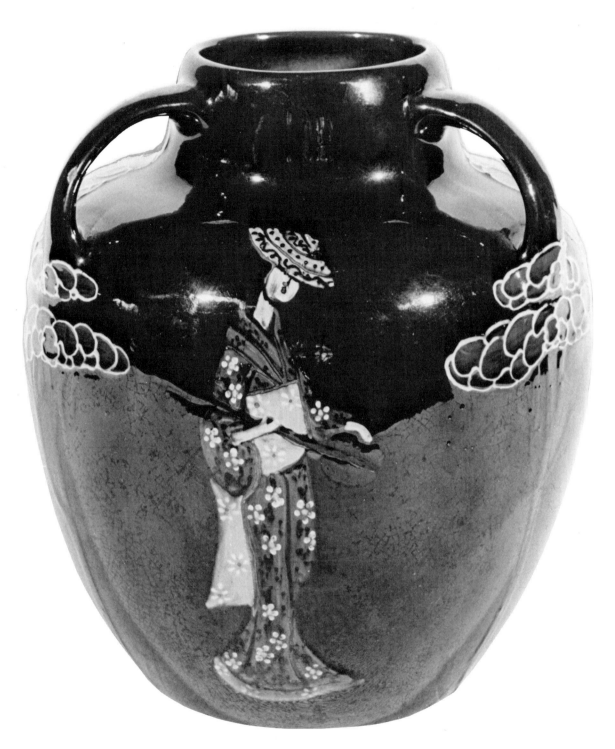

Three-handled vase. "Jap Birdimal," dark bluish-green background, marked "Weller Faïence," signed "Rhead," 8 in. high. *Collection of R. E. and F. G. O'Brien, Jr.; Knight photo*

wounded in the Battle of Verdun in World War I. Mrs. Christiana Gellie, after their return to France, continued to correspond for several years with the many friends they had made in America.

Weller Sicardo was made for approximately seven years and is quite scarce today. It is considered by most collectors and students of American art pottery to be the most renowned line ever made at the Weller Pottery.

In 1903 Sam Weller built the Weller Theater and decorated it extensively with Weller pottery. Even the box office was adorned with Dickens Ware; in the lobby were a pair of large Sicardo vases.

Frederick Alfred Rhead followed Upjohn as art director, a position he held from 1905 till 1920. Rhead was an Englishman who had worked for several potteries in England, including Minton, where he decorated the beautiful "Pate sur Pate" in the style of L. Solon. He and his brother, G. W. Rhead, were co-authors of the book *Staffordshire Pots and Potters,* published in 1906.

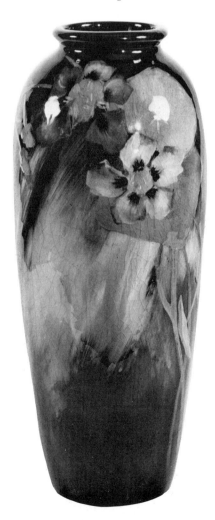

"Aurelian" vase. Multi bright colors, signed "Madge Hurst," 11½ in. high. *Author's collection; Knight photo*

"Etna" vases. Gray shading to pale pink, all signed "Etna Weller."
Author's collection; Johnson photo

By 1905 Weller Pottery had grown to a mammoth institution, sprawling over four acres of ground, having 600 employees, and operating twenty-three kilns with 300,000 feet of floor space. Twenty-two different lines had already been introduced to the public and three railroad boxcars of goods were shipped each day to the purchasers. The company, at this time, was definitely enjoying a thriving business, with an encouraging future ahead.

The various Weller lines seem to have been created by trial and error. The first line, the "Louwelsa" ware, was a duplication of Rookwood's standard glaze brown ware, with the high-gloss glaze. The "Aurelian" ware was merely Louwelsa, with a changed background. This background was sponged-on splashed effects, which appears somewhat like a distant forest fire, with the slip painting under the same standard glaze as Louwelsa. Later, the background colors of Louwelsa were changed from browns to shaded pastel colors of pink, blue, green, and gray. This afforded the artists a greater range of color for the under-the-glaze painting. These lines were called "Eocean," "Auroro," "Etna," "Floretta," and "Rochelle."

The following description of Eocean and third-line Dickens Ware was given by Marcus Benjamin in his article, "American Art Pottery," published in 1907.

> The name Eocean is applied to those wares which are of light body and have the background colors blended with an atomizer. Pale and delicate blues, grays and green color effects are the characteristics of this ware. The decorations are of flowers, fruits, and figures; sometimes the latter are in relief affording a pleasing effect, and when characters from the works of Charles Dickens are presented the ware takes its name from the great novelist and is called Dickensware.

The Weller artists were constantly developing new decorations and glazes. When Rookwood introduced the Vellum glaze in 1904, Weller retaliated with a similar matt-glaze line called "Dresden." This line contained a Dutch mill scene using, at times, Dutch boy and girl figures in blue on blue, with a touch of green blended into the light blue background. At this same time, another etched line was introduced, in the style of the second-line Dickens Ware. This was labeled "Etched Matt." Floretta also came "etched" in the same manner. Perhaps other lines were also further decorated in the sgraffito method. "Turada" and "Jap Birdimal" lines are the sgraffito type, with the incisions inlaid with designs standing out in relief from the surface of the vessel.

In 1904 another line, "L'Art Nouveau," was introduced. Most L'Art Nouveau pieces have a soft velvetlike finish; however, some have a semigloss or gloss glaze. Decorations on this line are the traditional misty flowing figures of the period. Most L'Art Nouveau pieces are pastel, but occasionally pieces will be found with a dark brown high glaze.

During the period directly after World War I, Weller felt the need for manufacturing a less expensive line of ware. It was then that the molded lines were introduced. One of the most prolific artists to model designs for these lines was Rudolph Lorber, a native of Mettlach, Germany. Lorber worked in the Putnam Plant studio, under the supervision of Ed Pickens, a brother of Mrs. S. A. Weller. The able potter who turned the shapes was Aloysius J. Schwerber. Many talented artists worked at the Putnam studio, including Karl Kappes, who became famous for his "Paintings in Oils."

"Turada" umbrella stand. Dark brown with golden yellow and blue trim, 21 in. high. *Author's collection, Orren photo*

Weller Pottery catalog, ca. 1919

CLASSIC

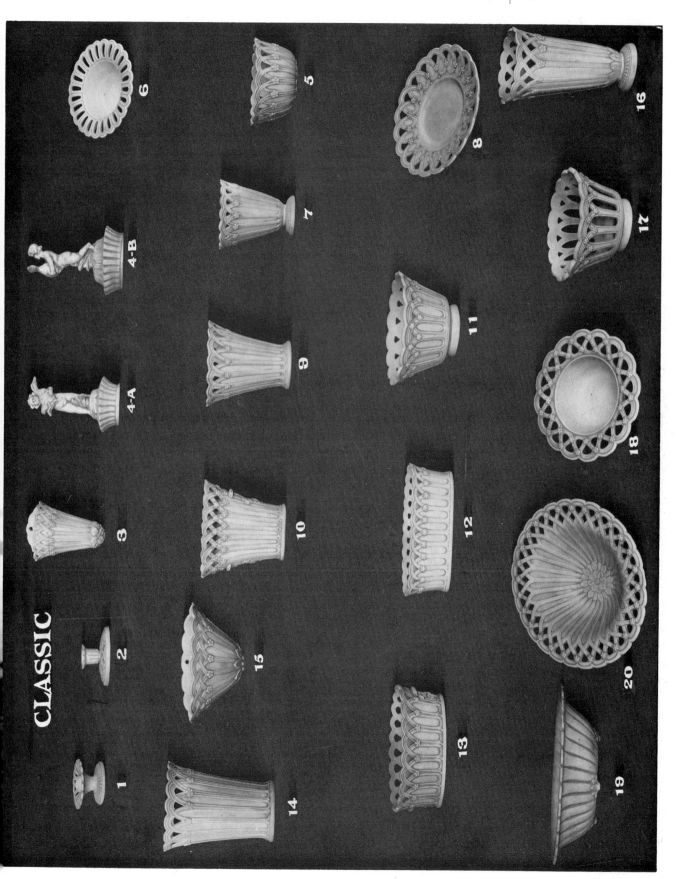

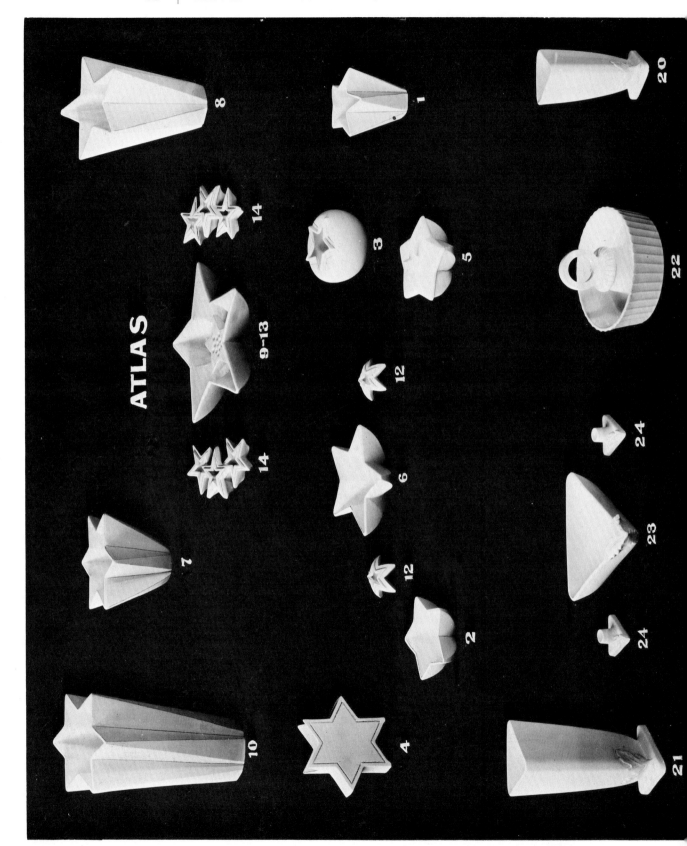

ATLAS

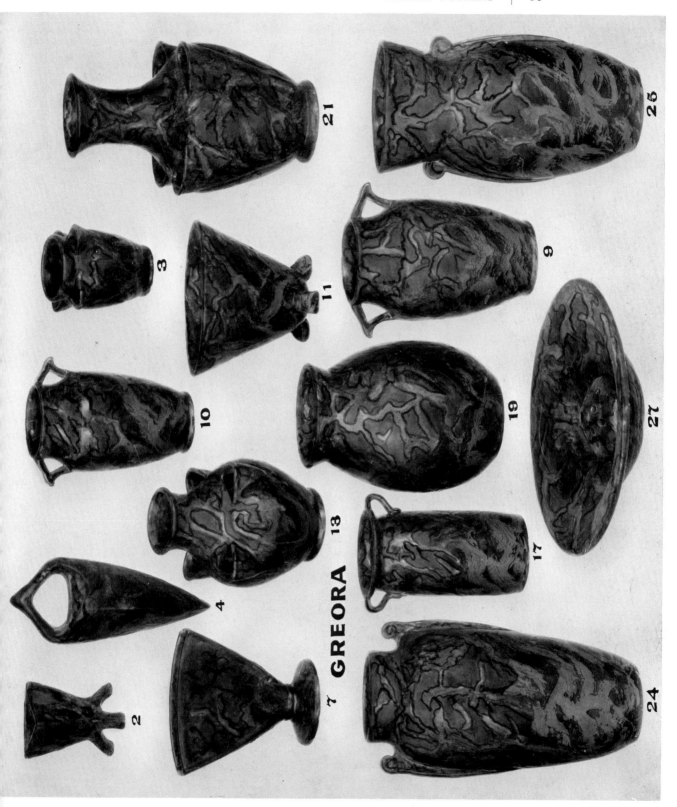

Weller Pottery catalog, ca. 1919

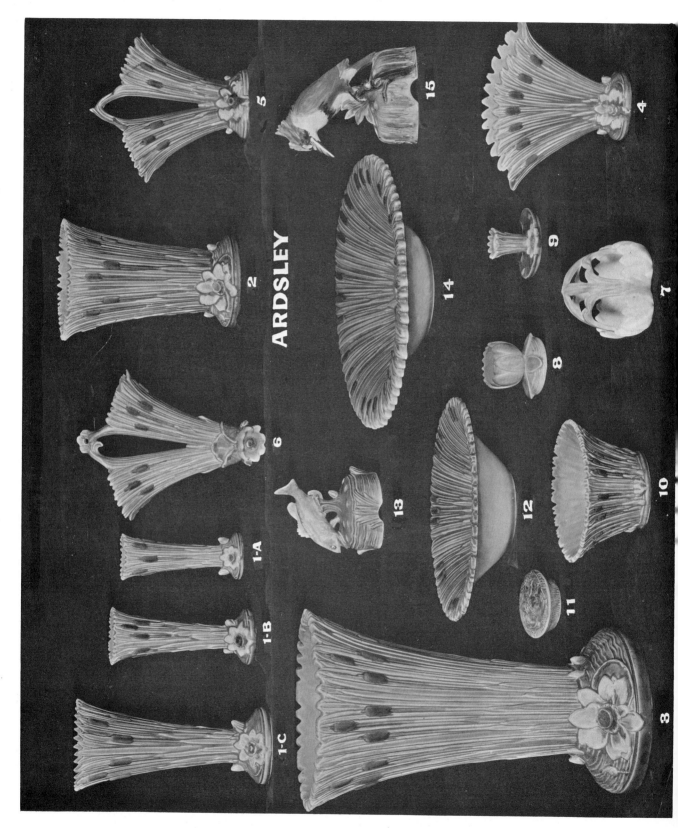

ARDSLEY

Weller Pottery catalog, ca. 1919

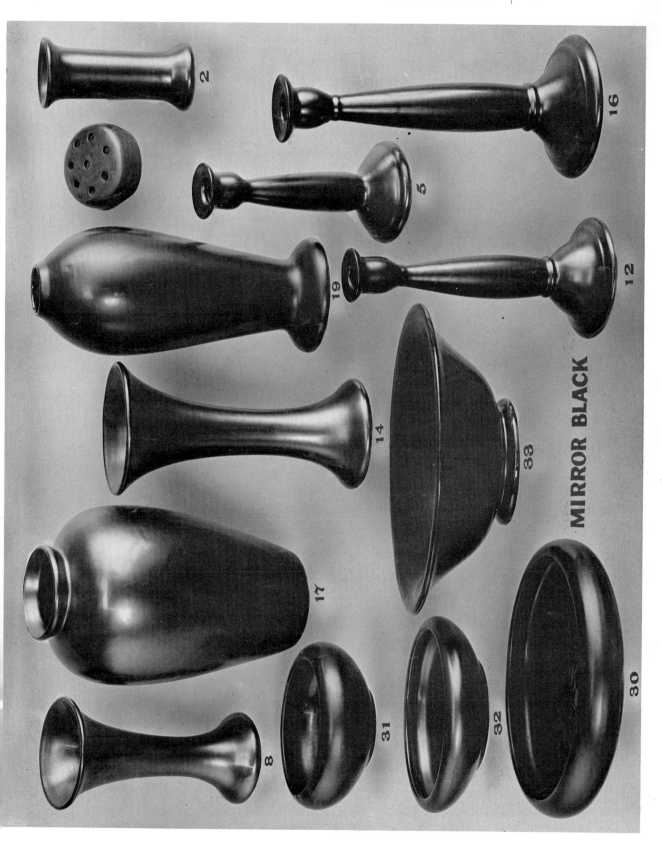

MIRROR BLACK

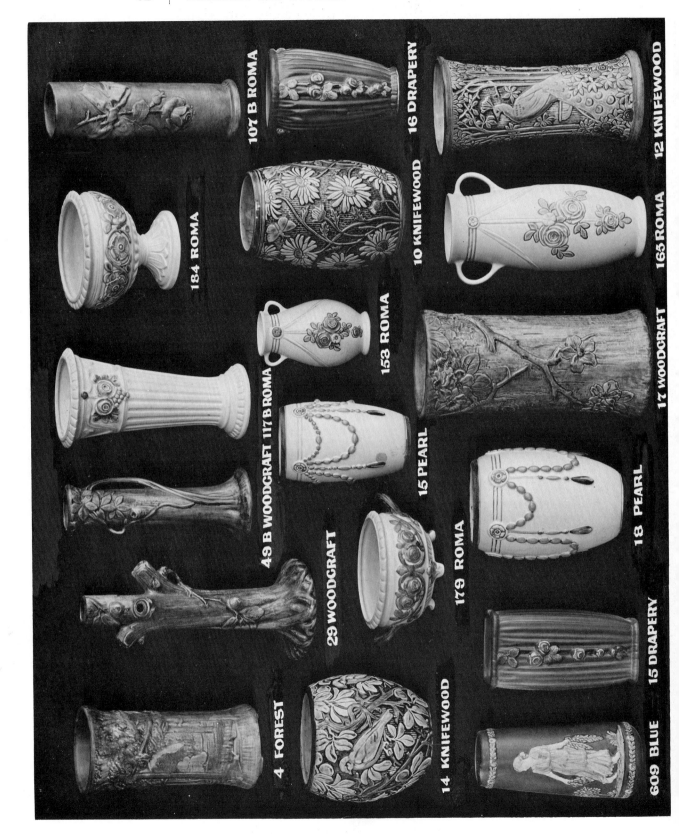

107 B ROMA

16 DRAPERY

12 KNIFEWOOD

184 ROMA

10 KNIFEWOOD

165 ROMA

153 ROMA

17 WOODCRAFT

49 B WOODCRAFT 117 B ROMA

15 PEARL

18 PEARL

29 WOODCRAFT

179 ROMA

15 DRAPERY

4 FOREST

14 KNIFEWOOD

609 BLUE

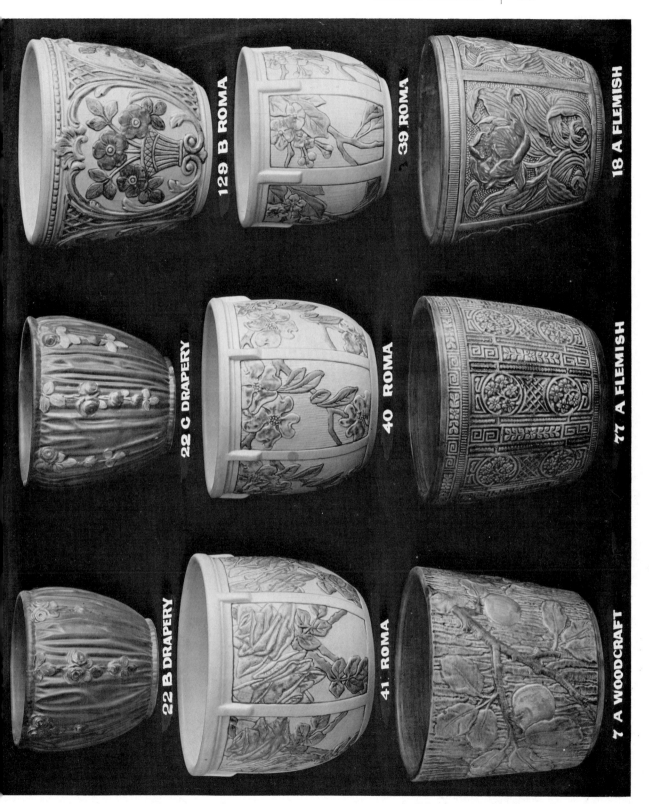

Weller Pottery catalog, ca. 1919

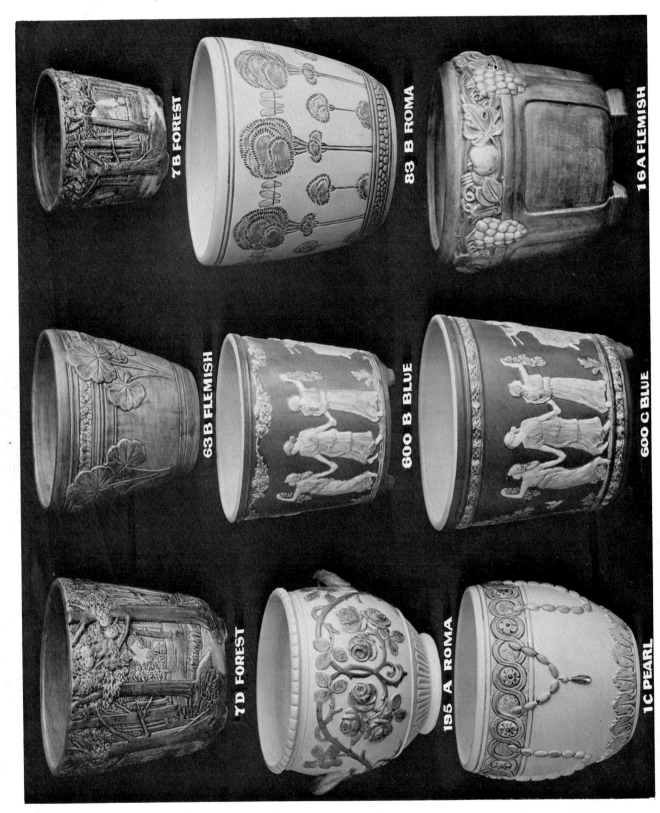

Weller Pottery catalog, ca. 1919

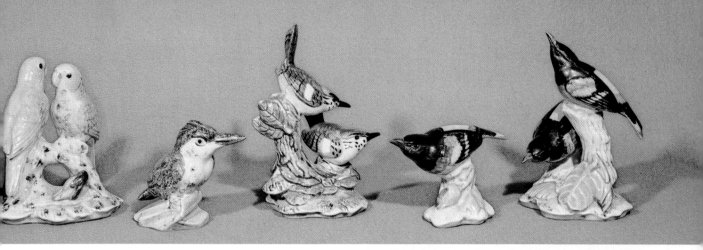

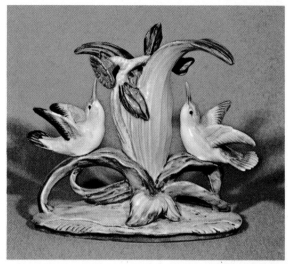

Stangl pottery birds; all ink-stamped "Stangl Pottery Birds"; made in limited quantities only in the early 1940s. *Left to right:* 5½-in.; 3½-in.; 6½-in.; 3¼-in.; 6-in. *Collection of Oma and Andy Anderson*

Stangl pottery birds; height 9 in.; ink-stamped "Stangl Pottery Birds"; these were made in limited quantities only in the early 1940s. *Author's collection*

Fulper ware. *Left to right:* 6-in. two-handled vase, "Mouse Gray with Blue of the Sky Flambe", ink-stamped "Fulper"; 12-in. vase "Mouse Gray with Cat's Eye and Yellow Flambe," impressed "Fulper," with added Fulper paper label. *Author's collection*

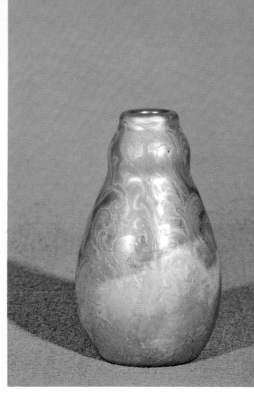

Left to right: Weller "Sicardo" plaque, 10-in. diameter, a special piece made of reddish brown clay and signed "J. Sicard" on the back; Weller 5-in. signed "Sicardo" vase, the pale coloring in this piece shows the results of uneven firing. *Author's collection*

Weller vases. *Left to right:* 8½-in. marked "LaSa"; 5½-in marked "Sicardo"; 7-in. "LaSa" after the third firing; 8½-in. marked "LaSa." *Author's collection*

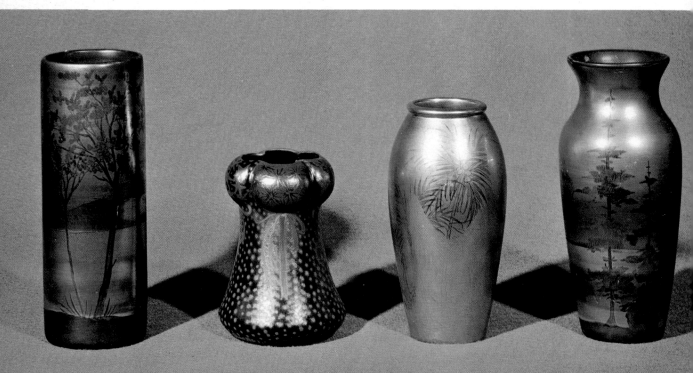

Weller vases. *Left to right:* 7-in. "Pictorial," ink-stamped "Weller Pottery", signed by Pillsbury; 7¼-in. "Hudson," block letters "Weller," signed by Hood; 8¼-in. "Hudson," hand script "Weller," signed by Timberlake; 9½-in. "Hudson," ink-stamped "Weller," signed by Pillsbury. *Author's collection*

Weller vases. *Left to right:* 11-in. unmarked "Marengo"; 12¼-in. "Lamar" with paper label; 8¼-in. unmarked "Marengo"; 11½-in. "Chengtu," ink-stamped "Weller," *Author's collection*

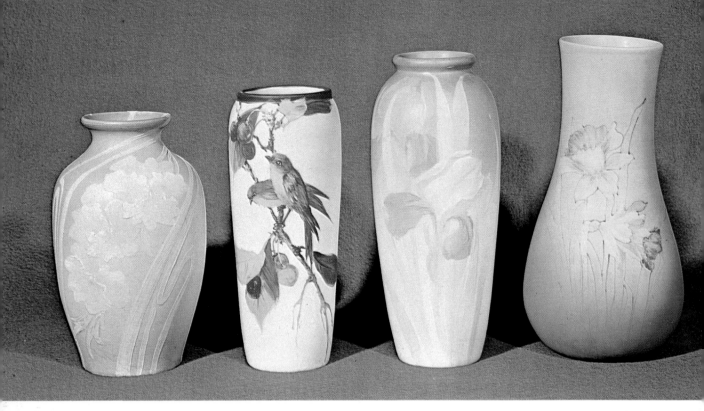

Weller vases. *Left to right:* 9¾-in. "Matt Louwelsa," very rare, marked "Louwelsa"; 10-in. "Hudson," marked "WELLER" in large block letters; 11-in. "Hudson," marked "Weller" in small block letters; 11½-in. "Hudson," marked "WELLER" in large block letters, signed by Claude Leffler. *Author's collection.*

Weller 16-in. "Pictorial" vase; hand-incised mark, "Weller Pottery"; signed by Timberlake.
Author's collection

Weller 8½-in. "Jap Birdimal" jardiniere; marked "Weller" in small block letters; 10-in. diameter.
Author's collection

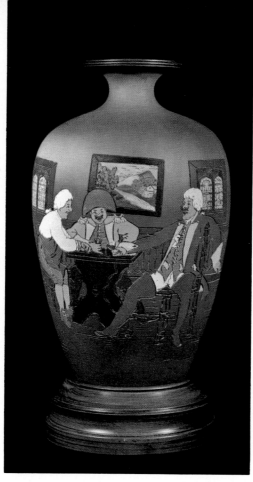

Left to right: 10½-in. Weller "Louwelsa Indian" vase; marked "Louwelsa Weller," incised in base "James Red Cloud, Sioux," signed by Karl Kappes, *Author's collection;* marked Weller 18-in. "Dickens Ware" vase, signed by Upjohn, dated 1901, *Author's collection;* Weller 16-in. "Art Nouveau" vase; marked "Art Nouveau Mat Weller" with incised block letters. *Collection of R. E. and F. G. O'Brien, Jr.*

Weller pottery. *Left to right:* 4½-in. marked blue "Louwelsa" vase; "Jap Birdimal" teapot, 5½-in. to top of finial, signed by Mary Gillie; 9-in. "Blue Decorated" vase; marked "WELLER" in block letters. *Author's collection.*

Weller pottery. *Left to right:* 6½-in. pink luster vase, ink-stamped "Weller"; 7½-in. "Brighton" line parrot, marked "WELLER" in block letters; 14-in. "Eocean" vase, hand-incised script "Weller," signed by William H. Stemn; 12-in. "Eocean" vase, hand-incised script "Weller," signed by Albert Haubrich. *Author's collection*

Weller vases. *Left to right:* 7-in. "Rosemont," marked "WELLER" in block letters; 8-in. "Flemish," marked "WELLER" in block letters *Collection of R. E. and F. G. O'Brien, Jr.*

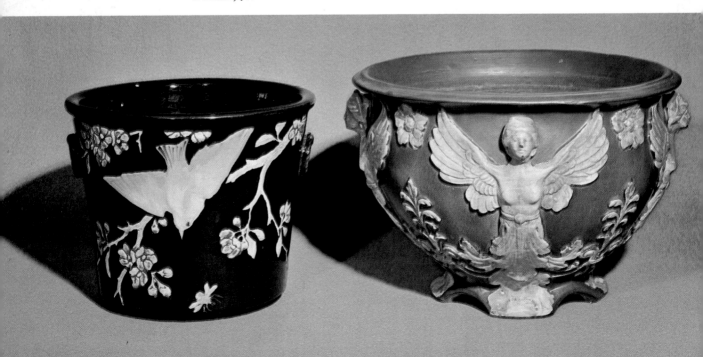

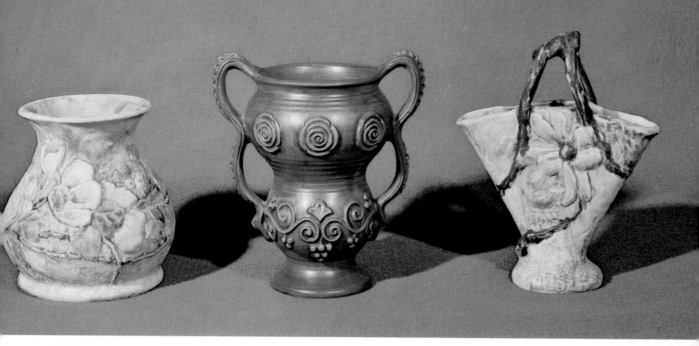

Weller pottery. *Left to right:* 6-in. "Silvertone" vase, ink-stamped "Weller Ware"; 8-in. "Clarmont" two-handled vase, marked "WELLER" in block letters, also has paper label with line name; "Silvertone" vase, 8½-in. to top of handle, ink-stamped "Weller Pottery." *Author's collection*

Weller pottery. *Left to right:* 7-in. "Delta" vase, marked "WELLER" in block letters, signed by Mae Timberlake; 10½-in. "Eocean Rose" vase, hand-incised "Eocean Rose / Weller," signed by Sarah Reid McLaughlin; 11-in. "Etna" vase, marked "Etna" with "Weller" in small letters; 11-in. "Rochelle" tankard pitcher, impressed mark "Weller Ware." *Author's collection*

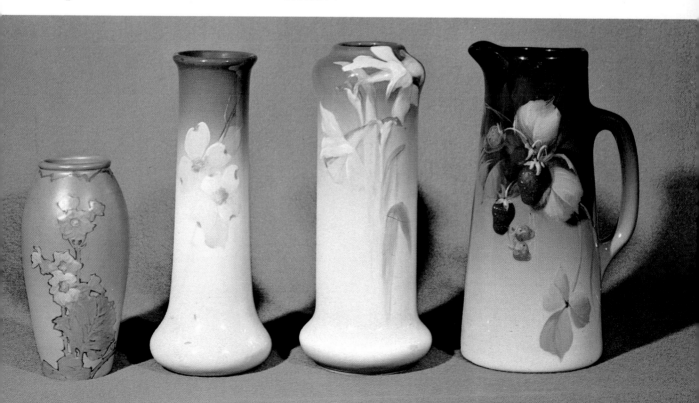

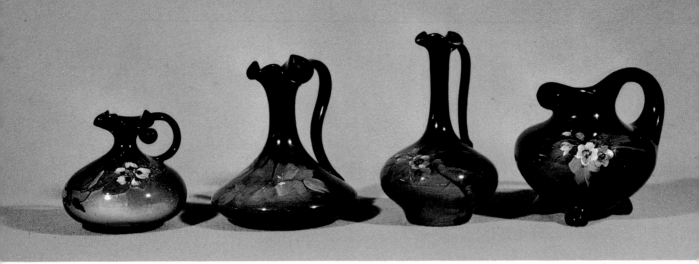

Group of Weller's "Louwelsa," none signed by an artist, all marked "Louwelsa Weller." *Left to right:* 4-in. pitcher; 5¾-in. ewer; 7-in. ewer; 5½-in. pitcher. *Author's collection*

Weller's "Aurelian" ware. *Left to right:* Handled 6½-in. mug, mark impressed in circle, signed by Mary Gillie; 13½-in. ewer, mark hand-inscribed in circle, with full signature of H. Mitchell (Hattie Mitchell); 7¾-in. pitcher, mark impressed in circle, signed by Delores Harvey. *Author's collection*

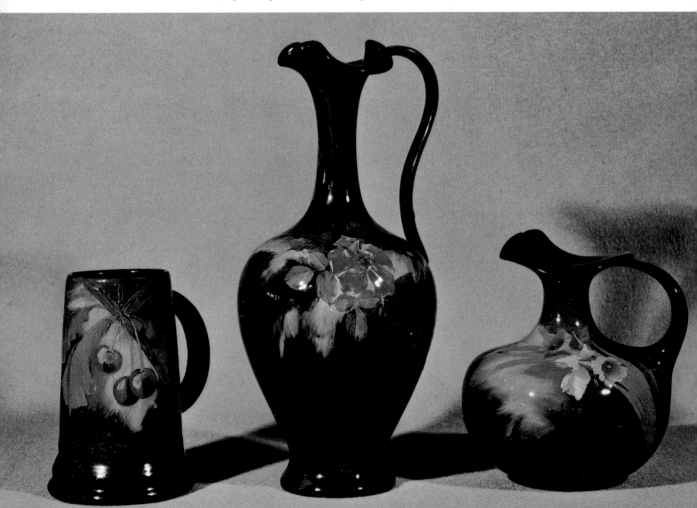

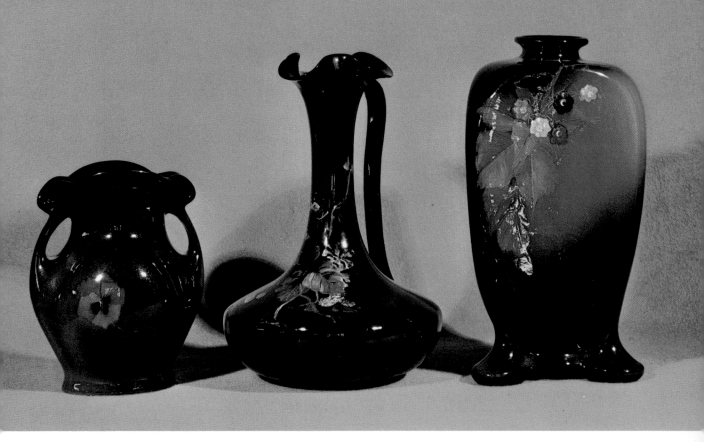

Group of Weller's "Louwelsa" ware, all marked 'Louwelsa Weller." *Left to right:* 8-in. two-handled vase, signed by Mary Pierce; 12-in. ewer, signed by Anna Dautherty; 12¼-in. three-footed vase, signed with a G. (an unknown signature). *Author's collection*

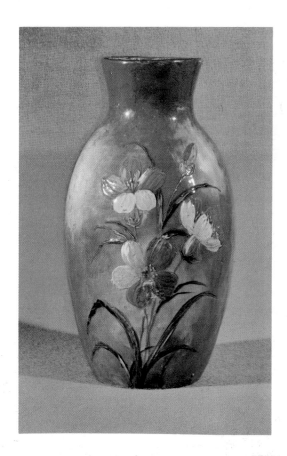

Wheatley 12-in. vase; marks on the base include "No. 22," "T J We Co.," and "Pat Sep 28, 1880." *Author's collection*

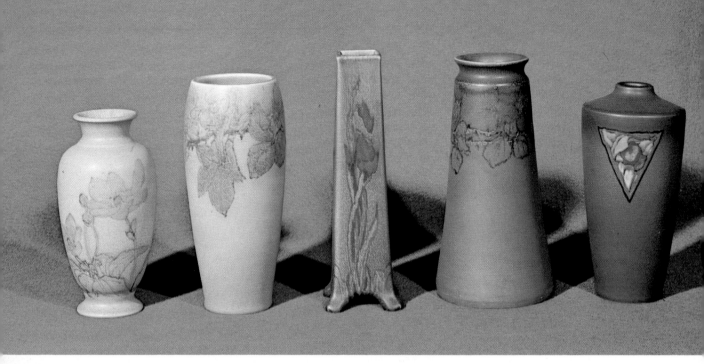

Rookwood vases. *Left to right:* 6¾-in., "Wax Matt" glaze, dated 1933, signed by Sallie E. Coyne, marked "Special"; 7¾-in., "Wax Matt" glaze, dated 1920, signed by Sallie E. Coyne; 8¼-in., "Wax Matt" glaze, dated 1925, signed by Margaret Helen McDonald; 8¼-in., "Wax Matt" glaze, dated 1925, signed by Margaret Helen McDonald; 7¼-in., conventional decoration-painted matt, dated 1911, signed by Chas. S. Todd. *Author's Collection*

Rookwood vases. *Left to right:* 7¾-in., "Sea Green" glaze, dated 1903, signed by Constance A. Baker; two-handled, 5¼-in. high, 10¼-in. from handle to handle, dated 1892, signed by Albert R. Valentien; 9-in., "Iris" glaze, dated 1910, signed by Edward Diers. *Author's collection*

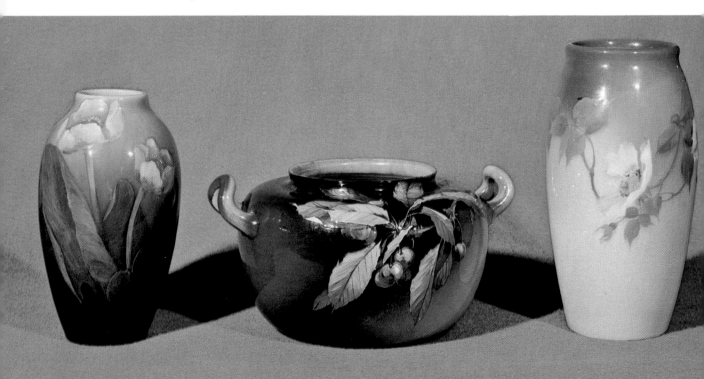

Group of Rookwood ware, all standard brown ware glaze. *Left to right:* 6¼-in vase, dated 1893, signed by Carrie Steinle; 7-in. vase with rare reversed color, dated 1904, signed by Laura E. Lindeman; jug, 8¼-in. to top of stopper, dated 1900, signed by Sallie E. Coyne; 7¾-in. vase with unusual scallop top, dated 1890, signed by Sallie Toohey. *Author's collection*

Rookwood scenic "Vellum" vases. *Left to right:* 6½-in., dated 1914, signed by Chas. J. McLaughlin; 7¾-in., dated 1911, signed by Kataro Shirayamadani; 7-in., dated 1921, signed by Sallie E. Coyne; 7¼-in., rare marine scene, dated 1908, signed by Sallie E. Coyne; 7½-in., dated 1919, signed by Sallie E. Coyne. *Author's collection*

Rookwood vases. *Left to right:* 4¾-in., incised matt, dated 1905, signed by Sarah Sax; *second and fourth vases*, a pair of very unusual lavender color, 7¼-in. to top of finial, plain matt finish, dated XXIV, covered pieces are a rarity; 9½-in., letter Z added to size number, painted matt, dated 1901, signed by Amelia B. Sprague; 6-in., modeled matt, letter Z added to size number, dated 1904, signed by Sallie Toohey. *Author's collection*

Rookwood 7¼-in. "Tiger Eye" vase; dated 1932; note the aventurine effect within the glaze. *Author's collection*

Rookwood 4¼-in. vase; rare piece marked "Special"; dated 1934; signed by Kataro Shirayamadani. *Author's collection*

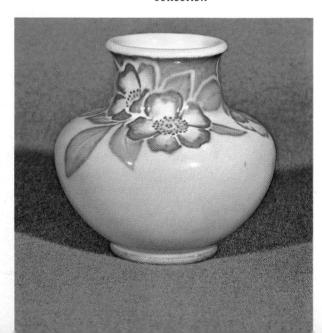

Matt Morgan 6½-in. handled jug; Limoges-type decoration; marked "Matt Morgan Art Pottery Co." (impressed); also bears paper label; signed by William McDonald. *Collection of R. E. and F. G. O'Brien, Jr.*

Rookwood floral "Vellum" vases. *Left to right:* 6-in., dated 1909, signed by Edith Noonan; 7-in., dated 1930, signed by Edward Diers; 7¾-in., dated 1913, signed by Mary Grace Denzler; 10¼-in., dated 1904, signed by Mary Nourse. *Author's collection*

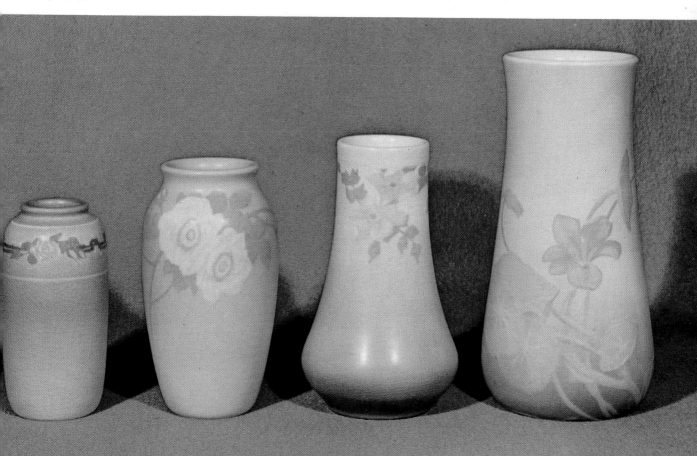

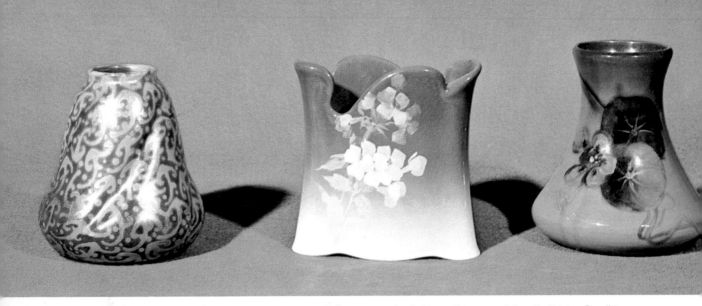

Roseville vases. *Left to right:* Unmarked 5½-in. "Rozane Mara"; 5½-in. flat "Rozane Royal," marked with wafer, signed by Pillsbury; 6-in. "Blue Ware" marked with black on black early paper label. *Author's collection*

Roseville art pottery. *Left to right:* Unmarked 7-in. "Rozane Mongol" pitcher; 10¾-in. "Rozane Della Robbia" pitcher marked with wafer, signed by Gussie Gerwick; 10½-in. "Rozane Olympic" pitcher, ink-stamped "Rozane Pottery/Trip-tolemos and the Grain of Wheat"; 9-in. "Rozane Woodland" vase marked with wafer, signed "F. T." *Author's collection*

Owens 11¾-in. vase with cat; very rare; marked "Owens
Utopian"; signed by Mae Timberlake. *Author's collection*

Owens "Utopian" kerosene lamp; all parts original;
marked "Owens Utopian"; signed by Mae Timberlake
(full signature); also bears the following, "Gentle Bird
Flatheads"; overall height 31½-in. *Collection of Oma
and Andy Anderson*

Newcomb 6-in. vase; the moon shines through trees
heavily laden with Spanish moss; the artist's signature
is not legible, but thought to be the work of Sadie
Irvine. *Author's collection*

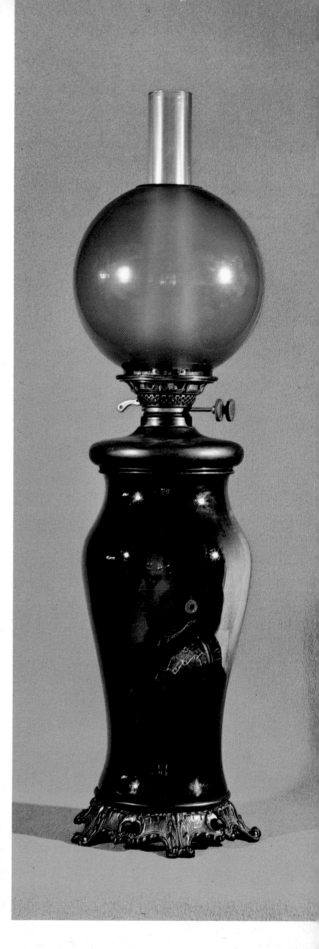

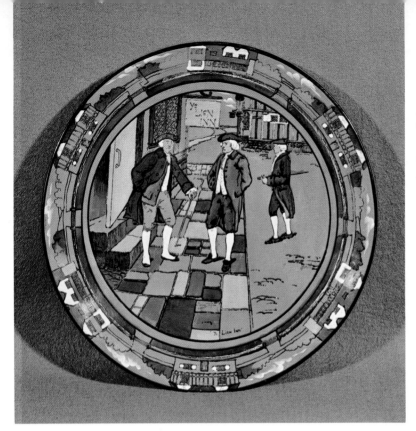

Buffalo "Deldare" 12-in. plate;
dated 1908; "Ye Olden Times"
pattern with "Ye Lion Inn"
center scene; artist, H. Ball.
Author's collection

Radford reproductions from the original molds; both in original color; impressed
mark on bottom, "An A. Radford / Reproduction / By F. Radford"; the number
and date are impressed on base near the edge. *Left to right:* Jasper # 21, marked
"#21 002 6 69"; Jasper #22, marked #22 002 6 69". *Author's collection*

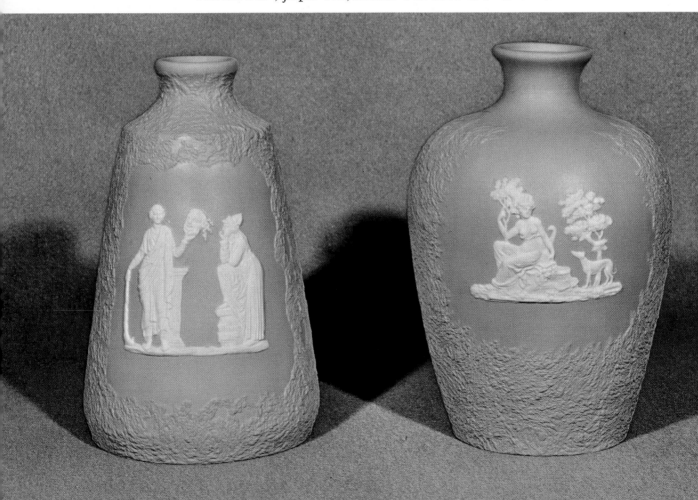

NO 38-19 1/2" CLAYWOOD

NO 233-21" LIGHT GLAZE

NO 67-19 1/2" IVORY

NO 16-22" TEAK WOOD

NO 87-21" BLUE MOTTLED

NO 25-20 3/4" LOUWELSA

NO 10-20" BEDFORD MATT

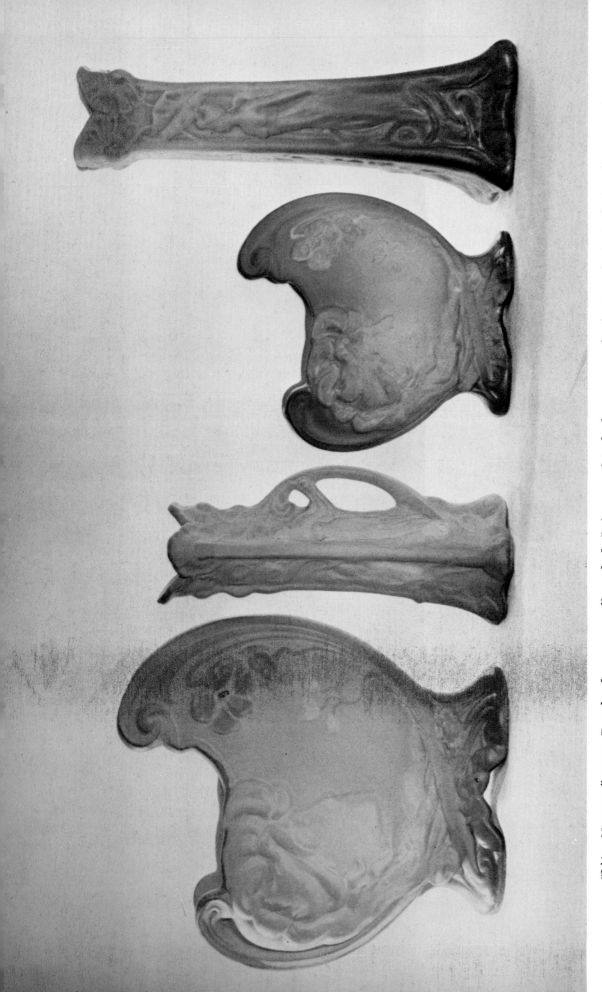

"L'Art Nouveau" vases. Pastel colors, group all marked. *Left to right:* Matt finish, 9 in. high; **matt finish**, 7½ in. high; matt finish, 6 in. high; semi-matt finish, 10 in. high. *Author's collection; Johnson photo*

Most of the molded patterns were created strictly from American scenes, flowers, and wildlife. One day, while riding on a train, Lorber was inspired by the wooded scenes, which gave him the idea for the "Forest" line. This line was well received by the public and similar lines were created, for example, a line decorated with owls, foxes, logs, and other rustic-type woody subjects, called "Woodcraft." Beautiful figures of nudes, birds, frogs, butterflies, and other subjects were used as ornaments in flower-arranging bowls. This is the "Muskota" line. Included in this line is the Tom Sawyer type "fisher boy."

Lorber also created the "Zona" line, which consisted of red apples on a light background, with a gloss glaze. The Gladding McBean Company, of California, purchased the rights to use the design for their wares. This company is still in operation, making this pattern which is known as their "Franciscan Apple" pattern. After the rights were sold, the name "Zona" was applied to other decorated lines with high glaze, such as the "Zona Baby Ware." From time to time the old patterns that had sold well would be introduced again under a new name, except that minor changes would be made in color, glaze, and so forth.

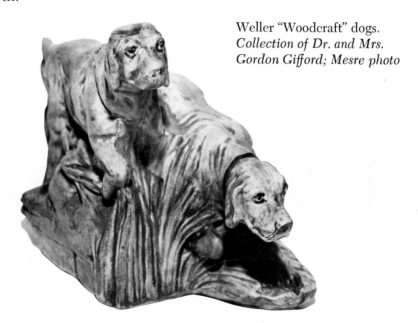

Weller "Woodcraft" dogs.
Collection of Dr. and Mrs. Gordon Gifford; Mesre photo

In 1920 Weller purchased the old Zanesville Art Pottery on Ceramic Avenue, this becoming plant No. 3. In 1924 it was remodeled and enlarged to a huge three-story building at a cost of $150,000.

Weller Pottery catalog, ca. 1919

John Lassell, who was already known as an expert in the field of metallic luster glazes, became art director in 1920. He had previously worked for the Owens Company. Lassell created the "LaSa," "Lamar," "Marengo," and other luster and metallic glazed ware. He also perfected a Chinese red line, called "Chengtu." At that time, only a very few artists were capable of working with luster glazes, Arthur "Art" Wagner being one of them. Mr. Wagner, a colorful and extremely alert gentleman, as of 1969 was still decorating pottery at the location that once housed the Weller showrooms. From 1930 to 1942 the showrooms were open and managed by Walter J. Gitter. This building as of 1969 houses the "Pottery Queen" and is located on the "Old Pike" (Route 40). The structure has not been changed to any great degree except for the removal from the face of the building of the tiles that spelled the name "Weller." Inside is a fine display of old Weller, including an Aurelian vase seven feet tall and valued at several thousand dollars. The vase is signed by Frank Ferrel and dated 1903. In one corner of the room Art Wagner has maintained since 1959 a studio with a modern electric kiln and is continuing to do luster work, which is quite beautiful, yet nothing like the old Weller lines.

Art Wagner was born December 24, 1899, near Marietta, in Washington County, Ohio. He was endowed with a natural talent and claims he never had an art lesson. He moved to Zanesville in 1907 and started his career with Weller in 1920 under the supervision of Lassell, who became both friend and teacher. He quickly learned the art of luster painting and worked on the second metallic luster line named "LaSa." (The first line made in this category was Weller's Sicardo, made several years earlier.) According to Wagner, the LaSa line was a very difficult ware to make and had to be fired six times. The first firing was the application of the white glaze; the second included an application of a certain type oil, dusting with lampblack, and the scratching of designs into this, and then fired at 1250 to 1310 degrees F. The third stage was a coating of bright gold, brushed on and fired. The fourth firing was for the addition of the luster for the colored background. The fifth firing came when the lining was added; and the sixth and final firing was the black luster for the ground and trees. LaSa is signed "LaSa Weller," in script, near the bottom of the vase

Weller vases. *Left:* "Ragenda," dark red, 9½ in. high; *right:* "Classic," medium green, 5½ in. high. *Author's collection; Johnson photo*

Weller pottery. *Left:* "Ivory" planter, marked "Weller" in block letters, 7 in. by 10 in. *Right:* "Barcelona" bowl, paper label "Weller Barcelona Ware," 9 in. diameter. *Collection of R. E. and F. G. O'Brien, Jr.; Knight photo*

"Burnt Wood" vase, 8½ in. high. *Collection of Joan R. Still; Johnson photo*

or vessel, oftentimes near the base of a tree. The signature is rather evasive and difficult to find.

Only three people made the Lamar line: John Lassell, Henry Weigelt, and Art Wagner. Lamar was very difficult to make as it had to be handled swiftly. The glaze was colorless when applied and great care had to be taken so as not to overlap since it would fade out completely where the overlap occurred. Lamar entailed three separate firings: The first a layer of carmine, brushed on and fired. The second, a spray coat of carmine, fired on; and the third and final, the black luster hand-painted decoration of trees, and the like, fired on. Mr. Wagner made the statement, "I've been using these lusters for such a long time, that I can tell by smell what color it is without looking at the label on the bottle." Lamar was never marked except by the use of a paper label.

Lassell and Wagner worked together making the various luster lines until the catastrophic fire in 1927, when the Ceramic Avenue plant was

Rare white Weller "Dickens
Ware" (2nd line) vase, signed
"E. L. Pickens." *Collection of
Dr. and Mrs. Gordon Gifford;
Mesre photo*

completely destroyed. It was the most spectacular devastation Zanesville ever had. The company was rebuilt almost immediately; however, Lassell and Wagner did not return and consequently no more LaSa or Lamar was made. Lassell moved to Newark and Wagner migrated to the Mosaic Tile Company.

S. A. Weller died in 1925 and was succeeded as president by his nephew, Harry Weller. After the fire, Lassell was replaced by Henry Fuchs, who became head of the decorating studio. Henry Weigelt remained along with other decorators who had for many years worked at the Weller plants. Rudolph Lorber continued as modeler, as did Dorothy England. She created many of the fine late patterns, including

Rare special Weller plaque. Terra-cotta colored matt glaze, Garden of Eden scene, marked in small block letters, 11 in. diameter. *Author's collection; Knight photo*

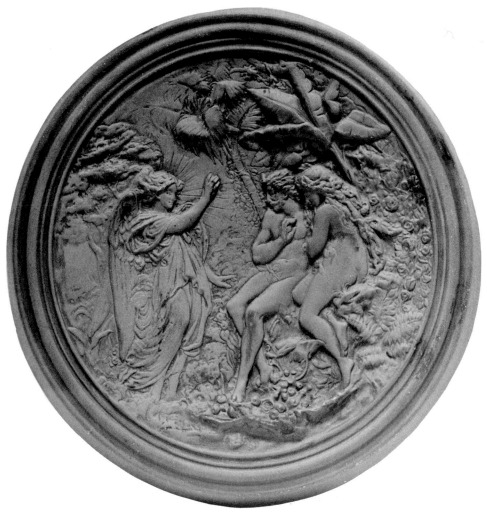

the Ollas Water Bottle which was made in the shape of a gourd with a stemmed lid and trimmed in various colors. The bottle was quite thick and porous, allowing a small amount of moisture, just enough to keep the outside of it damp, to seep through. The circulation of air around the outer surface supposedly kept the water cool. An underliner, a plate on which the bottle rested to hold any drippings from the bottle, was made to accompany the bottle. These bottles were very popular and sold by the thousands. After her marriage to Frank Laughead in 1938, Dorothy England continued to work, creating many other fine designs, but, for some reason or other, some of these never went into production. She still has in her collection many specimens of her beautiful work.

At the beginning of the 1929 depression there was less demand for pottery, especially the costly hand-decorated ware, competition became keener, and business began to wane. The Weller firm adjusted somewhat by closing two of the plants and moving all operations to the Ceramic Avenue building.

Weller made enormous amounts of utility ware, such as baking dishes and custard cups. After prohibition was repealed, in the 1930s Weller sold tons of beer mugs. Harry Weller was fatally injured in 1932 in an automobile accident and the position of president was turned over, in succession, to Sam Weller's sons-in-law: Frederick Grant, then Irvin Smith, and finally Walter M. Hughes.

Weller pottery. *Left to right:* "Muskota" figure, 6½ high; turtle, marked "Weller" in block letters, 9½ in. long; rare shiny "Forest"-line covered teapot, marked in block letters, 6 in. high. *Collection of R. E. and F. G. O'Brien, Jr.; Knight photo*

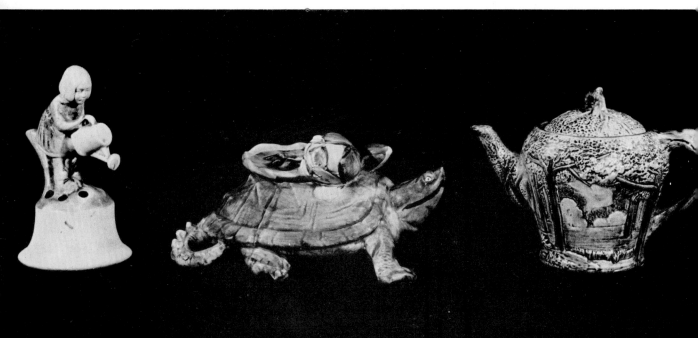

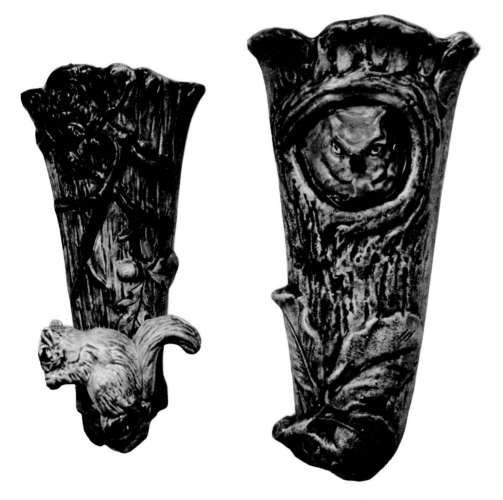

"Woodcraft" wall pockets. Rustic colors, marked block "Weller," squirrel 9 in. high, owl 10¾ in. high. *Author's collection; Knight photo*

The Weller Company managed to survive until World War II when money became more plentiful and potteries could sell their ware extensively. After the war, competition became even greater, with emphasis on foreign imports that were cheaper and were favored by the public. By 1945 the Weller Pottery was in financial difficulty and space in the building was leased to the Essex Wire Company of Detroit, Michigan. In 1947 the Essex Company bought the controlling stock; in 1948 the Pottery was closed.

During the fifty years that art pottery was manufactured by Weller, many different patterns were made and each was given a specific name. Former Weller employees claim that Walter Gitter, sales manager,

chose some of the names from Pullman cars as the trains passed through the city. Other names were given by the creators and artists; still others were named because of the special type of glaze or design. The following line names and descriptions have been gleaned from records, catalogs, and important collections.

Weller Pottery line names and description.

ALVIN	Rustic type with small apples entwined on vinelike limbs. Matt finish. Middle period.
ANSONIA	Hand turned with horizontal ridges in pastel colors. Middle period. Matt. Marked "handmade."
ARCOLA	Light background with applied grapes entwined on vines. Matt finish. Middle period.
ARDSLEY	Cattails among leaves with water lilies at the bottom. Matt finish. Middle period.
ATLANTIC	Heavy and crude burnt-wood type. Matt finish. Middle period.
ATLAS	Star-shaped top. Various colors. Semigloss. Late period.
AURELIAN	Duplicate of Louwelsa except for the background which has been sponged on and gives the illusion of a distant forest fire. High-gloss brown ware. Early period.
AURORO	Splotched pastel colors under high-gloss glaze. Slip decorated with flowers, fish, and other subjects. Early period.
BALDIN	Realistic apples on branches. Rustic. Matt finish. Middle period.

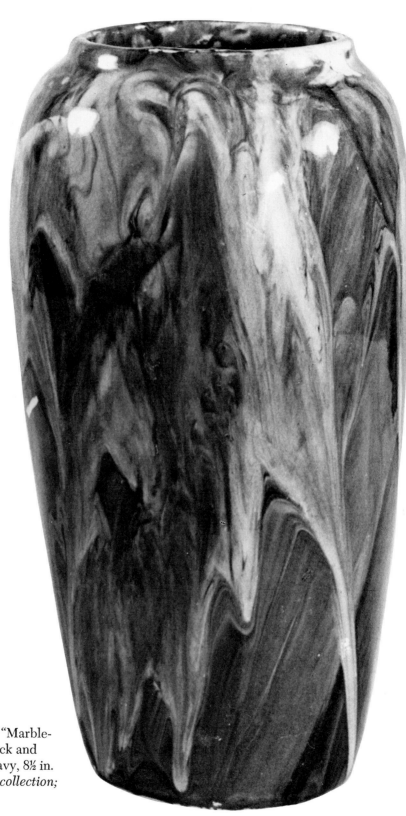

Signed Weller "Marble-
ized" vase. Black and
white, very heavy, 8½ in.
high. *Author's collection;
Knight photo*

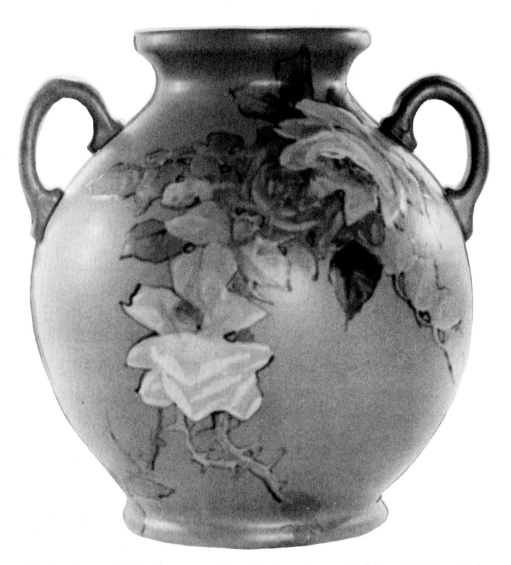

"Hudson" vase. Yellow roses on blue shading, signed "Pillsbury," 9½ in. high. *Author's collection; Johnson photo*

BARCELONA	Handmade with horizontal ridges with stenciled dark decoration. Yellow with pink stripe close to the base. Matt finish. Middle period.
BEDFORD MATT	Green, heavy glaze, matt finish. Middle period.
BLUE DECORATED	Same as blue Louwelsa except it is marked only "Weller." High-gloss glaze. Early period.

BLUE DRAPERY Dark blue background. Draped with clusters of roses. Matt finish. Middle period.

BLUE WARE Classic embossed figures on dark blue background. Matt finish. Middle period.

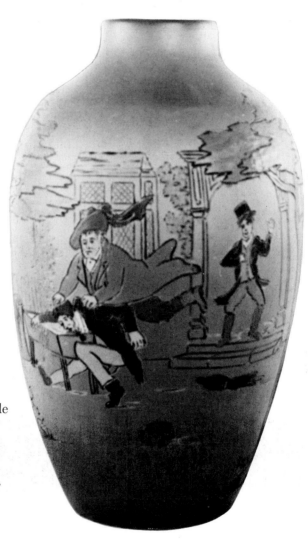

"Dickens Ware" (2nd line) vase. Brown with shades of yellow, quotation on reverse side from *Pickwick Papers:* "It was a still more exciting spectacle to behold Mr. Weller . . . immersing Mr. Stiggin's head in a horse-trough full of water." *Collection of Oma and Andy Anderson; Johnson photo*

BLO'RED Similar to Greenbriar. Red over blue. High-gloss glaze. Middle period.

BO-MARBLO Lightweight pottery with tree-of-life design. Various colors. Luster glaze. Middle period.

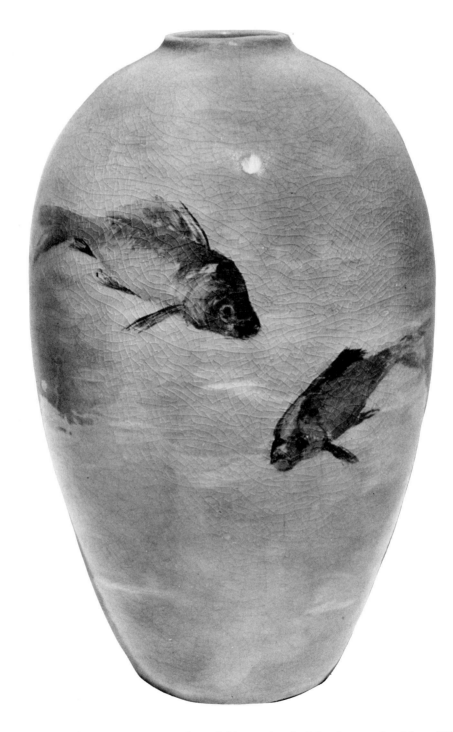

Weller "Auroro" vase. Pale pink and blue splotched background with goldfish, 8 in. high. *Collection of Dr. and Mrs. Gordon Gifford; Mesre photo*

BONITA	Cream color with hand decoration in mineral paints. Somewhat like Majolica. Matt finish. Middle period.
BOUQUET	Dogwood blossoms with matt finish. Various colors. Late period.
BRETON	Band of roses alternating with smaller flowers around the center. Mottled top and bottom. Matt finish. Middle period.
BRIGHTON	Figurines of bluebirds, peacocks, ducks, parrots, etc. Natural colors under a high-gloss glaze. Middle period.
BRONZE WARE	Similar to Sicardo without the predetermined designs. Middle period.
BURNT WOOD	Tan color with dark brown band at top and bottom. Etched designs. Appears like real burnt wood. Middle period.
CAMEO	White flowers and leaves on various background colors. Late period.
CHASE	Fox hunter and dogs embossed in white on various background colors. Matt finish. Middle period.
CHELSEA	Band of flowers similar to Roseville's Donatello. Matt finish. Middle period.
CHENGTU	Chinese orange-red glaze. Solid color. Semi-gloss. Middle period.
CLARMONT	This ware has a double handle with similated notches. The designs at the top of the vessel differs from those at the bottom. The top has a continuous row of twirling circles, whereas the bottom section has a continuous row of berries or grapes hanging on a swirling vine. Only dark monochrome backgrounds have been seen by the author.

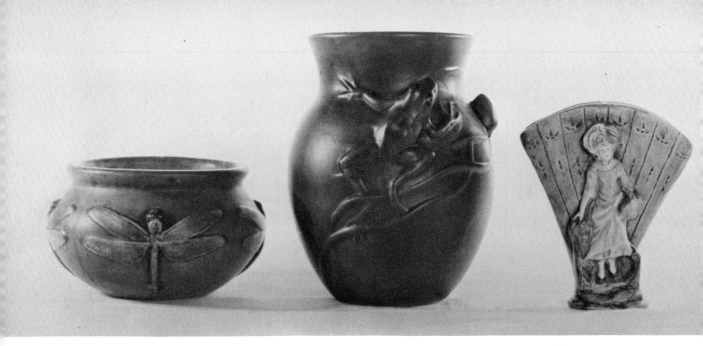

Weller ware. *Above, left to right:* "Modeled Matt" dragon fly, brown and tan, 3 in. high; "Modeled Matt" frog, gunmetal color 6½ in. high; trial piece modeled by Dorothy England (Laughead), white dress with natural colors on green background, signed "England," never put into production, 5 in. high. *Collection of Oma and Andy Anderson; Johnson photo*

Below, left: "Eocean" two-handled vase, flat-sided, pink and red flowers, 7½ in. high. *Author's collection; Knight photo. Below, right:* "Hunter" ewer, dark brown shaded to yellow, 5½ in. high. *Collection of Frances and Don Hall; Fox photo*

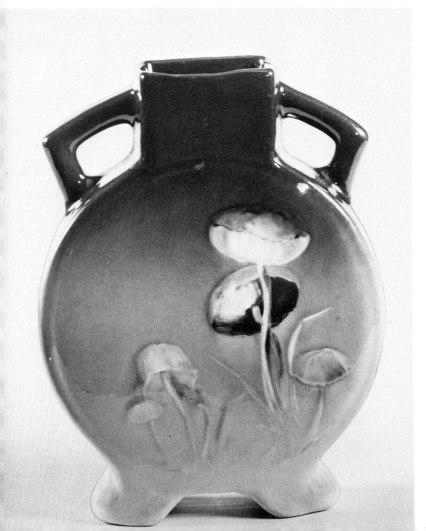

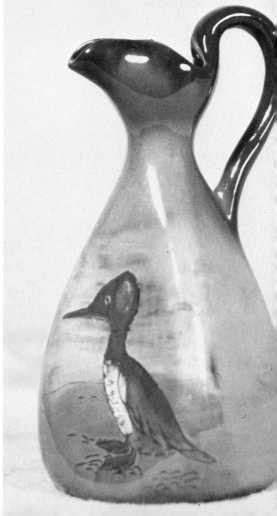

CLASSIC	Solid color with lattice work at the top dotted with small flowers; some pieces reticulated. Middle period.
CLAYWOOD	Similar to Burnt Wood. Panels separated by dark bands to match top and bottom. Matt finish. Middle period.
CLINTON IVORY	Various cream-colored patterns with rubbed-on brown. Matt finish. Middle period.
COMET	Stars scattered irregularly on white or pastel shades. Matt finish. Late period.
COPPERTONE	Bright green over brown similar to copper ore. Decorated with frogs, fish, and other natural subjects. Semigloss. Middle period.
CORNISH	Slightly mottled background with various-colored berries on long stem. Large leaves at the top. Base color is varied. Semigloss finish. Middle period.
CRYSTALLINE	Rows of stacked leaves. Various background colors. Semigloss finish. Late period.
DARSIE	Twisted cord with tassels wound around the body of the vessel. Various colors. Matt finish. Late period.
DELSA	Flowers and leaves with leaves turned out to make the handles. Various colors. Matt finish. Late period.
DELTA	Slip decorated under the glaze. Blue on blue. Hudson-type decoration. Matt finish. Middle period.
DICKENS WARE	First line. Underglaze slip painting on brown, green, or blue background. Always marked "Dickens Ware."
DICKENS WARE	Second line. Sgraffito-type decoration with blended shaded backgrounds. Usually found in a matt finish; however, can also be found with a high-gloss finish. The latter is a rarity. Decorations include outdoor scenes with peo-

ple, tavern scenes, Indian portraits, birds and fish, and a most common decor, the bust of a monk. Always marked "Dickens Ware."

DICKENS WARE

Third line. Underglaze slip decoration that is similar to Weller's Eocean except that the decor used are characters from the tales of Charles Dickens. Marked "Weller" in a rectangular frame on the base. Oftentimes a number accompanies the name.

DORLAND

Three-fold drape with scalloped top with beaded handles. Various colors. Matt finish. Late period.

DRESDEN

Dutch mill scene with occasional Dutch boy and girl. Color is blue, slip painted. Matt finish. Early period.

Weller "Dickens Ware" (2nd line) vase. Shaded turquoise to brown, matt finish, signed "I. F.," ca. 1909, 13 in. high. Note that the leaves of the trees have been modeled with slip in high relief. *Author's collection; Orren photo*

Weller "Woodcraft" pottery from middle period. Tree trunks, natural color, marked in block letters, 8½ and 9½ in. high; foxes, no. 26 in catalog, 5 in. high; log, no. 23 in catalog, natural colors, marked in block letters, 9½ in. long; owl, 7 in. high. *Author's collection; Johnson photo*

ECLAIR Applied roses on plain white glazed body. No piping. Middle period.

ELDORA Band of flowers at the top and ribbing at the bottom. Various colors. Matt finish. Middle period.

EOCEAN Decorated with under-the-glaze slip painting. Pastel color. High-gloss glaze. Early period.

EOCEAN ROSE Same as Eocean except the color goes from gray to pale pink. Also early period.

ETCHED MATT Comparable to second-line Dickens Ware, except that light clay is used. Incised portrait of a woman with windblown hair. Matt finish. Early period.

Weller pottery. *Left to right:* "Arcola" candlesticks, pink, 12 in. high; "Arcola" bowl, ivory, marked "Weller" in block letters, 13 in. diameter; "Etched Matt" vase, rust background, marked "Weller" in block letters, 10½ in. high. *Collection of R. E. and F. G. O'Brien, Jr.; Knight photo*

ETHEL	Profile of Ethel Weller, in a circle, sniffing a rose. Cream color. Matt finish. Circa 1915.
ETNA	Similar to Eocean in looks except the design is molded in low relief and then color applied. High gloss. Early period.
EUCLID	Plain matt finish; traditional Weller shapes. Middle period.
EVERGREEN	Solid turquoise green with soft matt finish with a white lining. Late period.
FAIRFIELD	Appearance similar to that of Roseville's Donatello with cherubs at the top and fluted at the bottom. Matt finish. Middle period.
FLEMISH	Small birds molded in relief with clusters of roses. Large birds along with other subjects were also used. Matt finish. Middle period.
FLORAL	Flowers on a ribbed background in pastel colors. Semigloss finish. Late period.
FLORALA	Cast flowers in square panels on cream background. Matt finish. Middle period.
FLORENZO	Ivory background with green edge. Ribbed or paneled with a grouping of flowers at the base. Matt finish. Middle period.
FLORETTA	Under-glaze decorated flowers and fruit cast in low relief. Brown and pastel colors both were used for the background. High-gloss glaze. Early period. The fruit was occasionally incised in the manner of second-line Dickens Ware.
FOREST	Rustic molded forest scene. Matt finish. Middle period.
GLENDALE	Birds in their natural habitat. Rustic. Birds with nests and eggs. Matt finish. Middle period.
GOLBROGREEN	Bicolor shaded gold to green with brown where the two colors meet. Semimatt finish. Middle period.

GOLD-GREEN Utility ware trimmed with gold decoration. High-gloss glaze. Middle period.

GRAYSTONE Outdoor line. Stoneware.

GREENBRIAR Handmade ware. Bright green underglaze with very pale flowing pink overglaze. Marbleized by adding maroon streaks. Horizontal ribbing around body. High-gloss glaze. Middle period.

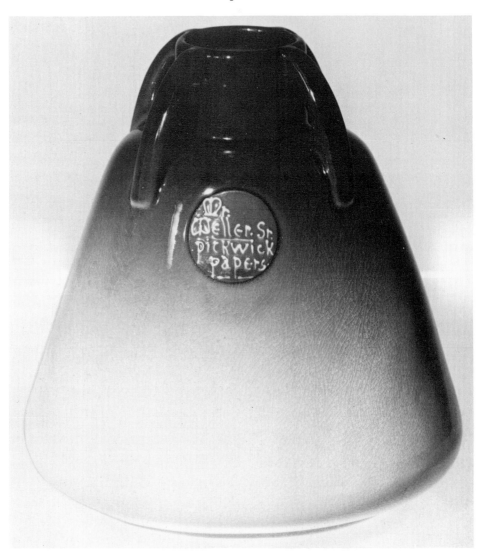

Very rare "Dickens Ware" (3rd line) vase. Dark gray shading to light gray, high clear glaze, under-the-slip painting in natural color, signed "Lillie Mitchell," signed "Weller" in raised frame with "15" in duplicate frame, ca. 1910, 7 inches

GREORA

Similar to Coppertone except the background is bicolor orange shaded to green splashed over with brighter green. The mixture of colors give the appearance of bronze color instead of orange. Semigloss finish. Middle period.

HOBART

Girls and swans in solid pastel colors. Matt finish. Middle period.

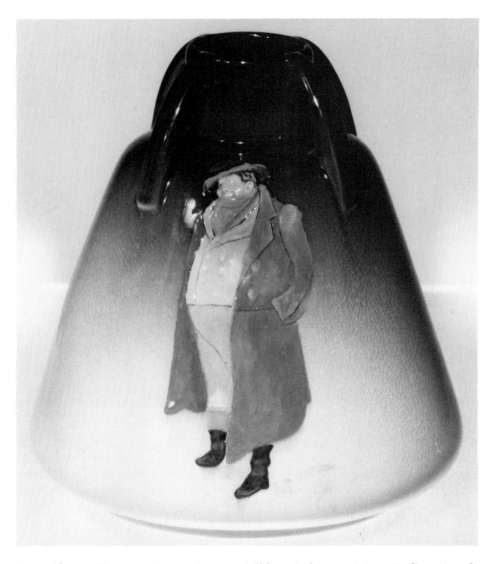

high. *Above:* Obverse of vase showing full-length figure of Sam Weller of *Pickwick Papers. Opposite page:* Reverse of vase showing title disk in raised white slip. *Author's collection; Orren photos*

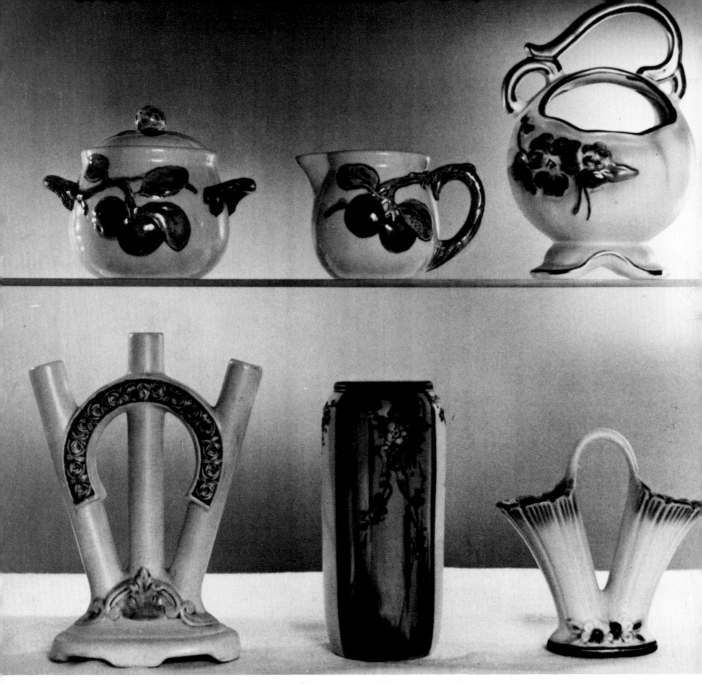

Weller pottery. *Left to right, top row:* "Zona" sugar and creamer, white with red apples, 3½ in. and 3 in. high; a "Weller" blank decorated in rich cream and gold, signed "Raoul," not a Weller artist. *Bottom row:* "Roma" vase, cream with pink roses, 8 in. high; "Hudson" vase, white with black decoration, 7 in. high; "Florenzo" vase, cream shaded to green, pink flowers, 6 in. to top of handle. *Author's collection; Johnson photo*

HUDSON	Matt finish with underglaze slip painting. Probably made in all periods.
HUDSON (GLAZED)	Underglaze slip painting. High-gloss glaze. Middle period.

HUNTER	Brown with under-the-glaze slip decoration of ducks, butterflies, and probably other outdoor subjects. Signed only "Hunter." High-gloss glaze. Early period.
INDIAN	Indian-type. Middle period.
IVORIS	Ivory colored in Oriental shapes. Semigloss. Late period.
IVORY	Ivory colored, various patterns with rubbed-on brown. Matt finish. Middle period.

Weller "Pictorial" vase. Blue-gray decorated in natural colors, signed "McLaughlin," 9 in. high. *Collection of Frances and Don Hall; Fox photo*

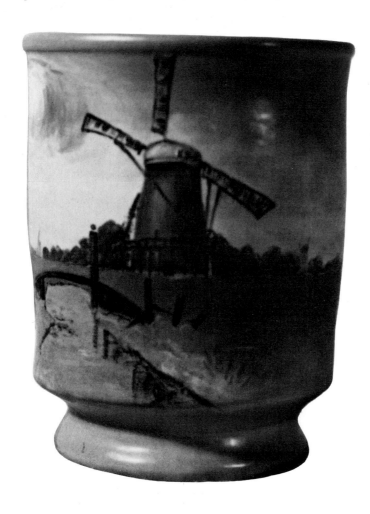

Weller figure. Brown clay with brown glaze and overglaze of white, signed script "Weller," 9 in. high. *Author's collection; Knight photo*

"L'Art Nouveau" vase. Brown, 13½ in. high. *Collection of Oma and Andy Anderson; Knight photo*

JAP BIRDIMAL The outlines of the design on this ware are first incised with a tool and then inlaid with slip that was squeezed from a tube or heavily painted on with a brush. The designs are then colored and covered with a high-gloss glaze. Early period.

JET BLACK Solid black background with matt finish. Late period.

JEWEL Similar to the Etna line except that it has molded jewels. High-gloss glaze. Middle period; possibly early period.

JUNEAU Stark white background with soft matt. Late period.

"Lavonia" line. Shaded from pink to turquoise, paper labels, 11 in. high; the figure is listed in catalog as "Hobart" line when in monochrome color; candle holders, 5 in. high. *Author's collection; Johnson photo*

Marked "Etched Matt" vase. Light green, 5½ high. *Author's collection; Knight photo*

KITCHEN-GEM	Brown utility ware. Late period.
KNIFEWOOD	Rustic-appearing molded dogs, swans, and other subjects to give the effect of carving. Matt finish. Middle period.
LAMAR	A metallic luster ware in a deep raspberry red decorated with black luster scenery. Never marked except with a paper label.
L'ART NOUVEAU	Molded line with figures. Most of these are in pastel colors in matt finish. Occasionally this line is found in brown with semi- and

high-gloss glaze. It is also sometimes signed "Art Nouveau." Early period.

LaSa A metallic luster ware decorated with outdoor scenes in gold, red, and green. Generally marked "Weller LaSa" near the bottom of the ware near the base of the trees. Signature is very illusive.

Lavonia Pastel pink shaded to blue-green or turquoise. This line denotes the color used on various molded designs. Matt finish. Middle period.

Lido Bicolor twisted-drape pattern without flowers. Various colors. Matt finish. Late period.

Weller bowl. Pastel green and pink, hand-incised "Weller Matt," 8½ in. high. *Author's collection; Knight photo*

Weller pottery. *Top row, left to right:* "Claywood" vase, designs in panels, brown and tan, 8 in. high; "Woodcraft" squirrel, natural color, 14½ in. long; "Pinecone" vase, pale green with natural color pine cones, 7 in. high. *Bottom row:* "Florenzo" jar, cream shaded to green, 7 in. high; "Voile" vase, light tan background, 6¼ in. high; "Ivory" jardiniere, light tan with darker tan rubbed in, 5¼ in. high. *Collection of Oma and Andy Anderson; Johnson photo*

Top: "Ivoris" ware, all with paper labels, covered jars 8½ in. high, vase 6 in. high. *Bottom:* "Hudson" vases, *left to right*, white, signed "Eugene Roberts," 7½ in. high; white with blue iris, signed "Hester Pillsbury," 9½ in. high; white glazed with pink, blue, and gray decoration, catalog no. 53. *Author's collection; Johnson photos*

LORU

Octagon-shaped with molded leaf design shading from light to dark. Matt finish. Late period.

LOUELLA

Similar to Blue Drapery with slip decoration. Various colors. Matt finish. Middle period.

LOUWELSA

Underglaze slip painting on brown shading to yellow. The blended backgrounds are very similar to Rookwood's standard glaze ware. Portraits and natural subjects are the usual decorations. Louwelsa may also be found in a shaded blue with a high-gloss glaze which can be considered rare. An extreme rarity is the Louwelsa ware in a pastel matt finish.

LUSTER

Plain metallic luster glaze without decoration. All colors. Middle period.

MALTA

Subjects from the Muskota and Brighton lines glazed in plain white. Semimatt finish. Middle period.

"Jap Birdimal" vase, light blue with black fish, 7 in. high. *Collection of Frances and Don Hall; Fox photo*

MALVERN — Modeled background in various assorted colors with molded leaves and buds in very high relief. Matt finish. Middle period.

MANHATTAN — Stylized flowers and leaves on various background colors. Matt finish. Late period.

MARBLEIZED — Marbleized high-gloss glaze. Middle period.

MARENGO — Luster glaze in pastel colors with line drawings of trees. Middle period. Sometimes referred to as Lassell Ware.

"Auroro" vase; pink and blue mottled background with pink flowers; incised "Auroro Weller" on base; 12 in. high. *Collection of Frances and Don Hall; Fox photo*

MARVO	Molded fern and leaf design on various background colors. Matt finish. Middle period.
MI-FLO	Horizontal ribbed with stair-step effect. Various background colors with flowers in relief. Semimatt. Late period.
MIRROR BLACK	Solid color black with mirrorlike glaze. Middle period.
MONOCHROME	Solid color semigloss glaze. Middle period.
MUSKOTA	Birds, figures, frogs, etc., with rustic bases and matt finish. These were made for use in flower arranging bowls. These pieces usually have holes for flower stems.

Weller pottery. *Left to right, top row:* "Selma" vase, same as "Knifewood" except for a high-gloss glaze, 5 in. high; "Muskota" line figure, rustic colors, 7 in. high; "Patricia" vase, yellow with green, 4 in. high. *Bottom row:* "Terose" teapot, no. 651 in catalog, 6 in. high; "Pierre" pitcher (7 in. high) and plate (10 in. diameter) in pink; "Silvertone" vase, splotched bluish pink, 7 in. high. *Collection of Oma and Andy Anderson; Johnson photo*

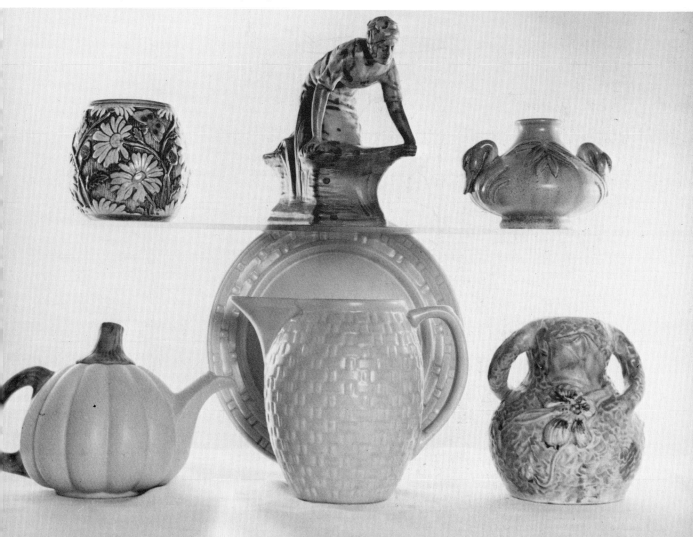

NARONA Roman classic figures rubbed-in brown on cream-color background. Matt finish. Middle period.

NEISKA Mottled various background colors on Ivoris shapes. Matt finish. Late period.

NOVAL White background piped in black with applied roses or fruit. High-gloss glaze. Middle period.

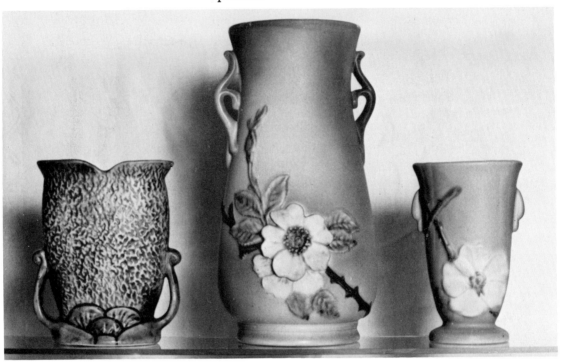

Weller vases. *Left to right:* "Patra," orange with bright colors at bottom, 6½ in. high; early "Wild Rose," orange shaded to cream, white applied rose, 11½ in. high; late "Wild Rose," green with white rose, 6½ in. high. *Author's collection;* Weller vases: *Left and right:* "Blue Ware," blue with light yellow figures, 8½ in. and 7 in. high. *Center:* "Chase," white on blue, 8¼ in. high. *Author's collection; Johnson photos*

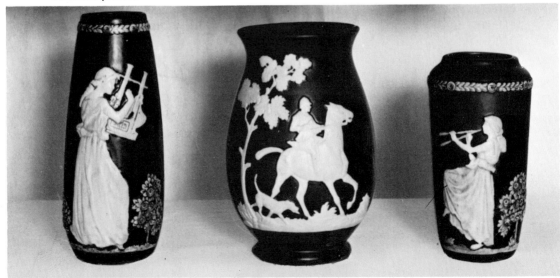

NOVELTY LINE	Various colors. Objects such as ashtrays with figures of monkeys, pigs, dogs, wolves, kangaroos, etc. Also tableware including tumblers with faces. Semigloss glaze. Middle period.
OAK LEAF	Molded oak leaves on one side and acorns on the other, with various background colors. Matt finish. Late period.
OLLAS WATER BOTTLE	Heavy gourd-shape water bottle with stemmed lid and an underplate. Common, ordinary paint was used to decorate upper portion, usually in red, green, or blue.
ORRIS	Similar to Greora except melon ribbed. Middle period.
PANELLA	Pansies in relief on various background colors. Matt finish. Late period.
PARAGON	Allover pattern of stylized flowers and leaves on various background colors. Semigloss finish. Late period.
PASTEL	Ultramodern shapes in pastel background colors. Matt finish. Late period.
PATRA	Rough orange-peel-like finish with stylized design at the bottom. Matt finish. Middle period.
PATRICIA	Matt finish. Swan handles. Various colors. Late period.
PEARL	Cream color draped with pearllike beads. Matt finish. Middle period.
PICTORIAL	A line with underglaze slip painting similar to Hudson, depicting outdoor scenes or landscapes done in very high relief. Colors are generally in pastels.
PIERRE	Utility kitchenware. Basket-weave pattern. Late period.
PINECONE	Stylized pinecone in panel similar to Claywood. Matt finish. Middle period.

Weller pottery vases. *Left to right, top row:* "Bonita," cream lined in green, blue flowers and green leaves, 5 in. high; "Stellar," white with blue stars, 5½ in. high; "Hudson," white with blue top, 7 in. high. *Bottom row:* "Noval," white piped in black, red roses, 7½ in. high; "Tivoli," no. 2 in catalog, cream piped in black, red roses, 5½ in. high; "Roma Cameo," cream with coral cameo, 3½ in. high. *Author's collection; Johnson photo*

PUMILA Panels of lily leaves flattened to make an
 eight-scallop top. Various colors including
 coppertone. Matt finish. Middle period.

RAGENDA Design features a sash draped in folds with
 the ends looped; same color as background.
 Middle period.

"Muskota" pottery, all in natural colors. Girl with swan, marked in block letters,
7 in. high; fishing boy, marked in block letters, 7½ in. high; frog in lily, marked in
block letters, 5 in. high; kingfisher, ink stamped, 9 in. high; cherub, unmarked, 5½
in. high. *Author's collection; Johnson photo*

RAYDENCE Upper half ribbed; band of flowers around lower half; large flower with group of small ones in between. Matt finish. Middle period.

ROBA Draped design with flowers and leaves. Various colors. Matt finish. Late period.

ROCHELLE Eocean line renamed. Marked only "Weller." Middle period. High-gloss glaze.

Weller vases. *Left to right, top row:* "Indian" in tan, brown, and black, 4¼ in. high; "Hudson" in shaded blue with white flowers, signed "Dorothy Laughead," made after her marriage in 1938, 5½ in. high; "Barcelona" in yellow with dark blue decoration, 6 in. high. *Bottom row:* "Delsa" in green with white flowers on green stems and leaves, no. 12 in catalog, 9 in. high; silver deposit on mottled turquoise, signed in late period script, 9 in. high; "Forest" in rustic shades, 8½ in. high. *Author's collection; Johnson photo*

Weller ware. *Left to right:* "Greenbriar" vase with paper label, no. 28 in catalog, pink over green, 9½ in. high; "Oak Leaf" vase, brown with natural leaves, 14 in. high; "Ollas Water Bottle," pale yellow with green top, 11½ in. high. *Author's collection; Johnson photo*

ROMA	Cream color, trimmed with garlands of flowers. Occasionally has medallions. Matt finish. Middle period.
ROMA CAMEO	Cameo in high relief with garlands of flowers and leaves. Cream-colored background. Matt finish. Middle period.
ROSEMONT	Bright colors on dark background of birds and flowers, etc. High-gloss glaze. Middle period.
RUDLOR	Floral design on spiral ribbed body. Beaded-type handles. Various colors. Flowers stand out in relief. Matt and semimatt finish. Late period.

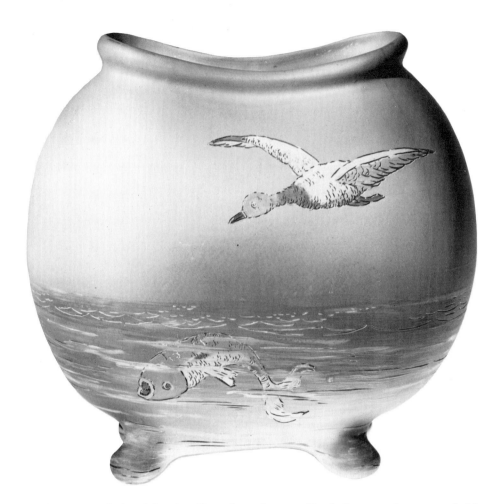

"Dickens Ware" (2nd line) pillow-shaped vase. Shaded turquoise, matt finish, signed "Upjohn," ca. 1901, 9½ in. high. *Author's collection; Orren photo*

SABRINIAN	Seashell body with sea-horse handle. **Pastel colors. Matt finish. Middle period.**
SELMA	Knifewood line with a high-gloss glaze. Occasionally with peacocks, butterflies, and daisies. Middle period.
SENIC	Late molded line with outdoor scenes. Pastel colors. Matt finish.
SICARDO	An iridescent glaze ware with a predetermined design worked into the glaze in brilliant colors of red, green, and blue. Some pieces occasionally will have a silver or gold sheen.

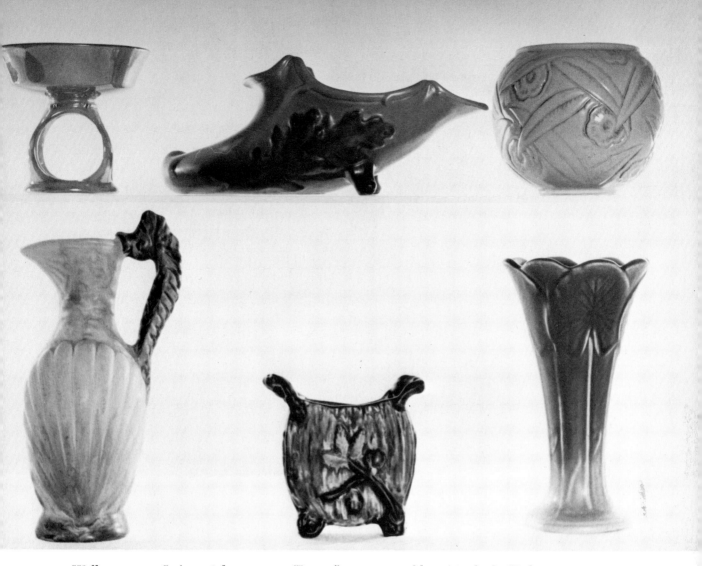

Weller pottery. *Left to right, top row:* "Luster" compote in blue, 4 in. high; "Oak Leaf" vase, brown, 4 in. by 10 in.; "Paragon" vase, blue, 4½ in. high. *Bottom row:* "Sabrinian" pitcher, no. 11 in catalog, mottled blue and pink, 9 in. high; "Warwick" vase; "Pumila" vase, green shaded to brown, 8 in. high. *Author's collection; Johnson photo*

SILVERTONE	Molded flowers; overall splotched with bluish pink glaze. Matt finish. Middle period.
SOFTONE	Three-fold drape design. Scallop top. Velvet-like finish. Various colors. Late period.
STELLAR	Hand slip decorated with blue stars in a "comet" design. White background. Matt finish. Middle period.
TEAKWOOD	Similar to Burnt Wood and Claywood except the colors are reversed in the design. White flowers and dark background. Matt finish. Middle period.

TEROSE Utility ware. Pumpkin shape. Color is white. Matt finish. Middle period.

TING Oriental shapes with ring handles. Semigloss finish. Late period.

TIVOLI Cream-colored background with black piping at the top. Base looks like teakwood with a band of flowers. High glaze. Middle period.

TURADA This ware is found with a lacelike pattern against a dark background of black, brown, or blue. The design is first incised and then

Weller pottery vases. *Left to right, top row:* "Panella," blue-white pansies, 5 in. high; "Roma," no. 119 in catalog, cream with orange and green decoration, 4¼ in. high; "Roba," white shaded to green, 6 in. high. *Bottom row:* "Loru," blue, 9 in. high; "Tutone," green on pink, 3 in. high; "Malvern," 8¼ in. high. *Author's collection; Johnson photo*

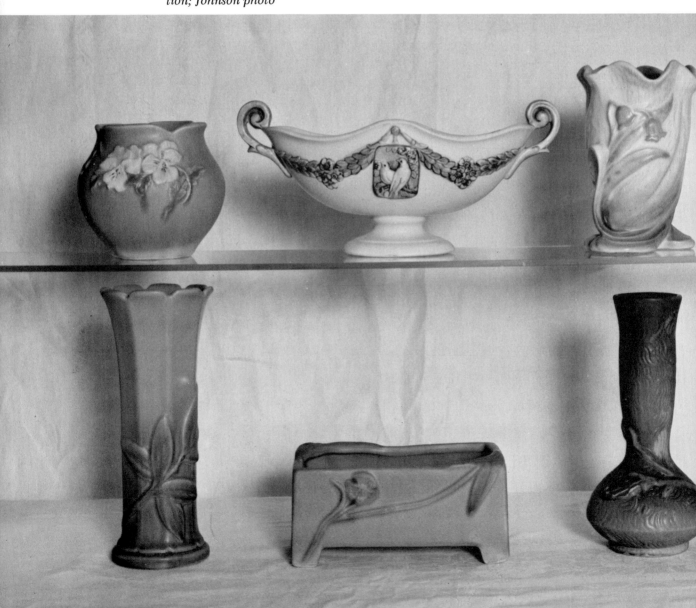

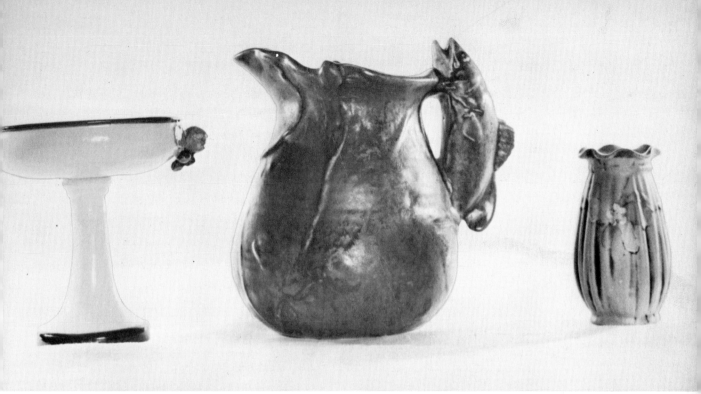

Weller ware. *Left to right:* "Noval" compote, white piped in black with fruit handles, 6 in. high; "Coppertone" pitcher, paper label, 8 in. high; "Louella" vase, gray on gray, 5 in. high. *Collection of Joan R. Still; Johnson photo*

inlaid with slip similar to the technique used on Jap Birdimal, with the exception that the designs are in much higher relief. The lacelike design is always done in light-colored slip. High glaze.

TUTONE — Various colors with flowers and leaves in high relief. Modern looking. Matt finish. Middle period.

UNDERGLAZE BLUE — Similar to Coppertone except color is blue. Middle period.

VELVA — Similar to Ivoris except for a change in color. Late period.

VOILE — Small apple trees on light background. Matt finish. Middle period.

WARWICK — Modeled rustic background with trees and fruit. Matt finish. Middle period.

WILD ROSE — An open rose on a light background. Rose applied in the middle period. Rose is molded in late period. Matt finish.

WOODCRAFT Rustic-type ware simulating the appearance of stumps, logs, and woody subjects. Some are adorned with owls, squirrels, dogs, and other outdoor animals.

WOOD ROSE An oaken bucket with rose clusters or berries, Rustic. Matt finish. Middle period.

ZONA Red apples with stems and leaves against a cream-colored background. A pitcher with a kingfisher bird and cattails was listed in the 1920 Weller catalog as Zona line.

ZONA BABY LINE Weller baby dishes.

Weller pottery. *Top row, left to right:* "Cornish" vase, blue background with red and blue berries and green leaves, 6 in. high; "Burnt Wood" vase, rich tan with dark brown, lined with glossy brown glaze, 5½ in. high. "Bouquet" vase, blue-white blossoms and green leaves, 5 in. high. *Bottom row, left and right:* "Blue Drapery" candlesticks, dark blue with pink roses, 8 in. high; *center:* "Rudlor" vase, yellow with white blossoms and green leaves, 6½ in. high. *Author's collection; Johnson photo*

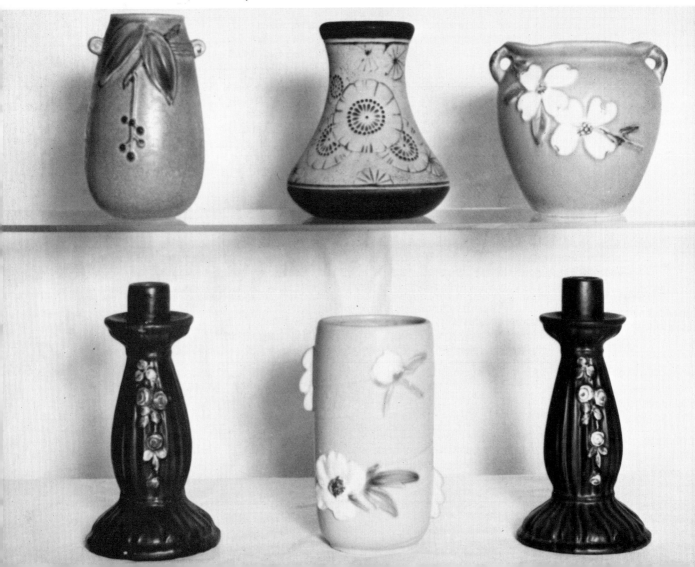

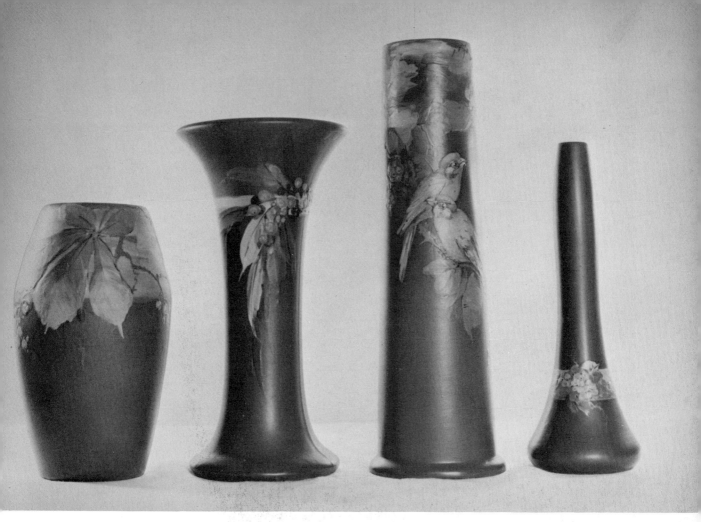

Dark blue "Hudson" with pink, yellow, blue, and green decoration. *Left to right:* 9 in. high; 10½ in.; 13 in.; 10 in. *Author's collection; Johnson photo*

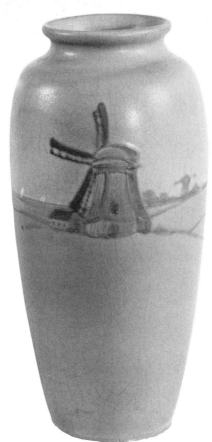

"Dresden" vase. Pale blue, marked "Matt Weller J.B.L.," 9½ in. high. *Author's collection; Knight photo*

Early period marks (1895-1918):

[During this period many of the marks included the line name along with the company title.]

LOUWELSA
WELLER

Louwelsa marks impressed

Aurelian
Weller

Incised

W

Incised

Eocean
Weller

Incised

Eocean Rose
Weller

Incised

Impressed

DICKENSWARE
WELLER

Impressed

WELLER DICKENS

Incised
(Appears on
tobacco jars)

WELLER DICKENS WARE

Incised

Raised frames
with raised lettering
(Appears on
third-line Dickens Ware)

weller

Hunter
hunter

Incised on various pieces of
hand-decorated ware in different
styles of handwriting.

MATT WELLER

Incised

WELLER ETCHED MAT

Incised on
Dresden line

Impressed

TURADA
WELLER

Impressed

Impressed

WELLER ETNA

Impressed

WELLER

Impressed in very
small lettering

Middle period marks (1918-35):

WELLER **WELLER**

Impressed in various sizes

Stamped in dark letters

Weller
Pottery

Weller
Hand Made

Incised in fine line by hand

WELLER

We ller

Stamped in dark lettering Incised in fine line by hand

Stamped in dark letters

Stamped in dark letters

Weller

Hand drawn on Barcelona,
using the color of the
swipe decoration

Late period marks (1935-48):

Weller
SINCE 1872

Weller
Pottery

Weller Pottery
SINCE 1872

Weller pottery

Weller

Impressed on all late-period Weller pieces. Paper labels were also used, designating the line name. A white label with black lettering was used during the first part of the late period. A black label with white lettering was used last.

Weller artists and their monograms:
[Some of the monograms were not available to this author.]

Virginia Adams	VA	Frank Ferrel	F.F.
Ruth Axline	R	Henry Fuchs	
Elizabeth Ayers	EA	Mary Gillie	MG M.G.
A. Best	AB	Charles Gray	C.G.
Lizabeth Blake	L·B·	Delores Harvey	D.H. H
Levi J. Burgess	L·J·B·	Albert Haubrich	A.H.
Sam Celli		Madge Hurst	MH
Anna Dautherty	A·D·	Hood	
Frank Dedonatis		Roy Hook	RH
Anthony Dunlavy	AD	Josephine Imlay	J.I.

Weller pottery. *Left to right, top row:* Marked "Floretta" mug, gray shading to pink, 5¼ in. high; "Muskota" bird, natural color, 6 in. high; marked "Floretta' jug, dark brown with grapes, 6 in. high. *Bottom row, left to right:* "Muskota" bird, natural color, 9 in. high; "Zona" pitcher with kingfisher, 8½ in. high; "Muskota" bird, natural color, 8½ in. high. *Author's collection; Johnson photo*

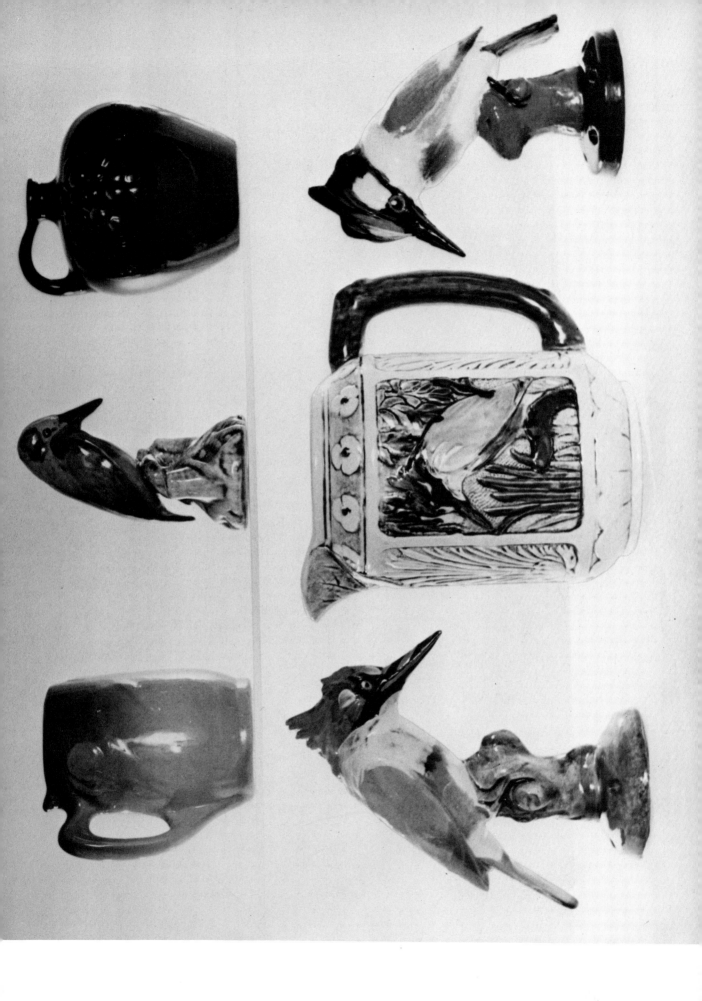

Artist	Mark	Artist	Mark
Karl Kappes	K·K·	Eugene Roberts	ER Er
L. Knaus	K	Tot Steele	T
Dorothy England (Laughead)	DL	William Stemm	WS
Claude Leffler	C.L	Sulcer	
Sarah Reid McLaughlin		C. Minnie Terry	T
Hattie Mitchell	HM	Mae Timberlake	M T
Lillie Mitchell	LM	Sarah Timberlake	S.T.
Minnie Mitchell	M M	Naomi Truitt	
Gordon Mull		Arthur Wagner	
M. Myers	M M	Walch	
Edwin Pickens	E.LP	Carl Weigelt	
Mary Pierce	Mp	Albert Wilson	
Hester W. Pillsbury	HP	Helen B. Windle	HW.

Weller pottery. *Left to right, top row:* "Warwick" vase, mottled dark red and brown with red and green fruit, 5 in. high; "Flemish" inkwell, no. 48 in catalog, cream with pink roses and blue birds, 4 in. high; "Wood Rose" candlestick with blue berries. *Bottom row:* "Wood Rose" bucket, 5 in. high; "Knifewood" jar, natural colors, 7 in. high; "Coppertone" vase, green over brown, 9 in. high. *Author's collection; Johnson photo*

MANHATTAN

Weller Pottery catalog, ca. 1919

NOVELTY ITEMS

Weller Pottery catalog, ca. 1919.

M. LOUISE McLAUGHLIN POTTERY CINCINNATI, OHIO
1876

The origin of Cincinnati, Ohio, art pottery can be traced back to 1874, when Benn Pitman, a native-born schoolteacher, organized a class in china painting for the young women of the city. Benn Pitman was a brother of Sir Isaac Pitman, who invented the Pitman shorthand method.

The wares these women decorated were displayed at the Philadelphia Centennial Exposition of 1876, where they received considerable attention. These women were greatly impressed by the pottery displays of the French and Japanese, which were also on exhibition at the Centennial. On their return home, they continued to study under Miss M. Louise McLaughlin, who had already been experimenting with pottery for five years. Miss McLaughlin organized the Pottery Club of Cincinnati, with an original membership of fifteen. Maria Longworth, of Rookwood fame, was a guest but was not a member.

In 1879 Miss McLaughlin and Miss Longworth advanced the Frederick Dallas Pottery, which was managed by Joseph Bailey and his son, enough money to build two kilns, one for the overglaze and one for the under-the-glaze painting. For several months, these two women continued to work at the Dallas Pottery, but they were not fully satisfied with their progress. Dissatisfaction soon compelled Miss McLaughlin to erect a small studio pottery on the grounds adjoining

her residence, where she began to perfect new bodies and new glazes. One line that Miss McLaughlin perfected was named "Lósanti," derived from the early name of the city, Losantiville. Losantiville was founded in 1788 by John Filson, a schoolmaster and surveyor. The name was supposed to mean "the town opposite the mouth of the Licking" (River). Two years later, the name Losantiville was changed to Cincinnati, in honor of the Society of the Cincinnati. Historians claim Miss M. Louise McLaughlin paved the way for the most popular and beautiful pottery in American history.

Pieces created by her are marked with her monogram or line name on the base. Occasionally these are impressed, on other items are painted in blue.

Marks:

M Lo'santi L M⊆ L

CINCINNATI ART POTTERY
1879—1891

The Cincinnati Art Pottery was established in Cincinnati, Ohio, in 1879, with Frank Huntington as president. A variety of wares were produced, such as vases, bowls, and plates.

This particular Pottery created an underglaze faïence known as "Hungarian," "Portland Blue," and "Ivory Colored Faïence." Of most importance was a dark blue glaze, embellished with Arabesque designs in rich gold. Cincinnati Art ware was also sold in blanks, to be decorated by "china painters," a practice in vogue during this era.

From the very outset, Cincinnati Art pottery was marked. The first mark was the figure of a turtle. In 1886 the name "Kezonta," the Indian name for turtle, was added along with the name "Cincinnati." This

mark was stamped in red on the finer pieces that were decorated in the pottery's own studios. The name "Kezonta" alone was impressed on the lesser wares and on the blanks that were sold to the china painters. The company closed about 1891.

Due to the short existence of this company, examples of this ware is extremely hard to come by. Most is probably in the hands of private collectors.

Cincinnati Art Pottery company marks:

1879-85

1886-90
Stamped in red

1886-90
Impressed
in semicircle

KEZONTA

1890
Impressed (very rare)

WHEATLEY POTTERY
1880—1906

The Wheatley Pottery was founded in May or June of 1880 by Thomas J. Wheatley at Cincinnati, Ohio. Here the first art-pottery kiln, constructed under the supervision of Mr. Wheatley, was in operation about six months prior to the organization of the Rookwood Pottery, of Cincinnati.

Wheatley pottery was of rather fine quality. Some items were made to resemble the old pitted surface of the buried pottery of Pompeii.

Another technique the company used was the under-the-glaze slip painting of scenes, flowers, and other beautiful decorations. Wheatley, being among the first to use this strictly American innovation, was widely copied by other potteries that were soon to be engaged in this highly competitive business. This new process of decorating pottery was patented in 1880, the patent reading as follows:

Wheatley vase. Shiny glaze, orange flowers on green and black, 1880, 6½ in. high. *Author's collection*

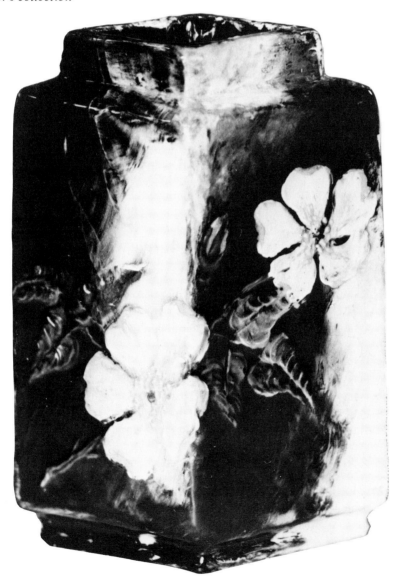

UNITED STATES PATENT OFFICE

Thomas J. Wheatley, of Cincinnati, Ohio.

PROCESS OF PAINTING POTTERY

SPECIFICATION forming part of Letters Patent No. 232,791, dated
September 28, 1880.
Application filed June 21, 1880. (Specimens)

To all whom it may concern:

Be it known that I, Thomas J. Wheatley, of Cincinnati, Hamilton County, Ohio, have invented a new and useful Improvement in the Art of Painting Pottery and other Ceramics, of which the following is a specification.

The object of my invention is to employ underglaze colors to pottery and other ceramics in such a manner as to cause the colors to become integral with the ware as soon as the latter is baked, thereby adding to the beauty and durability of the ornamentation and increasing the value of the ware, as hereinafter more fully described.

The first step in my improved art of ornamentation consists in forming the vessel or other piece of ware of any suitable plastic clay, and while yet moist or damp there is applied to it the background tint, which tint is composed of any appropriate oxide or underglaze color mixed with white slip. The background tint thus prepared is applied to the damp piece with a brush, care being taken to give the article a thick uniform coating of said tint. The white slip employed in this process is the kind used in all potteries in manufacturing Parian ware or white delft, the slip being simply mixed with water until the desired consistency is obtained. While the background coat of tinted slip is yet damp the piece is decorated with landscapes, flowers, figures, animals, or other desired ornamentation, which decorations are applied with a brush or other convenient tool or implement. The appropriate oxide colors or other pigments used for these decorations are mixed with slip in any suitable proportions, and if the ornaments consist of a bunch of flowers or fruit or other simple group it is preferred to impaste the colors, so as to cause such a group to stand out in high relief after the piece is burned, which burning is effected by placing the article in an ordinary kiln heated to the proper temperature—say about two thousand degrees. After being baked a sufficient length of time, according to the size of the piece and the kind of clay of which it is composed, the article is then removed from the kiln or oven in the condition commonly known as "biscuit," an examination of which will show that the colored ornaments have been so thoroughly baked onto the ware as to become integral therewith. This biscuit is now dipped in any suitable glaze and then reheated, so as to give it the final or vitreous coating, which operation completes the process.

From the above description it will be apparent that the colored ornaments are so completely fused or burnt onto the substance of the ware as to become part of the material body of the same, and consequently they cannot scale off or be removed by any means short of the destruction of the vessel.

Finally, to define my invention more explicitly, it consists in baking tinted clay ornaments onto pottery or other ceramics.

I claim as my invention – – – – – – – – –

The within described improvement in the art of painting ceramics, which improvement consists in mixing underglaze colors with slip or other suitable clay vehicle, then applying such tinted clays to the piece and baking or burning them onto the same so as to become integral with the substance of the ware, for the purpose specified.

In testimony of which invention I hereunto act my hand.

T. J. WHEATLEY.

Witness:
JAMES H. LAYMAN,
GEO. H. KOLKER.

Wheatley mark incised with a sharp tool on the base of each item:

TJ Webo
Pat Sep 28
1880

ROOKWOOD POTTERY
1880—1960

Prior to the Centennial at Philadelphia, in 1876, a group of women residing in Cincinnati, Ohio, were experimenting with different clays and glazes. Although they were considered amateurs in their decoratng abilities, they did place their finished products on display at the Cen-

tennial. One of these women was Maria Longworth Nichols (Storer). This group was quite impressed by the other exhibits, especially those of the Japanese and the French. On their return home, they began experimenting more extensively with the different clays and glazes, and also with underglaze decoration. Mrs. Nichols, along with Miss M. Louise McLaughlin of the Pottery Club of Cincinnati, set up studios at the Frederick Dallas (white-ware) Pottery, whose output was mostly graniteware. Neither woman was satisfied with her progress at the Dallas Pottery; furthermore, heat from the kilns was too intense for Mrs. Nichols' experiments and destroyed all the colors except cobalt

Rookwood "standard" glaze brown ware. Green foliage and red berries, 1890, signed "Amelia B. Sprague," 4 in. high, 7 in. across. *Author's collection; Knight photo*

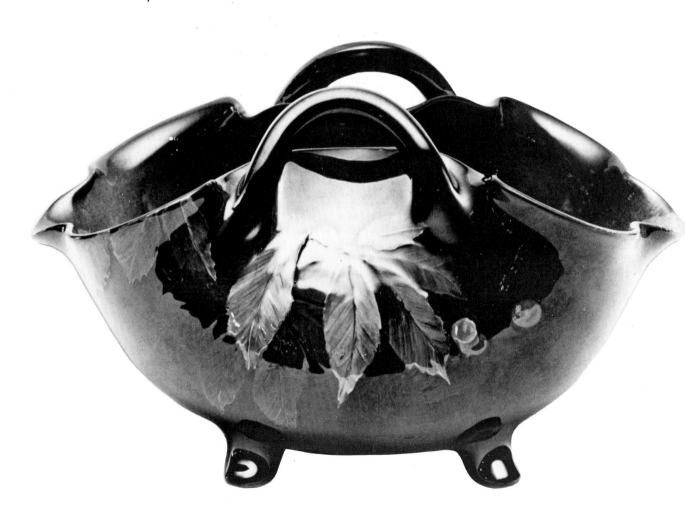

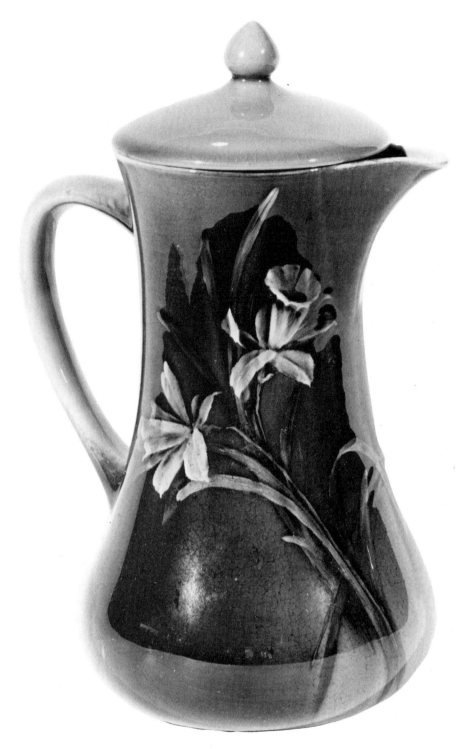

Chocolate pot. "Standard" glaze with yellow flowers, handle, and lid, marked, signed "ABS"—Amelia B. Sprague, dated 1890, 9 in. high. *Author's collection; Knight photo*

blue and black. What she actually desired and needed was a pottery of her own, where she could control the firing of the vessels and be free to test all clays and all glazes.

Her father, Joseph Longworth, a man of considerable wealth and also a patron of the arts, purchased an old abandoned schoolhouse for his daughter. Mr. Longworth was the son of Nicholas Longworth who, at one time, owned most of downtown Cincinnati. The schoolhouse was converted into a pottery and the first kiln was drawn on Thanksgiving Day 1880.

Mrs. Nichols named the Pottery after her father's estate, which was heavily wooded and well inhabited by rooks. Mrs. Nichols hired Joseph Bailey, Jr., the son of Joseph Bailey with whom she had worked at the Dallas Pottery, as superintendent as well as chemist-artist. She had great confidence in the elder Bailey and hoped he would be a guiding force behind his son. So it was, and after the death of Mr. Dallas, the senior Bailey also joined the Rookwood forces. E. P. Cranch was employed as handyman and artist, and the first Rockwood plaques can be accredited to him. Some of the earliest Rookwood pieces were not decorated by regularly employed Rookwood artists, but were blanks sold to artists, some of whom were members of the Cincinnati

The Rookwood Pottery, Cincinnati, Ohio.
View overlooking the river.

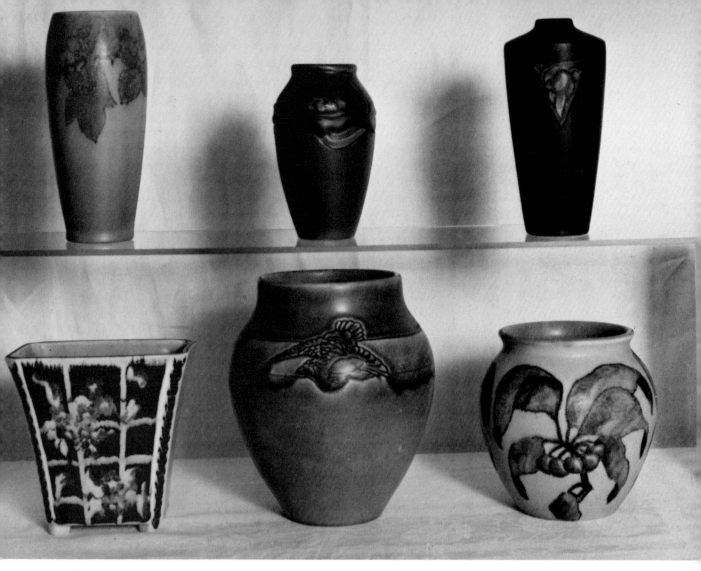

Rookwood signed vases. *Left to right, top row:* "Wax Matt," green shaded to yellow, "Sallie E. Coyne," 1929, 7½ in.; "Modeled Matt," red decorated in green, "Sallie Toohey," 1904, 6 in.; "Painted Matt," green, "C. S. Todd," 1911, 7½ in. *Bottom row:* "Butter Fat" glaze, green trimmed in various colors, "M. H. McDonald," 1930, 6 in., "Etched Matt," blue-green with turkey decoration, "W. E. Hentschel," 1911, 8½ in.; "Butter Fat" glaze, blue background with green and red decoration, "Jens Jensen," 1931, 6 in. *Author's collection.*

Pottery Club. The first paid artist to work for Rookwood was Albert Valentien (1881), who had previously been associated with the Wheatley Pottery. He was followed shortly by Matt Daly, from Matt Morgan Pottery, and by Laura Fry, William P. McDonald, and Kataro Shirayamadani. The very earliest Rookwood pottery was somewhat like the stoneware-type pottery, decorated with modeled designs or carved decoration on gray, cream, or other light-colored clays, with the color in the design. The appearance of the glaze was similar to that of salt glaze or smear glazes. Another type, known as "Limoge" decora-

A sketch of the famous RP mark created by Wm. P. McDonald

tion, was an underglaze decoration on both dark brown and light color clay with the decoration in color, further embellished with gold over the glaze, very reminiscent of Matt Morgan pottery. No doubt this was Matt Daly's contribution to the early wares.

The clays used were entirely American, mostly from the Ohio Valley. These native clays inclined the color quality toward the yellows, reds, and browns. The blend of browns and yellows on the background with

subjects painted in slip colors of yellow, red, and green in the manner of oil painting, then covered with a transparent glaze, is recognized as the "standard" glazed Rookwood. This is a rich, luxuriant style of ware, oftentimes decorated with portraits, animals, fish, fruit, and native flowers of every variety. This glaze was perfected by Laura Fry, who had this method patented March 5, 1889 (Patent No. 399,029). T. J. Wheatley had patented a similar method in 1880. Miss Fry's process differs in that the background is air brushed.

In 1883 W. W. Taylor assumed the active direction of the Pottery as partner to Mrs. Nichols. Taylor was neither artist nor potter, but was a good businessman and under his guidance the Pottery soon began to prosper and outside assistance was no longer necessary.

Maria's husband, Mr. Nichols, died in 1885 and the following year she married Bellamy Storer. When Mrs. Storer retired in 1890, she transferred all her interests to Mr. Taylor, who became president and held that position until his death in 1913. He in turn bequeathed his stock in the company to the trustees for the continuation of the "freedom of expression" policy, which had given Rookwood its unusual character as an art industry. Mr. Taylor was followed by J. H. Jest as president and J. D. Wareham as vice-president.

The number of artists was increasing steadily, most of them coming from the Art Academy of Cincinnati. However, there were exceptions, notable among them being James Bromfield of England, who was never listed as a Rookwood artist, but was responsible for the teasets with the little blue pirate ships, first made in the 1880s, then again in the early 1920s. The first of the "Blue Sailing Pirate Ships" on white background bore no factory mark, and the decoration was over the glaze. When this pattern was revived, it was marked with the RP monogram, but no flame marks added. Each was marked with a letter and a number, with the slip painting under the glaze. They were made for three to four years.

Other decorators not from America were Kataro Shirayamadani and E. H. Asano, both migrating from Japan. Asano is known for his work in metals. Kataro Shirayamadani worked for Rookwood from 1887 to 1948, with the exception of about ten years when he had gone back to Japan. He was a guiding influence and his work definitely added an Oriental flavor to Rookwood pottery. The Rookwood artists never

"Hi-glaze" plaque, 1894. Pottery portion signed "Bruce Horsfall," 8 by 10 in. *Collection of Joe Loadholtz; Loveland photo*

worked from patterns but each was allowed freedom to express his own individual feelings. Each was permitted to choose the glaze he desired, at any time, or try to develop new ones.

About 1884 the "Tiger Eye" was developed quite by accident. The glaze on this ware has an aventurine effect, which is very subtle, illusive, and very difficult to see. The glaze was developed within the kiln and the aventurine effect formula has always remained a mystery. Evidently the proper ingredients, plus the exact exposure to the heat, was important since the effect varies, sometimes appearing only on one side or in spots deep within the glaze. Tiger Eye was revived several years later; however, this later type contains more of the goldstone-appearing crystals. Under normal conditions, this aventurine effect is not noticeable and one must examine it under strong light before realizing it is Tiger Eye. This line is often undecorated and not artist signed.

Karl Langenbeck was hired by Taylor as Rookwood's first chemist. He later was known as America's first pottery chemist. His tenure with Rookwood was but one year—January till December of 1885. After severing connections with Rookwood, in 1886 he formed the Avon Pottery of Cincinnati, where he remained about one and one half years.

From Avon he went to Weller and then to Owens in Zanesville, Ohio. In 1895, Karl Langenbeck was the author of a book, *Chemistry of Pottery*.

In 1892, Rookwood erected a new factory. The new building crowned the summit of Mount Adams, one of Cincinnati's many hills. It commanded beautiful views in every direction—of the river, the city, its suburbs, and a large garden of flowers grown on the premises. A beautiful display room was also included where much pottery was sold to visitors. The factory was enlarged in 1899 and again in 1904.

In 1893, the "Iris" line was introduced. This was created by changing the background colors of the standard brown ware to pastel hues, decorated with the same style of slip painting, covered with a gloss glaze. The light background afforded the artists a wider command of color. These background tints were shaded from light to dark or bicolor, from gray to pink, and the like. About this same period, the "Aerial Blue" was introduced. This line has a solid grayish white background trimmed with blue decorations under a gloss glaze. Also in this period,

"Blue Sailing Pirate Ships" sugar and creamer. *Center:* "Iris" vase, pale pink to green, signed "Carrie Steinle," 1906, 5½ in. high. *Author's collection; Knight photo*

another type of decoration, known as "Sea Green," was introduced. It is characterized by a rich green shaded background, usually decorated with light-colored subjects, covered with a green glaze. This ware is generally marked with an incised "G," along with the other marks.

In 1900 Rookwood employed 35 to 40 decorators, each with freedom to create or use any decoration he might choose. Rookwood always encouraged the artists to improve techniques and sent many of the decorators abroad to study, paying all or a portion of their expenses. Artus Van Briggle was one of these decorators, spending over two years

Rookwood incised vase. Matt finish, blue and mauve, signed "Fannie Auckland, 1882," 11 in. high. *Collection of Joe Loadholtz; Loveland photo*

in Paris. After his return to Rookwood in 1896 he created a new variety of matt-glaze decoration. Before it could become a full reality and put into production, Van Briggle was forced to resign because of ill health. During the period he was testing these new glazes, he modeled one of his art nouveau-type figures for Mrs. Storer and covered

it with this new type of matt glaze. This is believed to be the only piece he modeled for Rookwood. It is very possible some of these may have been reproduced later by Rookwood. This type of matt glaze was then further developed by Stanley Burt.

Three different types of ware were treated with this matt finish. One, called "Painted Matt," was broadly painted with decorations of both naturalistic and stylized subjects. The second, known as "Incised Matt," was executed by using the sgraffito method with a matt finish. The third line, known as "Modeled Matt," was modeled in bas-relief or high relief, then covered with the matt finish. These pieces, dated between 1900 and 1905, are marked with the letter "Z," along with the size letter appearing on the base.

In 1904 a new variation of the matt glaze was introduced. This type is called "Vellum." It was pronounced by experts at the St. Louis Exposition as the only ceramic novelty at the Exposition. Vellum is a soft transparent matt glaze that was developed within the kiln at the same time as the decoration, without any other treatment to give it this soft texture. Previously, the matt glazes were heavy and the objects had to be broadly painted or modeled. This made it impossible to produce subjects in detail, such as appeared on the slip painting on the standard and other gloss glazes. Vellum afforded the artists a much

"Vellum" black rook, 1909, 3 in. high. *Author's collection; Orren photo*

Rookwood pottery. *Top:* Inkwell, "standard" glaze with yellow flowers, marked, signed by Carrie Steinle on both lid and insert, dated 1900, 4¼ in. by 9¼ in. *Lower left:* "Standard" glaze brown ware with light brown foliage, silver overlay, 1905, signed "LNL"—Elizabeth N. Lincoln, 7 in. high. *Lower right:* "Vellum" vase, gray to pink with blue decoration, signed "Margaret Helen McDonald," 1920, 11 in. high. *Author's collection; Knight photos*

"Standard" glaze brown ware stein signed by Grace Young, 1899, portrait of "Turning Eagle, Sioux," silver lid with dinosaur or lizard thumb lift, brown and yellow, 8 in. high. *Collection of Joe Loadholtz, Loveland photo*

greater variety of decoration, such as beautiful scenes, including snow scenes, sunsets, marine life, and a wide assortment of flowers. This ware was also decorated in the same style as some of the earlier matt (incised and modeled). Most of the Rookwood plaques are Vellum. Many of these plaques, with the title of each written on the back, came with fitted wooden frames. These plaques are artist signed, sometimes on the obverse, sometimes on the reverse. This particular type of decoration is quite easy to recognize as a "V" appears along with the other marks, occasionally impressed with a die, and at other times incised by hand.

In 1910 Rookwood celebrated its thirtieth anniversary by bringing out still another matt-glaze line known as "Ombroso." This finish was generally used on modeled objects, such as large bookends and paperweights. The finish is not easy to describe; however, it appears

somewhat like Vellum but has no identifying marks. The colors seem to have burned out more and to have run slightly, especially the pastel shades. Ombroso is generally found in monochrome colors.

In 1915 Rookwood introduced "Porcelain." This is a very hard, vitreouslike pottery, usually termed "soft porcelain" or "semiporcelain." Porcelain was made in all sorts of flower-arranging bowls, vases, figurines for use as flower frogs, and paperweights. The glazes used were both high gloss and matt finish. This ware was expensive to produce, as many pieces cracked or damaged severely in the firing; consequently, the line was discontinued after a short time. This ware is easily identified by the letter "P" along with other company marks on the base.

Rookwood tray. White mermaids on turquoise sea shell, marked "Porcelain," dated 1915, weight 5 pounds, 9½ in. diameter. *Author's collection; Knight photo*

Modeled "Ombroso." Ivory, signed by Louise Able, dated 1926. *Author's collection; Knight photo*

About 1920 Porcelain was replaced by "Jewel Porcelain." This is also a vitreous pottery that is translucent when held to a very strong light. It was made till the closing days and was covered with various glazes and decorations. The Jewel Porcelain was occasionally used in the commercial lines, cast in molds.

Years of experimenting and creative effort on the part of the chemist and artist brought about new glazes. Some of these were the "Butterfat," a soft, smooth monochrome matt glaze, and a "Wax Matt" glaze similar to the Butterfat except that it has bicolor backgrounds with soft waxy surfaces, at times having a curdled effect. The designs have a fuzzy or runny appearance. Practically all decorated pieces are artist

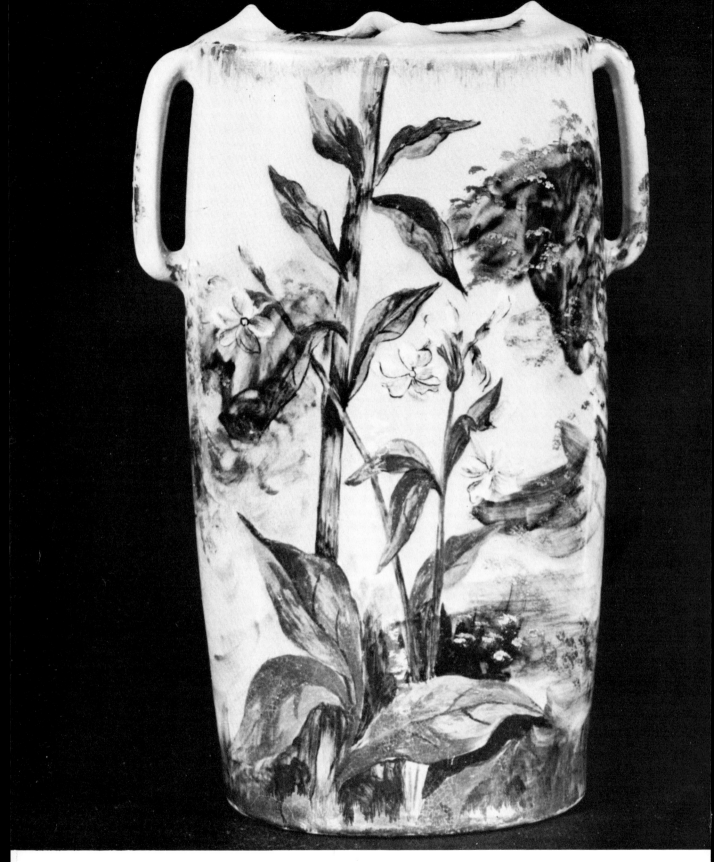

Vase with Limoges-type decoration. Rose-beige background with foliage in autumn hues, accented with gold over the glaze, marked "Rookwood 1882" with anchor mark, signed "MLN"—Marie Longworth Nichols, 10 in. high. *Collection of R. E. and F. G. O'Brien, Jr.; Knight photo*

signed. The Wax Matt glaze was the result of combined experiments of John D. Wareham and Stanley Burt, Wareham having conceived the idea for this glaze while visiting an exhibit of pottery in Paris. Jewel Porcelain is often decorated with this Wax Matt glaze.

Some of the earliest pieces of Rookwood are further embellished with metals, such as silver overlay or silver deposit. Others are fitted with silver stoppers or lids embossed with designs matching the painted decoration. Some pieces were adorned with other metals. E. H. Asano, a Japanese who came to America with Shirayamadani, when the latter returned from a trip to Japan, worked at Rookwood experimenting with silver and other metals. Asano spent some time teaching Mrs. Storer the art of working with these metals. Occasionally an article will be found marked EHA. Shirayamadani supposedly perfected a method of electrodeposit; however, most of the silver work was hall-marked by silver companies.

Although Rookwood was known primarily for small art objects (vases and the like), the company produced ornamental commercial lines such as tiles, outdoor garden ware, panels, and so forth. Clement J. Barnhorn, a sculptor and associate of the artist Frank Duveneck (1848–1919), a portrait painter and sculptor, made many designs for panels and beautiful fountains made at Rookwood. Complete murals were designed in tiles, some composed of hundreds of pieces.

Early in the 1900s, Rookwood began to produce ornamental wares cast in molds. The production of these wares increased in volume as the years passed. Since these molded pieces were less expensive to produce, they were made by the dozens in such forms as pleasing classic vases, paperweights, bookends, ashtrays, teasets, candlesticks, and bowls. These molded items were covered with a variety of colors and glazes. Although they were commercial pieces, they were marked with all the factory marks on the base, but never artist signed. The only exception to this was when the sculptor signed the master mold. The signature actually appears to be molded rather than incised by hand or stamped with a die. This type of signature usually will be found on bookends or other heavy modeled specimens. The objects made in molds should not be referred to as "signed Rookwood," but should be rightly called "marked Rookwood." The term "signed" should be reserved for the artist-signed pieces only, which were never duplicated. The commercial

lines were molded in different styles. Some were the modeled type with flowers, rooks, and other designs in bas-relief, while others were molded in the style of the early incised-matt technique. Many of these "cast in a mold" pieces were the Jewel Porcelain variety.

Rookwood hand-decorated vases were considered a quality work of art from the inception. These were often displayed on teakwood bases and sold in exclusive stores everywhere. These vases were comparatively

Above and opposite: Both sides of Rookwood "hi-glaze" brown ware pitcher with frogs, 1898, brown and yellow, silver overlay, signed "Wm. P. McDonald," 8 in. high. *Collection of Joe Loadholtz; Loveland photo*

expensive from the very beginning as Rookwood advertised no duplicates were ever made. Later, when a larger volume of commercial ware was placed on the market, the Rookwood advertisement read, in effect, "No duplications are ever made of artist-signed ware."

At the time the hand-decorated pieces were made, they were priced according to the popularity, ability, and salary of the artist. Works of Valentien, Daly, Nourse, Shirayamadani, Steinle, Coyne, Diers, and

several other early artists commanded a higher price than some of the newer or junior artists. At the present time, these earlier artist-signed pieces still continue to bring a higher price. One must realize, however, that all artists, despite the length of their tenure with Rookwood, did do some inferior work. One must not judge a specimen by the signature alone, but quality should also be of primary concern. Many of the later decorator's subjects were just as well executed as the early mas-

ters, and the works of these later artists should be given due consideration, for many indeed were very talented.

Mrs. Storer, a widow again in 1922, lived to the age of eighty-three. In her later years she resided in Paris with her daughter, who had married a French nobleman. Mrs. Storer passed away in 1932.

In 1934 J. D. Wareham succeeded J. H. Jest as president of the company. Wareham had been working for Rookwood for many years,

first as decorator and later as head of the decorating department, and holding the post of vice-president since 1914. When Wareham became president, the Rookwood Company was in deep financial difficulty. The equipment was practically obsolete and the depression years had taken its toll of the business. Although he tried every way and means to keep the operation on a paying basis, it was almost impossible to accomplish any real security. It became one struggle after another. In 1954 Mr. Wareham passed away.

In 1959 the Rockwood Company was sold to the Herschede Hall Clock Company and in 1960 was moved to Starksville, Mississippi. Pottery was made here from time to time, but was never of the quality of the original ware. This later ware did not appeal to the public and, consequently, operations ceased in the summer of 1967. This ware was marked with the company mark and was correctly dated.

Although Rookwood made fine quality pottery for many years it does not mean that the company did not also make inferior pieces, as did all potteries from time to time. You will notice that on some Rook-

"Standard" glaze brown ware. *Left to right:* Covered jar, dated 1895, signed "Sallie Toohey," 7 in. high; jug dated 1897, signed "Sallie Toohey," 9½ in. high; mug with sterling silver cap, dated 1895, signed "Bruce Horsfall," 7 in. high. *Collection of Frances and Don Hall; Fox photo*

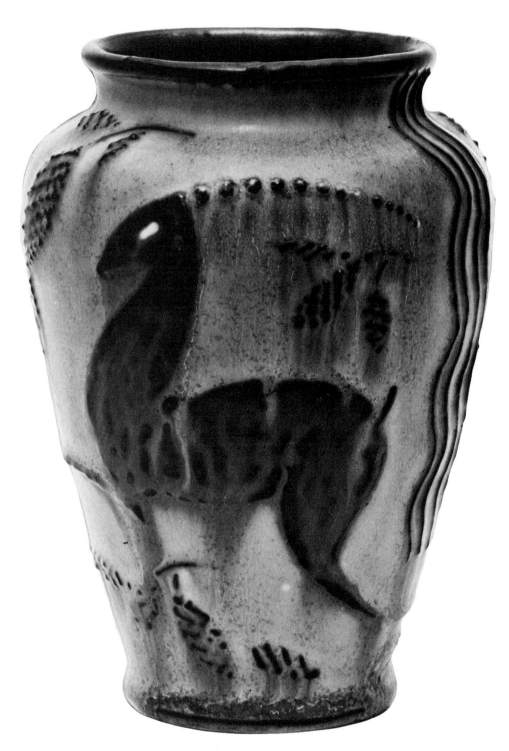

Rookwood vase. Brown figures in raised slip on turquoise background, marked "special," signed by Jens Jensen, dated 1934, 6 in. high. *Author's collection; Knight photo*

wood there is an "X" scratched in the base. This indicates that the piece was a "second" and was not allowed to be sold at the top quality price. Today, however, this mark does not actually mean what it did years ago, and does not decrease the value of the piece to any large degree. It is occasionally impossible to determine just why the "X" was placed there originally. On the other hand, one might find a piece of Rookwood of actual inferior quality and wonder why this piece was not marked with an "X." Such pieces were total rejects and were not allowed to be sold under any circumstances, but were given, at the rate of twelve pieces a year, to the employees for their own use. Every three months, these were distributed—three pieces to each employee. The company used the system of "drawing by lot number." As the years went by, however, these inferior pieces and rejects found their way into the salable market; consequently, every now and then, one will show up.

From the very beginning, the Rookwood Company was proud and rightly so. Plaques with slogans or mottoes could be found hanging in several spots around the pottery. The wording of these slogans or

"Standard" glaze brown ware. *Left to right:* Jug (7½ in. high) with ear of corn, 1903, signed "CCL"–Clara C. Lindeman; cup (2½ in. high) and saucer (4½ in. diameter) with holly leaves and berries, 1897, signed "Sara Sax"; jug (5½ in. high) with ear of corn, 1897, signed "Sallie Toohey." *Author's collection; Knight photo*

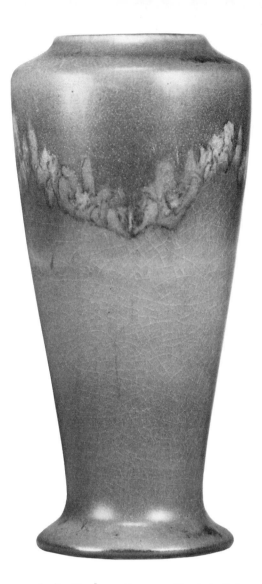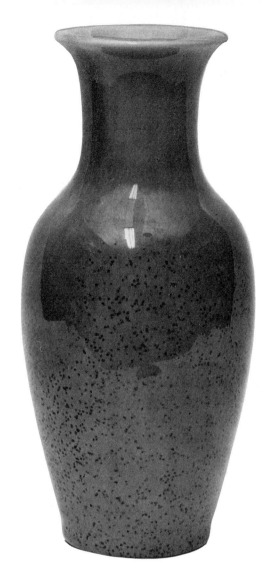

Left: Rookwood vase. Shaded light and dark brown, garland or rose-colored flowers with greenish yellow leaves, matt glaze, signed "C.S.T."–Charles S. Todd, dated 1911, 7 in. high. *Collection of A. C. Revi. Right:* Rookwood vase. Turquoise shading to rose-beige at top, glaze contains small pieces of mica, marked with an esoteric mark indicating a trial glaze, dated 1932, 7 in. high, very rare. *Author's collection; Knight photo*

mottoes went something like: "The World's Exclusive Producers of Jewel Porcelain," "There is no Rookwood without the Rookwood Mark," and "America's Contribution to the Fine Arts of the World."

It may be interesting to note that Charles A. Lindbergh was presented a fabulous Rookwood vase valued at several hundred dollars. This vase, signed by Sarah Sax, is now on display in a St. Louis Museum along with Lindbergh's other trophies.

The Rookwood Company received numerous honors at different expositions. We will not list them all; however, a few are worth mentioning.

FIRST PRIZE	Pottery decorated and modeled for underglaze slip painting. Pennsylvania Museum, Philadelphia. 1888.
GOLD MEDAL	First Prize. For faïence. Exhibition of American Art Industry. Philadelphia. 1889.
HIGHEST AWARDS	World's Columbian Exposition. Chicago. 1893.
GOLD MEDAL	Pan-American Exposition. Buffalo. 1901.
TWO GRAND PRIZES	Louisiana Purchase Exposition. St. Louis. 1904.
GOLD MEDAL	Jamestown Tercentennial Exposition. 1907.
GRAND PRIZE	Alaska, Yukon and Pacific Exposition. Seattle. 1911.

Rookwood also received several other high awards in countries outside the United States and one will find specimens of this fine art in many of the museums around the world. Probably no other American product received such enormous acclaim as did Rookwood.

From the very outset, every piece was marked and dated and hand-decorated pieces were artist signed. No other pottery marked its products as religiously as did Rookwood. Frequently, the type of clay and glaze used were indicated by symbols on the base. It has been said that the artists were fined if they failed to sign their own creations. The actual systematic dating of the pottery started in 1886, and every piece made thereafter bears the date. The letter "P" with the reversed

Rookwood pottery. *Left to right:* Geese paperweight, brownish gray, ombroso glaze, marked "Porcelain," dated 1916, 3½ in. high; flower frog, high-gloss turquoise glaze, dated 1922, 5 in. high; cheetah, dark green, gloss glaze, marked with monogram with fourteen flames, but missing the Roman numerals which usually appear on late figural pieces, ca. 1930, 3 in. high, 6 in. long. *Author's collection; Knight photo*

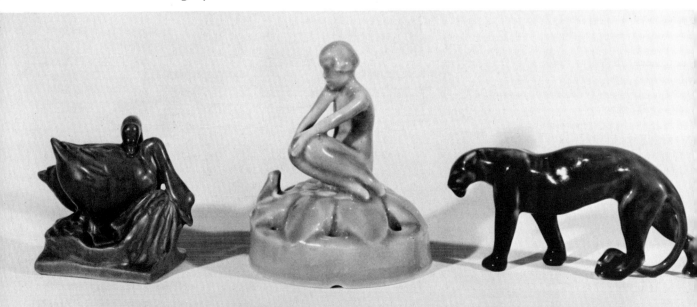

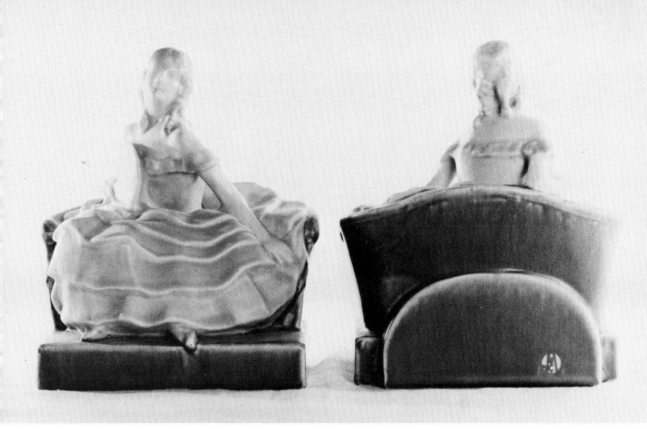

"Ombroso" book ends. Pale pink and brown, master mold signed by William McDonald, 7 in. high. *Author's collection; Johnson photo*

"R" was used for the monogram in 1886. Each succeeding year, up to and including 1900, a flame point was added to this monogram. In 1901 Roman numerals were added below the monogram for 1900 (for instance, in 1903 III would appear below the monogram). This system of dating was used until the closing days. From time to time, one will notice esoteric marks on Rookwood. What these meant was unknown to the public, as they were generally put on experimental pieces only.

Letters denoting the type of clay used were stamped on the base of each of the earlier pieces, below the company mark. These were as follows: G, Ginger; O, Olive; R, Red; S, Sage Green; W, White; and Y, Yellow; all these indicated the color of the clay. There is, however, one exception. One will at times find the letter "S" below the regular company mark. This was a "Special" piece created by the artist and was one of a kind. This "S" should not be confused with the "S" for Sage Green, since Sage Green clay is an extremely pale olive drab. In the event that a special piece was made with Sage Green clay, the letter "S" would appear twice. These special pieces are extremely rare and

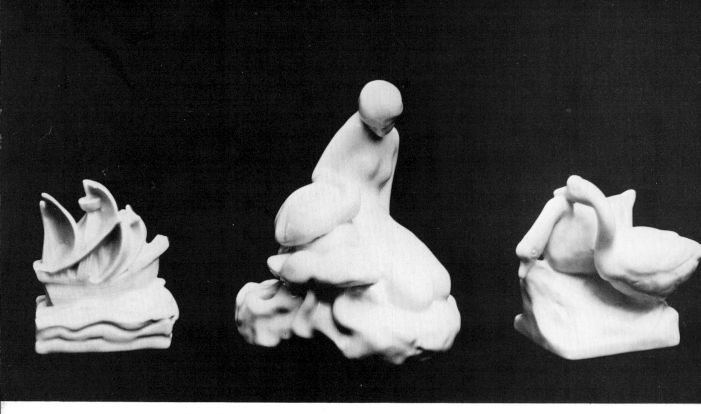

Rookwood pottery. *Left to right:* White ship paperweight, 1928, 3½ in. high; figure marked "Porcelain," high gloss, 1918, 6 in. high; geese paperweight, 1930, 4 in. high. *Author's collection; Knight photo*

were generally made for VIPs. When the letter "S" precedes the pattern number, it indicates it was made from a sketch.

Also appearing below the regular factory mark are numbers denoting the pattern design and shape. These numbers were kept on record at the factory. Accompanying these numbers were the size letters, ranging from "A" to "F." The letter "A" denotes the largest size made of the vase or vessel, and the letter "F" the smallest. All wares were not made in all sizes, perhaps in only three or four. It must be noted here that all wares marked with an "A" were not all the same size but, instead, the largest one made in that particular line. When no size letter appears along with the pattern number, it is an indication that this particular piece was made in only one size. The letter "T" preceeding the pattern number indicates a new shape was being tested. If the letter "X" both precedes and follows the pattern number, it indicates a trial glaze.

The Rookwood Pottery issued a brochure or booklet at intervals, especially when a new line was introduced. These contained a brief history of the company and a list of the artist's names and monograms.

Rookwood vase. Shaded light to dark rose-beige with pink apple blossoms on a branch, "Iris" glaze, signed "I.B."—Irene Bishop, dated 1906, 6⅛ in. high. *Collection of A. C. Revi*

Rare scenic vase. "Iris" glaze, marked, signed by Kataro Shirayamadani, dated 1909, 8½ in. high. *Author's collection; Knight photo*

"Standard" glaze brown ware. Red cherries and green leaves, 1893, signed "Mary Nourse," 5½ in. high, 8½ in. across. *Author's collection; Knight photo*

Rookwood Pottery line names and descriptions:

AERIAL BLUE Solid white with a gray cast background, with blue decorations under a transparent gloss glaze.

IRIS This is the same technique as the Standard Glaze ware except the backgrounds are light colors. Similar to Weller's Eocean and Etna, Owens' Lotus and Roseville's Rozane Royal (light).

JEWEL PORCELAIN A semiporcelain body which replaced the more costly Porcelain. Jewel Porcelain was used from 1920 until the closing days, covered with various glazes. The artist-signed pieces are often covered with the Wax Matt glaze. This type ware is translucent when held to a strong light.

LIMOGE WARE	This line is generally to be found in the earliest pieces. An underglaze decoration on dark red or light clay under a transparent gloss glaze. Further embellished with gold, similar to Matt Morgan.
MATT GLAZES	A soft smooth surface distinguished by the absence of gloss.
A. Butter Fat Glaze	A soft matt glaze with a monochrome background. Hand painted similar to Wax Matt.
B. Incised Matt	Sgraffito type. The designs are scratched into the surface of the ware with a tool in the same manner as Weller's second-line Dickens Ware.
C. Modeled Matt	The subjects are modeled in bas or high relief and covered with a matt glaze.
D. Painted Matt	The subjects are broadly painted in natural or stylized designs, then covered with a matt glaze.
E. Wax Matt	A waxy surface with a bicolored background, distinguished by the runny and fuzzy decoration having a curdled effect in the glaze. This glaze is generally applied to the Jewel Porcelain ware.
OMBROSO	Similar to Vellum but with no identifying marks. Usually covers heavy modeled pieces such as bookends, paperweights, figures, etc. Generally in monochrome shades, with a semi-gloss glaze.
PORCELAIN	A semiporcelain body covered in a variety of glazes. Always marked "P" on the base along with the other marks.

Electric lamp. Green with pink flowers, painted matt, signed by Harriett E. Wilcox, dated 1903, 23 in. high, shade 13 in. diameter. *Author's collection; Jarrett photo*

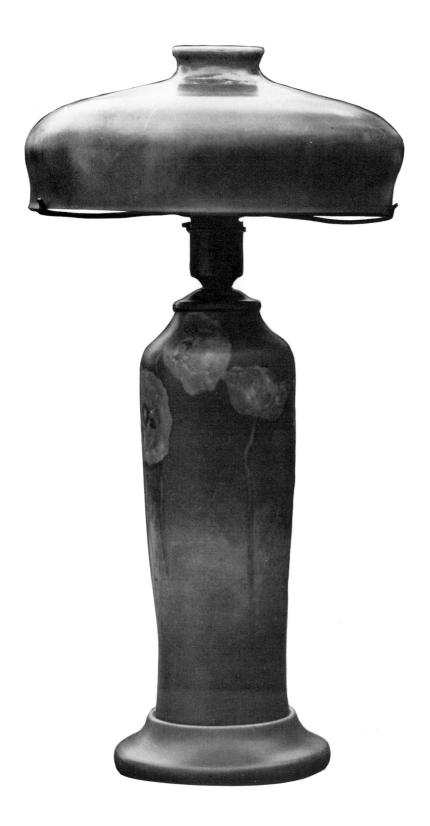

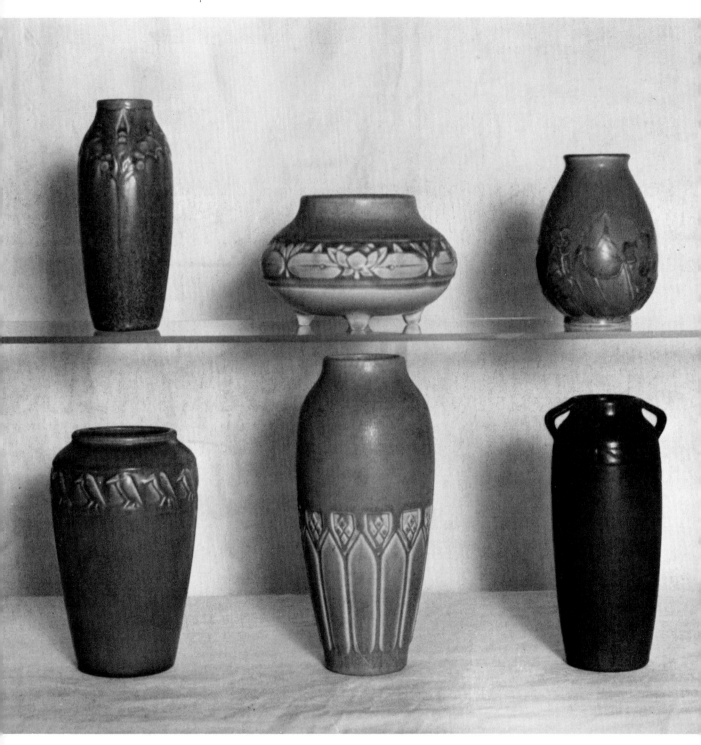

Assorted commercial molded vases. All have company marks and dates, but are not signed by the artists; all matt finish. *Left to right, top row:* Brown, 1923, 6½ in.; "Vellum," blue, 1909, 3½ in.; pink on green, 1935, 5 in. *Bottom row:* Green, 1921, 6¾ in.; lavender, 1926, 9 in.; brown, 1911, 7½ in. *Author's collection*

SEA GREEN	Shaded green backgrounds, some being quite dark. It is distinguished by a gloss green transparent glaze, marked "G."
STANDARD GLAZE	Dark rich shaded brown and yellow colors with underglaze slip paintings of flowers, fruits, and portraits. This is the line most often encountered and recognized as Rookwood. It was duplicated by Weller's Louwelsa, Owens' Utopian, and Roseville's Rozane Royal (dark).
TIGER EYE	An aventurine effect deep within the glaze. The goldstonelike crystals are subtle, illusive, and very difficult to detect under normal lighting conditions. Tiger Eye is seldom decorated or artist signed.
VELLUM	A soft transparent matt glaze developed within the kiln at the same time as the decoration. It is always marked "V" along with the other marks. Vellum is also decorated in modeled, incised, and painted styles. The scenic Vellums are considered very rare. Most plaques are of the Vellum type.

Company marks:

Name of the pottery and date. Also the name of the artist, either incised or painted.

R. P. C. o.

"Rookwood Pottery, Cincinnati, Ohio." The artist's monogram was included with these letters.

Still another mark used was the name and address of the factory and the date in an impressed oval.

Used in 1882. Impressed letters on a raised ribbon. This mark was used only on a special commercial item.

Used in 1882. Impressed letters on a raised ribbon.

Rookwood Pottery marks:

Another factory mark was a sketch of a kiln with two rooks. Underglaze mark printed in black was used during the first two years of operation. This trade mark was designed by H. F. Farny and was also used as Rookwood's first letterhead.

Impressed with the date. Some pieces with this mark also had the monogram of the artist.

In relief with the date. Some pieces with this mark also had the monogram of the artist.

ROOKWOOD 1882

This mark was used from 1882 until 1886, the date being changed each year.

In 1883, the name Rookwood and date were used, either alone or with a small kiln impressed.

1886

1890

1901

A list of known Rookwood artists and their monograms. This list is probably not complete. Notice that some decorators used more than one mark.

Edward Abel **E.A.** Louise Abel

Howard Altman HA

Alfred Brennan AB

Lenore Asbury LA. L.A

W. H. Breuer WHB

Fannie Auckland Fh

Arthur P. Conant [c]

Constance A. Baker CAB.

Patti M. Conant (PC)

Elizabeth Barrett

Daniel Cook .D.C.

Irene Bishop J.B.

Catherine Covalenco C C

Caroline Bonsall C.F.B.

Sallie E. Coyne S.E.C.

A. M. Bookprinter AMB

E. Berthan I. Cranch E.B.I.C.

Elizabeth W. Brain EwB

Edward P. Cranch EPC

Cora Crofton

Rose Fechheimer R.F. F

Matt A. Daly

Edith R. Felten E R. F

Virginia B. Demarest VB⊃

Emma D. Foermeyer E.D.F.

Mary Grace Denzler 〈G ▷

Mattie Foglesong �aF

Charles John Dibowski C J. D.

Laura A. Fry ⼚ ⼌

Edward Diers ⼲D.

Lois Furukawa LF

Cecil A. Duell CAD C.A.D.

Arthur Goetting AG

Lorinda Epply ⼷ ⼷

Grace M. Hall G. H

Lena E. Hanscom L.E.H. Albert Humphreys A.H.

Janet Harris JH E. T. Hurley E.T.H.

W. E. Hentschel VEH HEH Jens Jensen

Katherine Hickman JH Katherine Jones KJ

N. J. Hirschfeld JH N.J.H Flora King FK

Loretta Holtkamp LH Ora King OK

Bruce Horsfall B— William Klemm WK.

Hattie Horton H.H. F. D. Koehler K

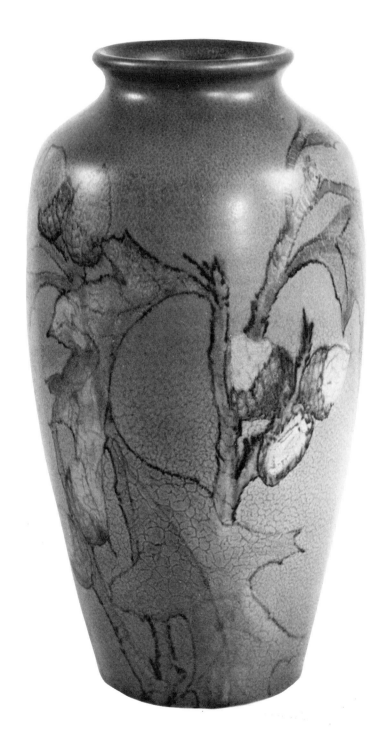

"Wax Matt" vase. Browns, greens, and reds, signed "LNL"—Elizabeth N. Lincoln, 1929, 10½ in. high. *Author's collection; Knight photo*

Sturgis Laurence *S.L.*

Sadie Markland *S.M.*

Eliza C. Lawrence *ECL*

Kate C. Matchette *K.C.M.*

Kay Ley *LEY*

Elizabeth F. McDermott *EFM*

Elizabeth N. Lincoln *LNL*

Margaret Helen McDonald *MHM* *CHB*

Clara C. Lindeman *CCL*

William P. McDonald *WPMcD* *WD* *(McD)*

Laura E. Lindeman *L.E.L.* *LEL*

Charles J. McLaughlin *JM*

Elizabeth N. Lingenfelter *L.N.L.*

Earl Menzel *EM*

Tom Lunt *TOM*

Marianna Mitchell

Helen M. Lyons *HM:*

Clara Chipman Newton *C.N*

Edith Noonan

Wilhelmine Rehm

Mary Nourse

Martin Rettig

Mary L. Perkins

Fred Rothenbusch

Pauline Peters

Jane Sacksteder

Albert F. Pons

Sara Sax

Wesley Pullman

Carl Schmidt

Marie Rauchfuss

Adeliza D. Sehon

O. Geneva Reed

Kataro Shirayamadani

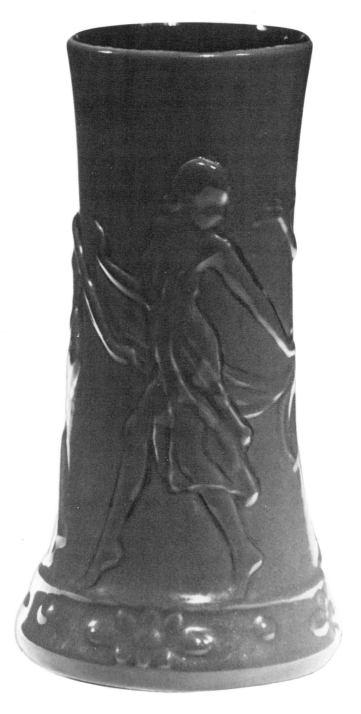

Vase sculptured and signed by Louise Abel. Maroon, 1921, 11 in. high. *Author's collection; Orren photo*

Marion H. Smalley · M·H·S· Mary A. Taylor

Amelia B. Sprague · ABS 🐙 Vera Tischler · VT

Carolyn Stegner Charles S. Todd · C.S.T. · C·S·J· · CSJ

Carrie Steinle · CS C.F.S. C.S. Sallie Toohey

MLS · M·L·N·
Maria Longworth Storer Albert R. Valentien · A.R.V.
R.P.C·O M·L·N

Harriet R. Strafer · H·R·S· Anna M. Valentien · a·m·v·

H. Pabodie Stuntz Artus Van Briggle

Jeannette Swing Leona Van Briggle · L·V·B·

Katherine Van Horne *K.H.*

Edith L. Wildman *ELW*

F. W. Vreeland *F.V.*

Delia Workum *W* *W*

John D. Wareham *JDW* *J Rw* *JDW.*

Grace Young *Ø* *GY*

Harriet Wenderoth *H.W.*

Clotilda Zanetta *C Z.*

Harriet E. Wilcox *H.E.W.* *H.E.W.*

Josephine E. Zettel *JE* *JE.* *J*

PAULINE POTTERY
1883—1905

The Pauline Pottery had its beginning in 1880 in Chicago, Illinois, when Mrs. Pauline Jacobus visited a display of ceramic art work by Sarah Bernhardt, the French actress. Being deeply impressed by what she saw, she became determined to work in ceramics herself. Mrs. Jacobus was also encouraged by her husband, J. I. Jacobus, who insisted that she go to Cincinnati to study under the supervision of Maria Longworth Nichols at the Rookwood Pottery, which was just getting under way itself. Upon her return to Chicago, she organized a class in ceramics, importing the clays from the Ohio Valley. The initial wares that were made were sent to the Rookwood Pottery for firing, which proved to be a difficult and inconvenient procedure. This inconvenience forced Mrs. Jacobus to have a small kiln built locally. Thereafter she continued to make art ware with much success. She named the company "Pauline Pottery," a name she continued to use until the closing days.

Mrs. Jacobus was continually searching for a suitable clay nearer her home than the Ohio Valley. Just such a bed of clay was soon discovered in Edgerton, Wisconsin. An old home was purchased near the clay bed and the Pauline Pottery was moved to this location in 1888. Mr. Jacobus resigned his position as a member of the Chicago Board of Trade and founded a separate plant for making commercial wares, such as porous cups for batteries for the Bell Telephone Company. Mr. Jacobus died in 1891 and, due to the invention of the dry-cell battery, this branch failed.

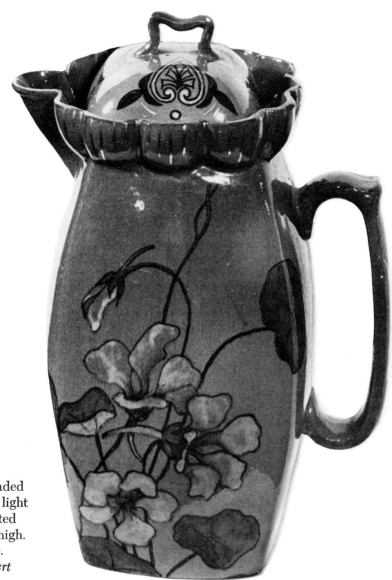

Pauline chocolate pot. Shaded
from a soft gray-brown to light
rust, yellow flowers accented
with gold, marked, 8½ in. high.
*Collection of Mr. and Mrs.
George M. Rydings; Gilbert
photo*

L. H. Towne, a lawyer, assumed control of the plant and employed
Helen Farnsworth Mears, a noted sculptress, to model statuettes that
were cast by Thorwald Samson. These were marked "Edgerton Art
Clay." In 1899 Mr. Samson returned to Denmark, his native land, and
Mrs. Jacobus retired to her country estate. She remained retired until
1902, then resumed the Pauline Pottery on the premises of her home
until it burned in 1905. She died July 6, 1930.

Pauline Pottery cookie jar. Yellow with blue outline decoration. *Middleton Collection, Wisconsin State Historical Society Museum. Madison, Wisconsin. Sketched by David Thompson.*

The earliest ware, with a yellow background, was decorated with underglaze blue painting. Later, a glaze was developed with a shaded background with underglaze slip painting, similar to Rookwood's standard glaze. The backgrounds were varied, other than the yellow

Pauline Pottery 4-in. statuette in unglazed white; marked "Edgerton Art Clay."
Sketched by David Thompson.

and brown. Some Pauline was made in dark green shaded to dark
blue, giving the effect of the vivid colors of peacock feathers. A marine
blue, shaded to cool gray, was a refreshing combination. On occasion,
even three tints were used—green to blue to a glowing rose pink.

The forms seem to emulate every style, such as English, French, German, Chinese, Japanese, and even the simple shapes of plain American crockery. Pauline was made in vases, bowls, pitchers, tableware, and statuettes. A most popular item was the teaset.

Among agents and outlets for Pauline Pottery was Tiffany's in New York, Marshall Field's in Chicago and Kimball's of Boston. Pauline pottery is on display at the Neville Museum in Green Bay, Wisconsin, and the Wisconsin State Historical Society in Madison.

Most Pauline pottery is marked on the base and is often signed by the artist.

Pauline Pottery company marks:

Impressed

Impressed

Stamped

Stamped

Stamped

Stamped

MATT MORGAN ART POTTERY
1883—1885

In 1883 Matt Morgan founded the Matt Morgan Art Pottery in Cincinnati, Ohio. Already an achieved artist, he had worked in Spain in the pottery business, then later was brought to America from England by a New York publisher.

Morgan eventually migrated to Cincinnati, where he encountered George Ligowsky, the inventor of the "Clay Pigeons." He induced him to aid in experimentation with different native clays and glazes. This venture became the Matt Morgan Art Pottery.

At first they designed Moresque-type pottery with a Spanish accent. This ware was rich in color and profusely decorated with gold. Some of the later wares resembled the early Rookwood. This is understandable since some of the fine Rookwood artists, such as Matt A. Daly and N. J. Hirschfeld, produced art work for Matt Morgan. The modeled pieces were principally done by Herman C. Mueller in conjunction with Morgan.

The company was incorporated and the stockholders desired to place the business on a commercial basis. In so doing, the artistic element, for unknown reasons, was lost and the company failed. The molds, models, and the remaining stock were disposed of at a loss. Mr. Mueller later went into the tile business and Matt Morgan finished his career as art director for a lithographic firm.

Company marks were impressed on the base with a number:

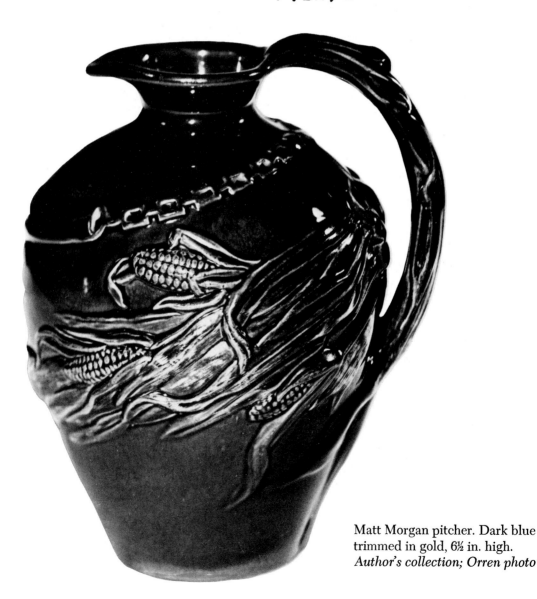

Matt Morgan pitcher. Dark blue trimmed in gold, 6½ in. high. *Author's collection; Orren photo*

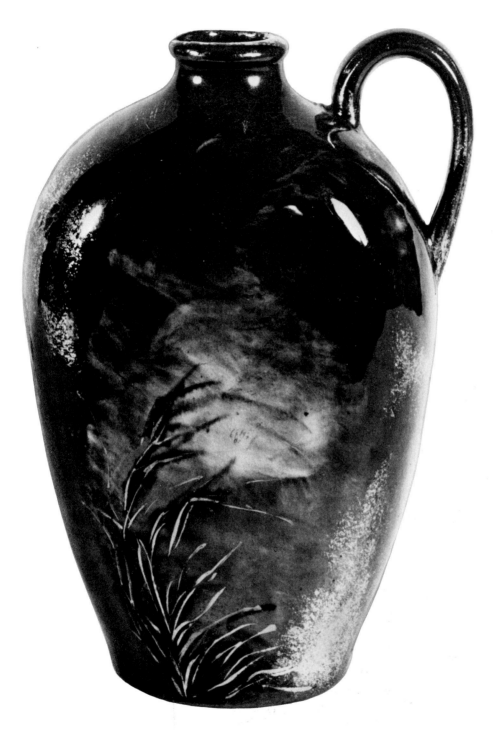

Brown jug with gold decoration. Marked with "Matt Morgan," signed by the artist, "Matt A. Daly," 6½ in. high. *Collection of Irma and Bill Runyon; Knight photo*

Artists names and monograms:

Matt A. Daly

N. J. Hirschfeld

William P. McDonald

AVON POTTERY
1886—1887

The Avon Pottery was founded by Karl Langenbeck in January of 1886, in Cincinnati, Ohio. Prior to the opening of this Pottery, Langenbeck had been associated with the Rookwood Pottery, where he had been employed for approximately one year. Avon Pottery was in existence for only one and one half years.

Langenbeck was destined to become one of America's foremost ceramic chemists. In 1895 he wrote a book entitled *Chemistry of Pottery*.

Avon Pottery made the usual ornamental pieces in graceful classical forms. These wares were decorated with both modeled and sgraffito techniques. Heads of elephants, rams, and other animals were modeled and applied as handles to many pieces of this pottery. One variety of ware was the matt glaze on yellow clay. Another was a type similar to Rookwood's standard glaze ware and their Iris ware.

Avon vase. Black stylized
trees silhouetted against a
deep rust background,
marked "Avon," 4 in. high.
*Collection of Bill G. Smith;
Gilbert photo*

Specimens of Avon Pottery are in the collection of the Pennsylvania
Museum. Each piece of this ware is marked with the company "Avon"
mark.

Avon Pottery company marks:

$$Avon \qquad Avon$$

J. B. OWENS POTTERY
1890—1929

As did other potters of this era, Owens took advantage of the fine rich
clays in the Ohio Valley.

J. B. Owens was born on a farm in Muskingum County, Ohio, De-
cember 21, 1859. The lads who grew up in this section of the country
learned the art of throwing a pot almost as early as they learned the art

of farming. Owens and George Young, of Roseville fame, grew up in the same area and each started his career in Roseville, Ohio.

Eagerness to sell made Owens a supersalesman. He took a position selling a line of stoneware for a pottery in Roseville and rapidly became the highest-salaried man on the sales force. In a short period of time he saved enough money to start a small stoneware pottery of his own. He engaged workmen to make the wares but he himself took the responsibility of selling them. Soon he had enough capital to erect a new plant in Roseville.

In 1891 a new subdivision, Brighton, was being laid out in Zanesville. Promoters of this subdivision encouraged Owens to build a new factory in this location. Owens promptly induced them to give him the land free of charge, along with $3,500 in cash. A new three-story building

Owens "Navarre" vase. Black with white decoration, stamped in green on bottom, 9 in. high. *Collection of Frances and Don Hall; Fox photo*

"Lotus" pitcher. Dark gray to light gray, 6½ in. high. *Author's collection; Orren photo*

was erected, and the company was incorporated. Owens was known to be a persuasive individual and could obtain practically anything he wanted.

At this time, he engaged Karl Langenbeck as head chemist. Karl Langenbeck, as a boy in 1873, resided in Cincinnati, Ohio. He earned his spending money by making pen and ink drawings on cards, and decorating desk sets. When he received a set of china-painting colors from an uncle in Frankfort, Germany, he turned to the art of china painting. Mrs. Maria Longworth Nichols and Mrs. Learner Harrison, two of his neighbors, were captivated by the new art, and they joined him, using his colors until they could import some for themselves. Later, Karl Langenbeck became the first ceramic chemist in America. In 1886 he founded the Avon Pottery, which he operated for one and one half years. Along with Herman C. Mueller, in 1894, he organized the Mosaic Tile Co. of Zanesville, Ohio.

Owens' enterprise expanded rapidly and, in 1896, he entered the art-pottery field. His first product was the "Utopian" ware which was

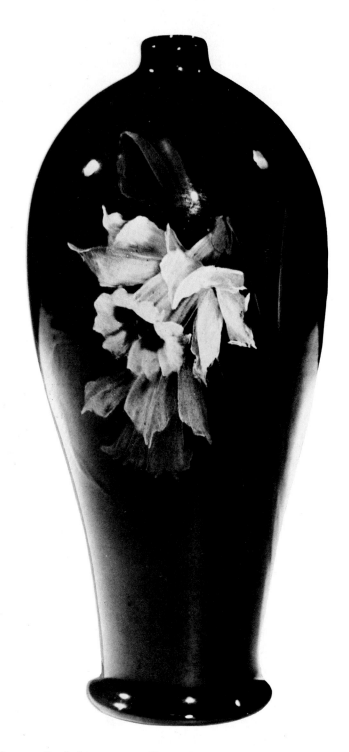

"Utopian" vase. Dark brown to yellow, signed "Dolores Harvey," 11 in. high. *Author's collection; Orren photo*

similar to Weller's Louwelsa, Rookwood's standard brown ware, and George Young's brown Rozane ware. During the decade he made art pottery, he employed the most talented artists in ceramics, including W. A. Long from the Lonhuda and Weller potteries; John Lassell, an expert in the field of iridescent glazes; John J. Herold; Hugo Herb, waxwork expert from Berlin; and Guido Howorth from Austria-Hungary. Howorth designed some Persian effects of unusual beauty. Frank Ferrel came to Owens about 1907, then later became designer for Roseville Pottery. These men were but few of the experts that were em-

"Cyrano" vase. Dark blue shaded with white decoration, not marked, 6 in. high. *Collection of Frances and Don Hall; Fox photo*

ployed by the Owens factory. It was said that Owens, in the short period of time that he made art pottery, introduced more new lines than any other potter of that period. In 1904 Owens issued a forty-page catalog, said to be the largest ever issued by an American pottery, being fourteen by twenty inches and containing eight hundred items. He duplicated every line made by his competitors and created new ones. Some of these lines were expensive to make; others so nearly copied products of other potteries, it was hard to market them. Outlets for Owens' pottery were established in New York, Chicago, and Philadelphia.

Large shipments were also sent to foreign countries, as far as Australia, the West Indies, and Brazil.

Owens stopped making art pottery about 1907 or 1908 and turned to the manufacturing of commercial tile. During his years in the art-pottery business he had won four gold medals and a grand prize (at the Lewis and Clark Exposition in Portland, Oregon, in 1905). He managed to get along quite well until his factory burned in 1928. According to Owens, only East Liverpool, Ohio, and Trenton, New Jersey, outranked Zanesville as pottery centers in the country.

Against the advice of several businessmen, he rebuilt at the beginning of the 1929 depression; as a result, he lost all his properties. He moved to Homestead, Florida, where he invested in a fifteen-acre citrus grove. Owens died in 1934.

Owens art pottery is almost always marked; however, there are exceptions.

Owens marks, impressed on the base of each item:

J. B. OWENS
UTOPIAN
1031

OWENS
UTOPIAN
214

OWENS ART
UTOPIAN
1129

owens
VTopian
1060

OWENS FEROZA

HENRI
DEUX

UTOPIAN
J.B.OWENS *MISSION* *OWENS*
 123

Artist names and monograms:

Estelle Beardsley Harrie Eberlein *HE*

Edith Bell *EB* Hattie Eberlein *HE*

Fanny Bell *FB* Cecil Excel *CE*

A. F. Best Charles Gray *G*

Cecilia Bloomer *B* Martha E. Gray *M.G.*

Lillian Bloomer *LB* Delores Harvey *D.H.*

Cora Davis *C.D.* Albert Haubrich *R Haubrich*

W. Denny *WD* Roy Hook

H. Hoskins

Hattie M. Ross

Harry Larzelere

R. Lillian Shoemaker

A. V. Lewis

Ida Steele

Cora McCandless

Will H. Stemm

Carrie McDonald

Mary Fauntleroy Stevens

Miss Oshe

Mae Timberlake

Mary L. Peirce

Sarah Timberlake

Harry Robinson

Arthur Williams

Owens Pottery line names, with approximate dates of presentation and descriptions:

ABORIGINE 1907
ALPINE 1905

Indian-type pottery.
Matt finish on soft shaded background with freehand slip decoration. Each has a white top, like a snow-capped mountain.

AQUA VERDI 1907 Embossed classical figures and designs with semigloss in green glaze.

ART VELLUM WARE 1905 A delicate velvetlike finish in warm, exquisite shades of autumn foliage.

"Lotus" vase. Light blue-gray with pink and green decoration, matt glaze, marked "Owens Lotus," 5 in. high. *Author's collection; Knight photo*

CORONA ANIMALS 1905

Figures of animals for both indoor and outdoor use. These were in natural colors ranging from 4½ to 43 inches in height, including dogs from dachshund to Great Danes in their natural sizes.

CORONA WARE 1904

The decoration of this ware resembles the many varieties of bronze wares in form and decoration.

CYRANO 1898

Sgraffito designs with incisions filled with clay in the manner of lace. Very similar to Weller's Turada.

"Matt" vase. Pastel colors, 13½ in. high. *Author's collection; Orren photo*

DELFT 1904

Old Holland bucket shapes ornamented with Dutch scenes in shades of blue.

FEROZA 1902

Ware with iridescent glaze. Similar to Weller's Sicardo.

GUNMETAL WARE 1905

Ware with a glaze resembling the rich, dull surface of gunmetal with decorations etched in delicate designs.

HENRI DEUX 1905

An inlaid process similar to some French pottery and Stallmacher Teplitz, Austria.

LOTUS 1900

Under-the-glaze slip painting. Similar to Weller's Eocean.

MATT UTOPIAN 1905

Soft matt finish ware with slip decoration. Usually found in light colors.

MISSION 1903

Western landscapes and churches applied by hand with a splashed effect. Each piece was fitted with a wooden stand.

NAVARRE 1905

Dark background with white enameled figures.

OPALESCE INLAID 1905

This ware has a background in solid colors of green or other light shades. Wavy lines are traced in gold, silver, or bronze with floral decorations inlaid in colors and outlined in black. This ware was made to duplicate to a certain extent the Italian Vermiculated designed ware of the sixteenth century.

OPALESCE UTOPIAN 1905

This ware was coated with gold, then overlaid with small coraline-like beads with slip decoration on one side.

RED FLAME 1905

Embossed flower decoration with red glaze.

RUSTIC 1904

Rustic looking or as if decorated with trees and stumps.

SOUDANEZE 1907

Ebony black ware with pastel color inlaid slip decoration.

SUNBURST 1906

A Utopian-type ware with a high-gloss glaze with the background sponged on. Similar to Weller's Aurelian.

UTOPIAN 1896

High-glaze brown ware with under-the-glaze slip painting. Similar to Weller's Louwelsa, Rookwood's standard brown ware, and Roseville's Rozane brown ware.

VENETIAN 1904

This ware features a metallic glaze with iridescence intensified by depressions or elevations on the surface.

WEDGWOOD JASPERWARE 1903

Very similar to the English Jasperware and Radford's Jasperware.

"Cyrano" vase. Dark brown shaded with yellow, white decoration with blue flowers, 6½ in. high.
Author's collection; Knight photo

GRUEBY POTTERY
1891—1907

In June of 1891, the Grueby Faïence and Tile Company was fully organized in Boston, Massachusetts, by William H. Grueby, George Prentiss Kendrick, and William H. Graves (as treasurer). George Kendrick was an artist and modeler and perhaps most of the animals that were sculptured can be attributed to him. However, some of the statues were executed by Frederick G. R. Roth.

William Grueby was apparently inspired by the fine display of French pottery at the Columbian Exposition of 1893. This inspiration was the beginning of his career in the art-pottery field. From the outset he created stylistic molded designs with leaves and flowers in relief. This ware was completely handmade of a semiporcelain body, covered with an opaque lusterless glaze which gave a smooth satiny matt finish. A cool cucumber green was the color most often used. However, a few other colors, such as yellow, blue, and pink, were also utilized.

Since Grueby art pottery was completely handmade and in production for only a decade, and being quite expensive to produce, the amount reaching the public market was relatively small. Because of the fine quality of this pottery, its influence was felt all over the United States. Van Briggle copied this finish in 1901 and Teco Ware also copied the finish a year or two later.

Many beautiful architectural tiles were created. One such fascinating set of tiles, depicting four Apostles, was used in the Cathedral of Saint John the Divine in New York City. It may also be interesting to note

Grueby pottery tile. Tiffany mounted, designed by Le Boutillier, green on green with white tulip, 6½ in. square. *Collection of Irma and Bill Runyon; Knight photo*

that L. C. Tiffany purchased Grueby pottery, prior to the manufacturing of Tiffany pottery, to be further embellished by metals to form lamps, tea tiles, inkstands, and the like.

Grueby was one of the several prominent art potteries exhibiting wares in the Art Palace at the St. Louis Exposition of 1904. Another important pottery whose name appeared in a catalog distributed by the Exposition was the Poillon Pottery of Woodbridge, New Jersey. Their monogram was two Ps joined together, one being upside down. Another pottery listed was the Merrimac Ceramic Co. of Newburyport, Massachusetts, which was established in 1897. Their mark was the word "MERRIMAC."

Among studio potters, not connected with any particular pottery, who exhibited some of their own creations were: Charles Volkmar, New York City; Mrs. Adelaide Alsop Robineau, Syracuse, New York; Anna B. Leonard, New York City; and L. C. Tiffany, who was just beginning to experiment in the pottery field. Several pieces were exhibited by Charles F. Binns, who was director and instructor at the New York State School of Clay-working and Ceramics, at Alfred University in Alfred, New York. All of these potters and artists are considered by historians to have had a great impact on the art-pottery movement in the United States. Their contribution and participation in this field should certainly be given due recognition.

Grueby vase. Two shades of lush green, impressed mark, 5½ in. high. *Author's collection; Knight photo*

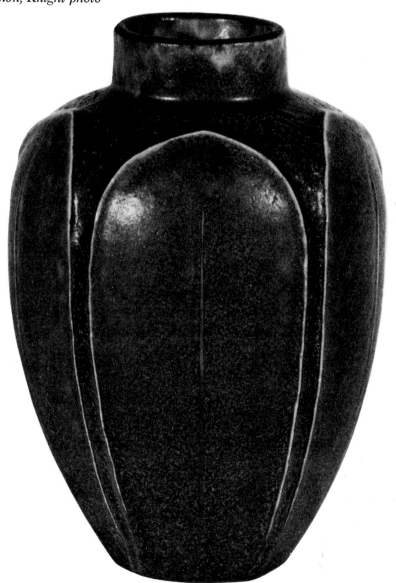

Grueby ware was always marked and generally signed by the artist. After the closing of the Pottery, Mr. Grueby was employed by the C. Pardee Works, Perth Amboy, New Jersey, as manager of the faïence department.

Artists and their monograms:

Ruth Erickson	Æ	Norma Pierce	A
Ellen R. Farrington	E R F.	Wilhelmina Post	W W.P.
Le Boutillier	D	Gertrude Priest	℗
Florence S. Liley	℄	Marie Seaman	S M.S.
Anna V. Lingley	A	Gertrude Stanwood	S
Lillian Newman	Ⓝ	Kiiche Yamada	KY

Company marks, impressed:

**GRUEBY POTTERY
BOSTON U.S.A**

**GRUEBY
BOSTON MASS.**

GRUEBY

Grueby faïence decorative tile inserts

Grueby faïence decorative tile inserts

A. RADFORD AND COMPANY
1891—1907

In the latter part of the nineteenth century, when the peoples of Europe were migrating to this land of opportunity, many day-laborers aspired to become American businessmen. From England, where potteries and glassworks flourished, came talented artists who were destined to gain fame and fortune in the United States. One such artist was Albert Radford, who was born in Staffordshire, England, on November 10, 1862.

Albert Radford arrived in this country aboard the *Hanoverian* on September 10, 1882. He was soon employed by the Haines (or Haynes) Pottery in Baltimore, Maryland. Approximately three years later, his parents, Mr. and Mrs. Edward Radford, arrived in the United States.

In September 1886 the Radfords moved to Trenton, New Jersey, where Albert took a position with the Eagle Pottery. In 1889, while working at the Eagle Pottery, he won a bronze medal at the Philadelphia Exposition. The actual award was a bronze medal or thirty-five dollars in cash, but which one he accepted is not known.

Albert Radford built his first Pottery in Broadway, Virginia, where the initial kiln was drawn March 19, 1891. About 1893 Radford moved to Tiffin, Ohio, where he erected a Pottery with one kiln on the back of his property. It was at Tiffin that Radford created his finest art pottery. This ware, which is known as "Radford Jasper," is very

similar to the Wedgwood type made in England. Radford's Jasper was decorated with the "sprigged-on" decoration, a skill he acquired while working for Wedgwood. According to Fred W. Radford, Albert's grandson, every piece of Radford Jasper made at Tiffin, Ohio, was created by his grandfather personally. No one else in the United States, at that time, possessed the skill to produce this type of ware with the cameo-type decoration. This ware was fired at an extremely high temperature, exceeding well over 2450 degrees Fahrenheit. The cameo-type decorations were first modeled and then a mold was made in plaster of Paris or some other suitable material. Then, when firm enough to handle, they were stuck (sprigged on) to the wet unfired clay body and then fired. The slightest contact was a firm commitment, as the cameos could not be moved after the initial contact. The background colors of this ware, made at Tiffin, were royal blue, light blue, olive green, and dove gray. These were decorated with white figures and other subjects in white. The forms are very reminiscent of the English Wedgwood. Lucky indeed, is the collector who has a specimen of this Tiffin Radford in his collection, for it is very rare.

Radford moved from Tiffin to Zanesville, Ohio, about 1898, where he was known to have been employed by Weller as a modeler. He also

Albert Radford at work in the modeling room of the S. A. Weller Pottery, Zanesville, Ohio. *Courtesy of Fred W. Radford*

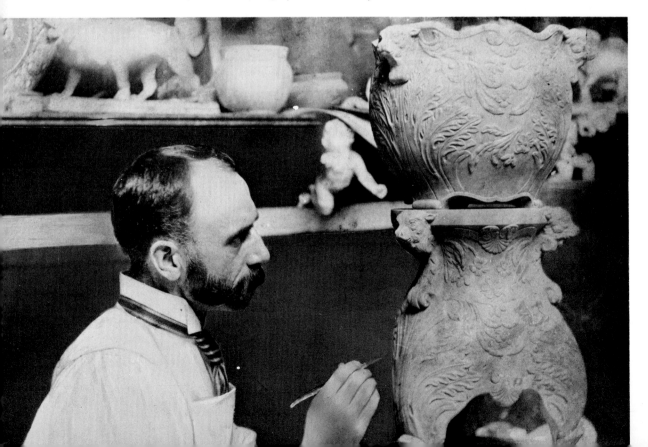

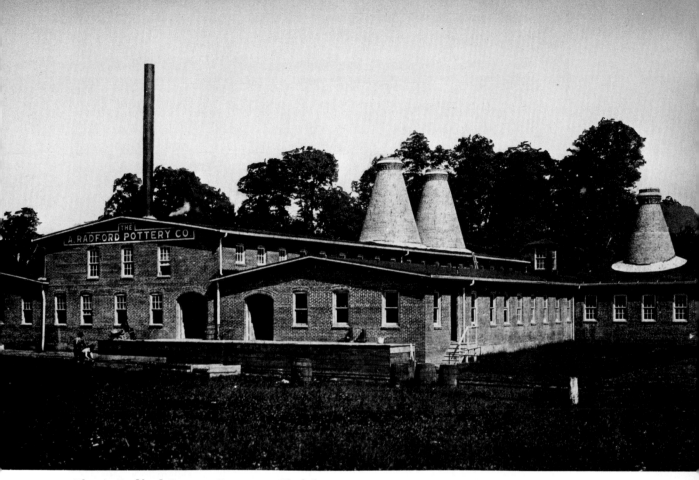

The A. Radford Pottery Company, Clarksburg, West Virginia, in 1904. *Courtesy of Fred W. Radford*

worked for the Zanesville Art Pottery as foreman of the art department. Here, a ware was made called "La Moro," which is very similar to Weller's Louwelsa. Radford also is known to have worked for the Owens Pottery. Some of the early specimens of Peters and Reed are decorated with sprigged-on cameos and garlands of flowers against a dark brown background, then covered with a gloss glaze. The high glaze tends to hide the fine detailed workmanship of the cameo work. We feel it almost a certainty that Radford did these fine pieces.

According to family records and dates involved, the Pottery Radford built in Zanesville was constructed for the Arc-En-Ceil Company. Evidently there was some sort of agreement that Radford would turn over the buildings to them as soon as the new Radford Pottery, then under construction at Clarksburg, Virginia, was completed. In the latter part of 1903 Radford moved to his new location and the contract with the Arc-En-Ceil Company was fulfilled.

The ware made in Zanesville was a fine vitrified ware decorated with the classic cameo-relief figures in white. This ware was often further ornamented with an overlay of contrasting colored clay, resembling tree bark or orange peel, either in matt or semimatt finish. This type of decoration was usually done in brown, black, tan, green, or gray with contrasting backgrounds in lighter shades of pink, blue, green, dove gray, and tan. Small pieces did not have the bark decoration and some larger articles, such as tankard pitchers and mugs, were made without the bark.

The formula for making this ware differed completely from the ware made at Tiffin. The Zanesville Radford ware was fired at 2250 degrees Fahrenheit, a much lower temperature than the Tiffin ware. The Zanesville Jasper was never marked with the name Radford, but each bears an incised number which was assigned to each different model. All Radford that was made at Zanesville is of the bisque type and is vitrified. In other words, it is of such hardness that it will hold water without the use of a surface glaze to make it waterproof.

The Radford Pottery at Clarksburg, Virginia, began operations in the fall of 1903. Albert Haubrich, who had been a decorator for Weller, was given the position of manager of the decorating department. Haubrich had also worked for the Owens Pottery and was considered quite a talented artist. The Radford Pottery was in operation for only

Radford pottery vases. *Left to right:* Blue with dark brown glazed "bark" and white figures, no. 18, 6½ in. high; light blue with white figures, no. 55, 3½ in. high; beige with dark brown matt "bark" and white figures, no. 18, 6½ in. high. *Author's collection; Johnson photo*

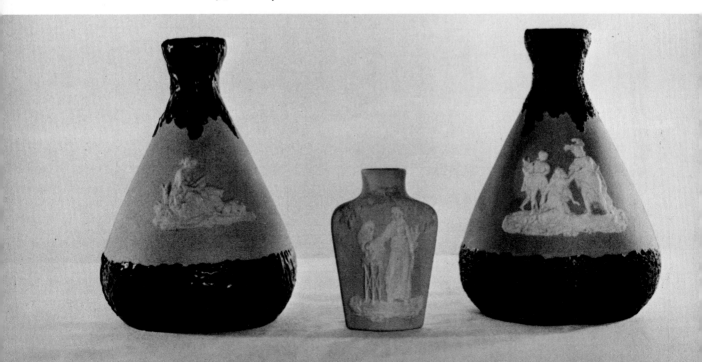

Zanesville Art Pottery's "La Moro." *Left:* Shaded brown to yellow and green, yellow flowers, marked, 2 in. high. *Right:* Green shaded to yellow, red flowers, marked, signed "A.E.," 7 in. high. *Author's collection; Knight photo*

a few months when disaster struck. Albert Radford suffered a heart attack and died August 4, 1904, at the age of 41.

The types of ware produced at Clarksburg were called "Ruko," "Radora," and "Thera." The Ruko is a duplication of Weller's Louwelsa and has the name Ruko impressed in the base. Radora is a green matt-glaze ware that was created by Albert Edward Radford (Albert's son) who at one time had been employed by the Roseville Pottery. His talents had been utilized there in the glaze-mixing department. The exact description of Thera is unknown, but is thought to be one of the brown-ware type.

Radford had planned to make the Jasperware at the Clarksburg plant but, due to his early death, it was never produced at this location.

Radford was succeeded by W. J. Owen, a salesman who worked for the J. B. Owens Pottery in Zanesville, and he in turn was succeeded by O. C. Applegate. The plant ceased production of art pottery about 1907 and failed shortly afterwards.

Albert Edward Radford, a son of Albert Radford, was born in Trenton, New Jersey, in 1887 and during his life has worked in American potteries for almost fifty years. He is the seventh generation of Radford potters. Fred W. Radford, a son of Albert Edward and grandson of Albert, is the eighth generation of potters, for he is, in a manner, carrying on the tradition. In his spare time he is making reproductions of the Jasper ware, of the type made in Zanesville by his grandfather. These are molded from the original pieces, using the original formula. The results are beautiful works of art made by a gifted craftsman and will enhance any collection of American art pottery. All pieces are and will be properly marked. The mark is impressed with a die and shows the following: "An A. Radford Reproduction by F. Radford." The article bears the original number with the sequence of production beginning with 001 and the month and year, 6 69. Mr. Radford states that positively no numbers will be duplicated. The reproductions are somewhat smaller than the originals due to shrinkage in the kiln. Production of these will be limited since Radford cannot possibly produce more than five or six, at the most, in any one week, and he doesn't know how long he will continue this project.

Under the management of John Lassell, the Radford company became the Arc-En-Ceil Pottery (1903–05).

Arc-En-Ceil pottery is noted for the gold luster glaze. It was made in pitchers, vases, dresser bottles, small decorated items, and the like.

Between 1905 and 1907 the factory operated as the Brighton Pottery.

Arc-En-Ceil mark stamped in ink

ROSEVILLE POTTERY

1892—1954

The year 1890 was a depression year and the Youngs, Anna and George, were struggling desperately to get along financially. George Young was born in Washington County, Ohio, on February 24, 1863, and spent a portion of his early years as a schoolteacher. Later, he made an attempt at selling Singer Sewing Machines while Anna was trying her luck at selling millinery. Neither venture appeared to be very successful; consequently, George relinquished his position with Singer. He decided there was more demand for pottery and therefore made an investment in a pottery in Roseville, Muskingum County, Ohio, just eleven miles south of Zanesville.

The perfect clays of the Muskingum Valley, along with the plentiful supply of natural gas and coal, were inducive to potting. Potteries sprang up by the score in the area, some of them growing to be of great importance. One of the most productive and best known, worldwide, was George Young's and his "Roseville."

On January 4, 1892, the firm was incorporated. George Young was elected secretary and general manager, C. F. Allison, president, J. F. Weaver, manager, and Thomas Brown, treasurer. The company began prospering almost immediately; and in 1895 they acquired a new plant in Roseville and expanded the manufacturing of stoneware.

In 1898 the company moved to Zanesville, purchasing the Clark Stoneware Company on Linden Avenue. Peters and Reed were operating a pottery at this location but were forced to move to a new plant. A year later, in 1899, Young built a three-story building on this site.

The company continued to operate under the name "Roseville." By 1900 Young was ready to capture some of the profits claimed by other Ohio potters.

Ross C. Purdy, an artist, was hired to develop an art line. He created a line with a high-gloss glaze, with under-the-glaze slip painting, which was named "Rozane Royal." Some of these were dark while others were in pastel colors. These subjects on clay are oftentimes as bold as oil

Roseville "Rozane Royal" vase. Dark brown shaded to yellow, decorated in natural colors, 9 in. high. *Author's collection; Orren photo*

paintings, other times as pale as water colors. The dark was very similar to Weller's Louwelsa, Rookwood's standard glaze ware, and Owens' Utopian. One must look for the mark before becoming positive just which company manufactured it. Since the artists migrated from one pottery to another, you will find some Rozane Royal pieces signed by artists whose names will also appear on other Ohio pottery.

In 1900 Roseville hired John J. Herold, who had worked for both Weller and Owens, to take over as art director and designer. Herold

"Rozane Egypto" vase. *Left:* Lush green, marked with a wafer, 12½ in. high. *Author's collection; Knight photo.* Roseville "Rozane Mongol" vase. *Right:* Silver overlay. Marked in wafer "Rozane Ware Mongol," 10 in. high. *Collection of Frances and Don Hall; Fox photo*

was responsible for the "Rozane Mongol," with its difficult-to-produce, dark red crystalline glaze. This is a solid red glaze and, on occasion, is found with a silver overlay. His exhibits won first prize at the St. Louis Exposition in 1904. In 1908 Herold left the Roseville Pottery to organize the Herold China Company at Golden, Colorado. Later this firm became the Coors Porcelain Company.

In 1901 the Roseville Company acquired a fourth plant, the old Mosaic Tile Company auxiliary at Muskingum Avenue and Harrison Street, in Zanesville. Cookware was made in this plant, which kept four kilns operating and approximately fifty men employed. By 1905 the company had 350 people on its payroll with an annual output of five hundred thousand dollars in merchandise.

Young employed all available talent. In 1902 Christian Neilson, who was born in Denmark in 1870, worked at the Roseville Pottery. Neilson

Group of "Rozane Fugi" vases, tan and brown trimmed in blue and brown. *Left:* Unmarked. *Center:* Two vases as pictured in Rozane catalog. *Right:* marked "Fugiyama" in green on base. *Collection of Dr. and Mrs. Gordon Gifford; Mesre photo*

had studied sculpture at the Royal Academy of Art at Copenhagen before coming to the United States in 1891. In 1894 he went with the American Encaustic Tiling Company in Zanesville, but remained there only a short time. He then migrated to Roseville where he remained until 1906. He was responsible for the "Egypto" figures and some of the "Della Robbia" patterns that pictured seventy-five different designs in the catalog.

Frederick Hurten Rhead was a guiding influence at Roseville from 1903 until 1908, at which time his brother, Harry W. Rhead, became

art director. Frederick Hurten was a son of Frederick Alfred Rhead, who was employed by Weller during this same period. Perhaps this explains why Rozane Mara and other Rozane lines were copies of Weller lines. By 1911 Frederick Hurten Rhead had migrated to California, where he aided in organizing the Arequipa Pottery for patients in a tuberculosis sanatorium.

Rozane became popular and sold well. Every time Weller or other Ohio potteries would produce a new line, Young would produce a comparable one. When Weller introduced his Dickens Ware, Young intro-

"Rozane Royal" creamer. Slip decorated in blue, marked "RPCo," signed by Grace Young, ca. 1900, 3½ in. high. *Author's collection; Orren photo*

duced not one, but three, similar lines. "Rozane Woodland" and "Rozane Fugi" in 1904, and "Della Robbia" in 1906. All these lines are the sgraffito type. In 1904 the "Mongol" pattern was introduced as well as a beautiful line named "Olympic." This line was decorated with Grecian figures in white, on a dark red background, outlined in black. The decoration was not hand done but apparently a printed technique was used. This pattern is extremely rare, perhaps the rarest of the Roseville lines.

Weller then introduced his Sicardo, which was supposed to be a secret process. Young retaliated with "Rozane Mara," which was an

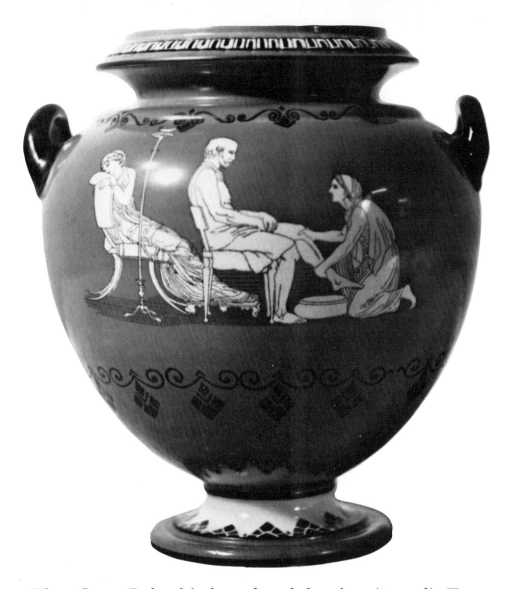

"Olympic" vase. Dark red background, marked on base (stamped), "Rozane Olympic Pottery" and "Turyclea Discovers Ulysses," 11 in. high. *Collection of Frances and Don Hall; Fox photo*

iridescent metallic line and more varied in color than Sicardo. Mara had the deep reds and purples, and also came in a pearl white with pastel designs as changeable as a seashell. It was quite elegant with the predetermined design developed within the iridescence. Practically all Mara is unsigned and consequently is often mistaken for unsigned Sicardo. Roseville also added a Japanese influence to the art lines by hiring Gazo Foudji, formerly of Paris. He was given his own studio where he perfected Rozane Woodland and Rozane Fugi. These lines were decorated in the sgraffito method with the designs covered with a gloss glaze, with a soft matt-finished background. These were usually done in russet autumn hues.

Although Young introduced a new line every time his competitors did, he did not make his lines in as vast a quantity as did the other potters. Some lines were never in mass production, just a few being made on special order. Some pieces were further embellished with silver overlay.

Harry W. Rhead, an Englishman, succeeded Herold as art director in 1908. It was he who, in 1914, developed the "Pauleo" line, named for Young's daughter Leota and his daughter-in-law Pauline. In going through the material on the Roseville Pottery at the Ohio Historical Society in Columbus, the formula for Pauleo was made available. It denoted two types. Type one entailed covering the ware with a red metallic luster glaze. Type two described a finish with a marbleized cover. The entire recipe was given for making both these lines.

Roseville vases. *Left to right:* "Donatello" with high glaze, light green with tan background in band, 8 in. high; "Mock Orange" (marked) green, 9 in. high; "Ixia," as shown in catalog, tan shaded with cream, 7½ in. high. *Author's collection; Johnson photo*

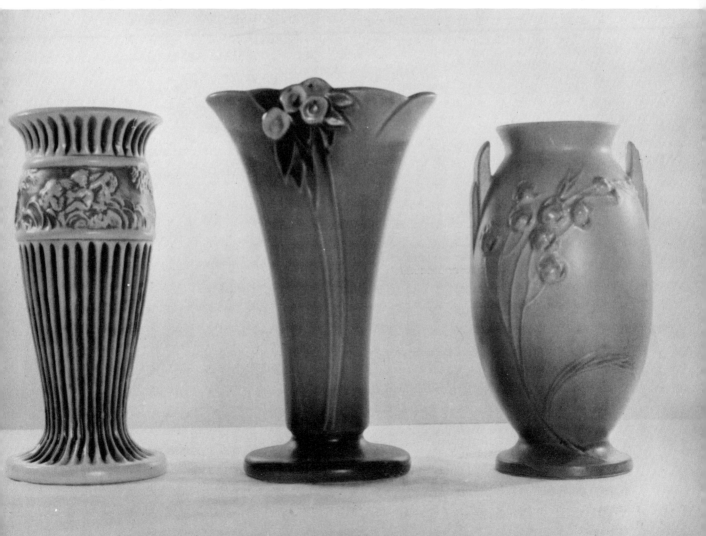

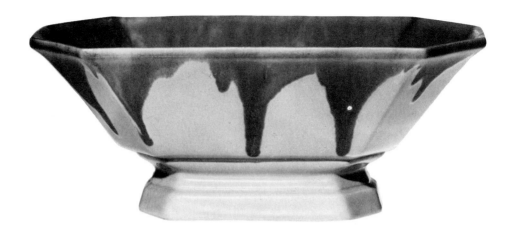

"Carnelian" bowl. Blue and pink, marked "v" in loop of "R," ca. 1917, 4½ in. high, 7 in. by 9½ in. *Author's collection; Orren photo*

Although every piece we have seen in type two has been yellow, it is possible that other colors also exist.

Rhead also designed several popular lines that were less expensive and more widely distributed. He created a line called "Donatello," with frolicking cherubs in panels separated by trees. Each piece is fluted at both top and bottom. Colors are light green and tan against a white background. Donatello was a great favorite with the public and was constantly in demand. This line was made for a decade and was produced in as many as a hundred different shapes and sizes, thus becoming one of Roseville's successful lines.

By 1910 Young had closed the two plants in Roseville, but had retained the two in Zanesville. The Linden plant was busy making the art lines while the Muskingum Avenue plant produced the commercial lines. In 1917 the Muskingum plant burned and all operations moved to the Linden site. At about this time (1919), Russell T. Young became director, succeeding his father, and George Krause, a native of Germany, became technical supervisor. Frank Ferrel took Rhead's position as art director.

During the Ferrel period, Roseville pottery was developed at the rate of two or more patterns each year. The "Dogwood" was a popular line among his first floral designs. His most popular line was "Pinecone," which he developed when he worked for Weller, although

Weller had rejected this particular line as being a poor gamble. Later, Ferrel redesigned the Pinecone pattern for Peters and Reed and named it Moss Aztec. Still later, he redesigned it once again and called it Pinecone, which became the most popular line ever designed at Roseville. It was made in seventy-five different shapes and sizes and came in an array of colors—brown, blue, green, and pink. The rarest of these colors is the pink. The Pinecone pattern sold well for fifteen years and consequently was a contributing factor in the company achieving a million-dollar-a-year business.

In 1932 Mrs. Anna Young became president of the Roseville Pottery, following her son. Most people who traveled Route 40, near the western part of Zanesville, in the 1930s and early 1940s will remember well the tearoom and the showrooms Mrs. Young had built. It was a most popular resting place for the weary traveler. After Mrs. Young's death in 1938, her son-in-law, F. S. Clement, became president and served until 1945; he was followed by his son-in-law, Robert Windisch, who held the office until Roseville closed in 1954.

In the waning years, to reduce the cost of production, and in an attempt to stimulate sales, Roseville turned to a glossy glaze instead

Roseville vases. *Left to right:* "White Rose," tan, embossed mark, 6 in. high; "Carnelian," green with tan drippings, paper label, 8 in. high; "Sunflower," tan with yellow flowers, paper label, 6 in. high. *Author's collection; Johnson photo*

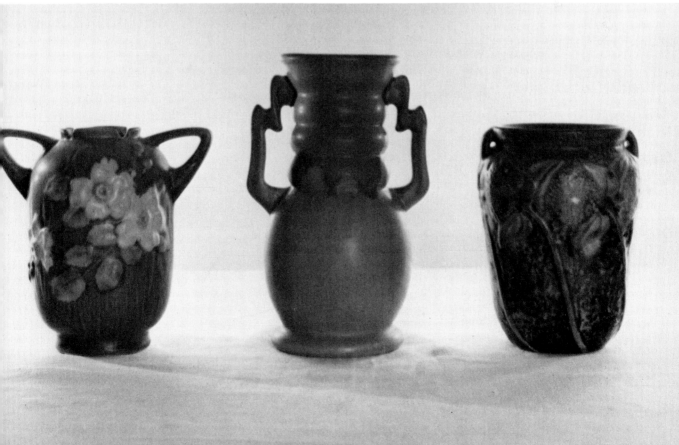

of the traditional matt finish. The transition was called "Wincraft." Although it was quite artistic, it did not please the public, consequently, sales began to decline. The Pinecone pattern, along with other patterns that had previously sold well, was included in the Wincraft line.

In 1952 Roseville developed a fancy oven-proof tableware called "Raymor." This line came in covered casserole and serving dishes with ultra-modern shapes. This also proved unsuccessful and the company failed. Operations were closed down and the plant was sold to the Mosaic Tile Company. One might place part of the blame for failure on the tremendous increase in the manufacture of plastic articles during this period. Plastics could be purchased at a much lower price and had the added convenience of being almost unbreakable.

The Roseville Company enjoyed a long and productive life. During the late period of operation, Roseville made vast quantities of pottery, including a variety of colors and sizes in pitchers, vases, baskets, bowls,

"Donatello" vase, 8 in. high. *Author's collection; Orren photo*

Left: "Rozane Royal" pitcher. Teal blue shaded dark to light with pink and yellow berries, signed by M. Myers, ca. 1900, 10½ in. high. *Author's collection; Knight photo. Right:* "Wincraft" vase. Green lined in chartreuse, ca. 1952, 9 in. high. *Author's collection; Orren photo*

teasets, and all sorts of vessels for making flower arrangements. Practically all department stores and catalog houses sold Roseville. Incidentally, it may be interesting to note that the S & H Green Stamp Centers redeemed stamps for Roseville pottery during the late period.

The Roseville Company adopted a regular system of marking their wares. Paper labels alone were used on some pieces, especially in the early and middle periods. Many of these labels have long since gone the way of all paper labels, which accounts for many pieces turning up unmarked. The name "Rozane" was dropped about 1917, but during the period Rozane Royal was made, no definite records were kept of the artist's signatures, although much of it is artist signed.

Early period marks, 1900-18:

[During the first period, the marks were not consistent. Some pieces were marked with raised disks; on some, the line name appeared in a ribbon under the disk. Other pieces carried marks impressed or stamped in dark color; while still others bore no mark at all, having only paper labels.]

Raised disks with raised lettering

RPCO RVPCO ROZANE
RPC

All impressed

Rozane Pottery

Stamped in black on Olympic line. Also includes title of decoration

Rozane
RPCO

Impressed

Rozane
67-B
RPCO

Impressed

Roseville Rozane Pottery

Stamped on
Rozane Pattern

Earliest paper label. Dark with dark
lettering. Embossed. Does not include
the R with the V in the loop

Jugiyama

Stamped on Rozane Fugi

Middle period marks, 1918-35:

[During this period many pieces were unmarked except with paper labels. Some patterns may appear marked two or three ways. For instance, the Donatello line is found marked in three ways: paper label, the RV mark, or the Donatello line name.]

Roseville
858 - 8"

Incised with pattern
number and size

Printed

Impressed

Paper label.
Black on silver.
Includes the RV mark

R

Printed

Late period marks, 1935-54:

[These marks are in high relief with "U.S.A." added. Also bears
the pattern number and size in inches.]

Roseville
USA
1 BK - 8"

Appears on
baskets

Roseville
U.S.A.
858-8"

R USA
138-4"

On small
pieces

156
raymor
by Roseville
USA

Circa 1952

Roseville
USA
934-10"
MOCK ORANGE

Pattern number and size.
Line name added

A partial list of artist names and monograms found on Rozane Ware:

V. Adams VA

Jenny Burgoon

Anthony Dunlavy AD

Charles Duvall

Frank Ferrel F.F.

Gazo Foudji

Gussie Gerwick G

Madge Hurst MH

Josephine Imlay J.I.

Mignon Martineau

L. McGrath

Lillie Mitchell L M

M. Myers m-m

Grace Neff F. Steel

Hester Pillsbury **HP** Tot Steele **S̶**

Lois Rhead Mae Timberlake **M T**

Frederick Hurten Rhead Sarah Timberlake **S. T.**

Helen Smith Arthur Williams **AH**

Roseville Pottery line names, with approximate dates of presentation, and descriptions:

APPLE BLOSSOM 1948	Natural springlike apple blossoms with the brown stems curling to form handles.
AZTEC 1916	Slip-decorated ware similar to Newcomb pottery.
BANEDA 1933	Band around center of vessel with cherries and small flowers. Solid background color.
BITTERSWEET 1940s	Natural blossoms with stem handles. Various background colors.
BLACKBERRY 1933	Natural blackberries on a very soft matt finish. Various background colors.
BLEEDING HEART 1938	Natural blossoms on various background colors.
BLUE WARE 1910	Similar to Weller's Blue Louwelsa.
BUSH BERRY 1948	Hollylike leaves and berries. Various background colors.
CAMEO 1920	Similar to Donatello with dogs and classical figures in the bands.
CARNELIAN 1910-15	One glaze running down over another. Classical style in various colors.
CHERRY BLOSSOM 1933	Natural blossoms on various background colors.

"Clemana" vase. Light green,
8 in. high. *Author's collection;*
Johnson photo

CLEMANA 1934	Stylized blossoms on basket-weave background. Various colors.
CLEMATIS 1944	Natural blossoms on various background colors.
COLUMBINE 1940s	Natural flowers on various bicolor background colors, usually shaded from one to another, such as brown to green.
CORINTHIAN 1923	Similar to Donatello with flowers in the bands. Ribbed.
COSMOS 1940	Natural blossoms. Various background colors.

"Baneda" vase. Pink with blue
band, paper label, ca. 1933,
4¼ in. high. *Author's collection;*
Orren photo

Left: Marked "Rozane" pitcher. Brown to yellow, 5 in. high. *Right:* Marked "Rozane Royal" vase. Signed by artist, "M. Myers," dark brown with yellow shadings and orange flowers, ca. 1900, 12½ in. high. *Author's collection; Orren photos*

CRYSTALIS (ROZANE) 1910-15	A crystallized glaze resembling ice on a window pane. Salt crystals. Various colors.
DAHLROSE 1924-28	Daisylike band of flowers around top with mottled background. Various colors.
DAWN 1937	Spiderlike flowers against solid-color background.
DELLA ROBBIA (ROZANE) 1906	Incised designs with allover high-gloss glaze. Made in 75 different patterns. Similar to Weller's Dickens Ware with high-gloss glaze.
DOGWOOD I 1916-18	Natural flowers. Various background colors.
DOGWOOD II 1928	Similar to Dogwood I except has the later mark and detail not as sharp.

DONATELLO 1915	Light green fluted top and bottom with a band of frolicking cherubs in panels separated by trees. Background color in the panels light brown.
EARLAM 1930	Similar to Weller's Golbrogreen.
EGYPTO (ROZANE) 1905	Shape and decoration resembling old Egyptian art. Finish is shades of soft green matt.
FALLINE 1933	Stylized designs with triangles around top rim and peapod-shape designs near the bottom. Various background colors.
FERRELLA 1930	Mottled glaze with small flowers in a line around the rim. Reticulated. Various background colors.
FLORENTINE 1924-28	Panels of flowers with cascades of fruit and leaves between the panels. Various background colors.
FOXGLOVE 1940s	Natural flowers. Various background colors.
FREESIA 1945	Natural flowers. Various background colors.
FUCHSIA 1939	Natural flowers. Various background colors.

Roseville vases. *Left to right:* "Morning Glory," white background with purple and yellow flowers, early paper label, 8½ in. high; "Wisteria," blue, tan mottled background with natural color flowers, marked "R," 8 in. high; "Gardenia," silver gray shaded in pink, embossed mark, 8½ in. high. *Author's collection; Johnson photo*

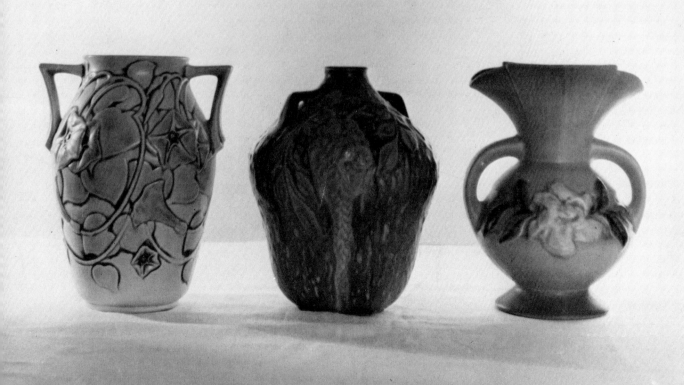

FUGI (ROZANE) 1904	Same technique as Rozane Woodland. Sometimes trimmed with dots and studs and wavy lines. Matt-finished background. Detailed decorations are in high gloss.
GARDENIA 1940s	Natural flowers. Various background colors.
GREMO 1920s	Solid-color matt-finish background shading from red to yellow to green.
HOLLAND 1930	Dutch boy and girl on light-colored stoneware-type pottery.
HOLLY 1930s	Natural leaves and berries. Various background colors.
IMPERIAL I 1916-19	Pretzel-shaped flowers and swirled leaves on heavy rough background. Various colors.

"Iris" vase. Blue, embossed mark, 4 in. high. *Author's collection; Johnson photo*

Marked "Rozane" vase. Signed "AD"—Anthony Dunlavy, brown with yellow, 20 in. high. *Collection of Frances and Don Hall; Fox photo*

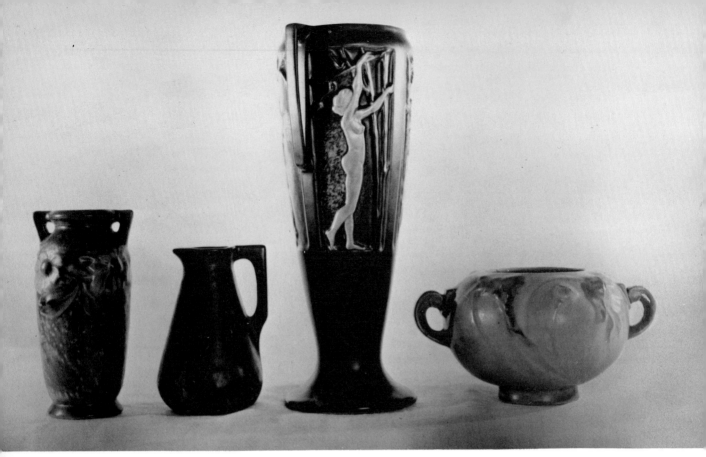

Roseville vases. *Left to right:* "Dahlrose," tan with yellow, black embossed paper label, 6 in. high; "Rozane Egypto," dark green, marked with wafer with title below, 5 in. high; "Silhouette," dark green with white figures, 11½ in. high; "Poppy," blue with white flowers, 4½ in. high. *Collection of Oma and Andy Anderson; Johnson photo*

IMPERIAL II 1924-28	A splotched glaze ware. Pink over blue.
IRIS 1938	Natural flower. Various background colors.
IVORY 1920s	A classic figure with dog in a band circling the vessel. Also ivory color in other lines such as Donatello. Background all ivory.
IXIA 1930s	Natural flowers. Various background colors.
JONQUIL 1931	Natural flowers. Various background colors.
JUVENILE 1930s	Children's plates and other dishes in light backgrounds with decal decor.
LA ROSE 1924-28	Cream-color background draped with leaves and roses.
LAUREL 1934	Natural laurel leaves with berries in panels with three lines between. Various background colors.
LOMBARDY 1924-28	Panels ending in scallops near the top with square odd feet. Various background colors.

Lotus 1941	Natural flowers. Various background colors.
Luffa 1934	Poison-ivy-type leaves stacked one over the other. All of the ware is covered with these leaves.
Magnolia 1943	Natural flowers. Various background colors.
Mara (Rozane) 1905	Iridescent line very similar to Weller's Sicardo. One noticeable difference is that Mara is decorated with damask-type design in a repeat pattern developed within the glaze.
Matt Green 1910	Heavy dark green matt glaze. Solid color.
Ming Tree 1949	Natural-type ming-tree decoration. Solid colors of white, blue, and green. High-gloss glaze.

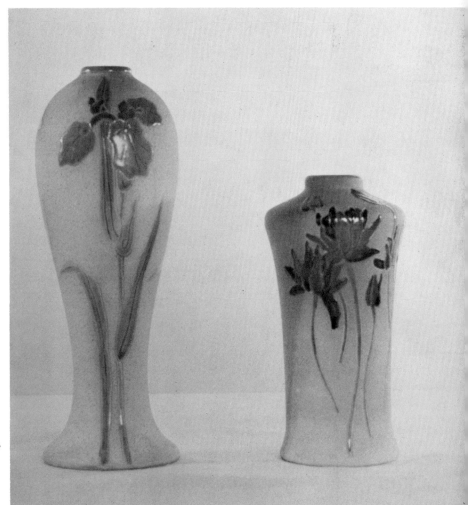

Signed "Rozane Woodland" vases. Wafer with line name, brown iris on light tan background, 9 in. and 6½ in. high. *Author's collection; Johnson photo*

Mock Orange 1950 Floral. Various background colors. "Mock Orange" included in the mark.

Moderne 1930s Classic shapes. Teal-blue matt-glaze background trimmed with touches of gold.

Mongol (Rozane) 1904 A beautiful deep rich solid red without decorations. Resembles Chinese lacquer. Occasionally trimmed with silver deposit. See text.

Roseville vases. *Left to right, top row:* "Carnelian," as pictured in catalog, black-embossed paper label, 8 in. high; "Rozane," cream with red and blue flowers, marked in circle with pattern name, 3½ in. high; "Ming Tree," turquoise, embossed mark, 11 in. high. *Bottom row:* "La Rose," as pictured in catalog, white with red roses and green leaves, marked "R," with "v, 8½ in. high; "Fuchsia," blue with red flowers, early paper label, 6 in. high; "Imperial II," as pictured in catalog, pink mottled on blue, "Rv," 7 in. high. *Author's collection; Johnson photo*

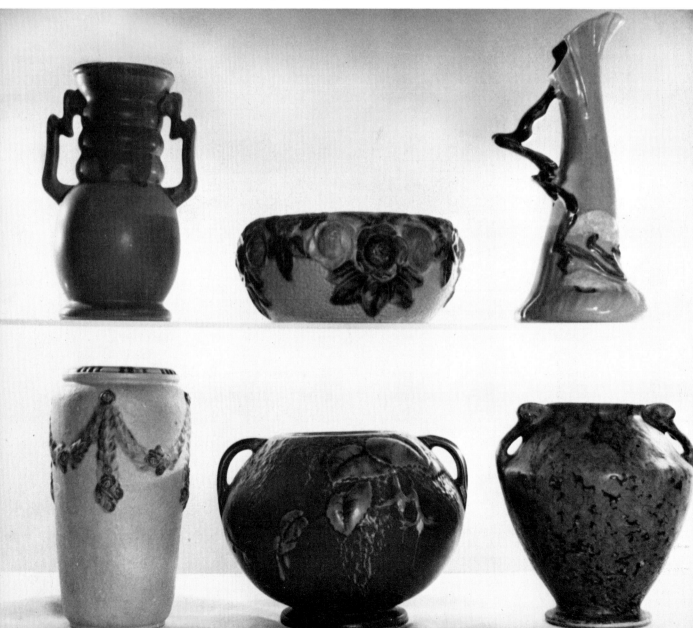

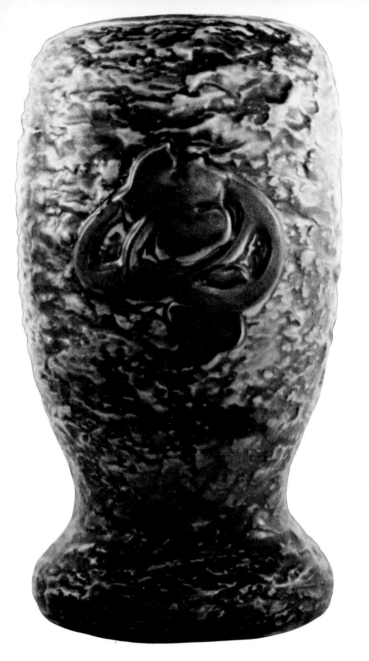

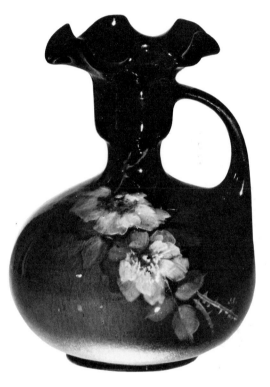

Left: "Imperial I" vase. Pattern as shown in catalog, mottled browns, paper label, 12 in. high. *Author's collection; Johnson photo. Right:* Marked "Rozane" vase. Yellow roses on brown, signed "Josephine Imlay," 5½ in. high. *Author's collection; Orren photo*

MONTICELLO 1931	A matt-glaze ware with small white crosslike designs with keyhole-shape designs between the crosses. Various dark background colors.
MORNING GLORY 1935	Stylized flowers covering the ware on light colored matt glaze.
Moss 1930s	Moss background with five-pointed leaves. Matt finish. Various background colors.

MOSTIQUE 1915 — Pebbled background with stylized designs in high-gloss glaze. Various background colors, usually in gray or tan.

NORMANDY 1924-28 — Fluted similar to Donatello with grapes and leaves in a circle at the top.

NURSERY 1920s — Children's dishes decorated in nursery-rhyme motifs. Light color.

OLYMPIC (ROZANE) 1905 — Dark red background decorated with white Grecian figures outlined in black; similar to a ware made in England by the F & R Pratt Company, Fenton. See text.

ORIAN 1935 — Chinese shapes in bright colors with high-gloss glaze. Allover geometric-design pattern.

PANEL 1940s — Various flowers in panels. Various glazes and backgrounds.

PAULEO (ROZANE) 1914 — See text.

PEONY 1940s — Natural flowers. Various background colors.

PERSIAN 1915 — Persian-type decoration on light-colored matt background.

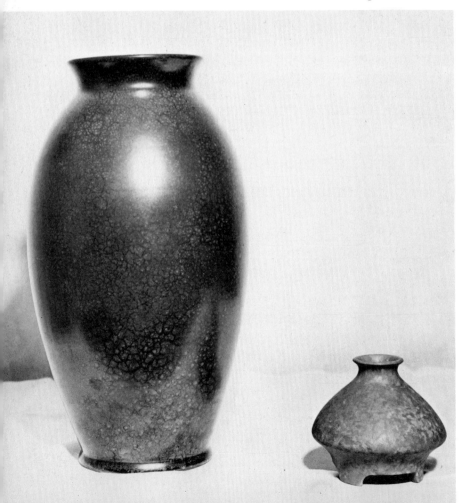

"Pauleo" vases. *Left to right:* First-line "Pauleo," red metallic glaze, unmarked; second-line "Pauleo," yellow marbleized cover, marked in wafer. *Collection of Dr. and Mrs. Gordon Gifford; Mesre photo*

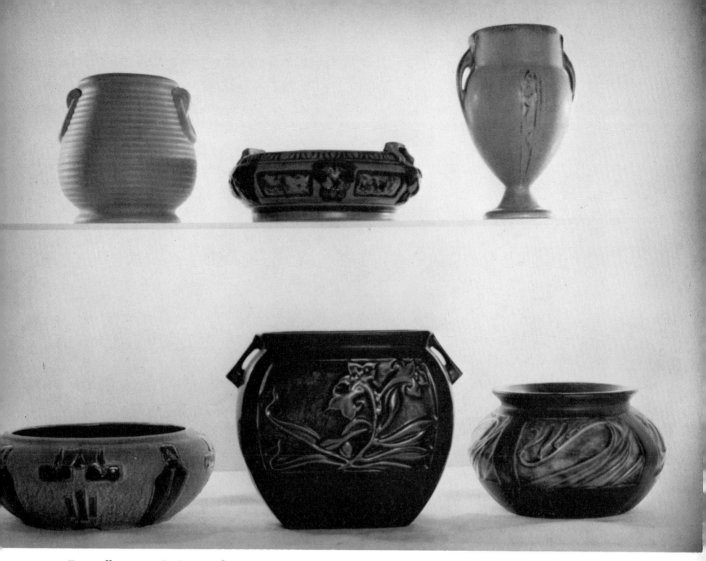

Roseville vases. *Left to right, top row:* Coors pottery, Denver (designed by J. J. Herold after leaving Roseville), rich rose-tan lined in bright turquoise, 5 in. high; "Florentine," rustic colors, 3 in. high; "Moderne," turquoise trimmed in gold, incised mark, 6½ in. high. *Bottom row:* "Mostique," green and red on ivory background, 3 in. high, 8 in. diameter; "Panel," brown with vivid orange decoration, 6 in. high; "Panel," green with white decoration, 4½ in. high. *Author's collection; Johnson photo*

PINECONE	Natural design of pinecones and leaves. Made for several years. See text.
POPPY 1930s	Natural flowers. Various background colors.
PRIMROSE 1930s	Natural flowers. Various background colors.
ROSECRAFT 1915	A plain classic shape with luster glaze. No decoration.
ROSECRAFT HEXAGON 1924-28	Hexagon shape with small white bleeding-heart-type decoration. Dark matt glaze.
ROSECRAFT VINTAGE 1916-28	A band with grapes and leaves around shoulder. Dark matt glaze.

ROZANE I 1917	Roses on stippled light background. Marked "Rozane" in center, along with the mark "Roseville Pottery."
ROZANE II 1940s	Various solid colors with molded seashells.
ROZANE MATT 1920s	Similar to Weller's Hudson pattern.
ROZANE ROYAL, DARK Early 1900s	Similar to Rookwood's standard brown ware and Weller's Louwelsa.
ROZANE ROYAL, LIGHT Early 1900s	Similar to Rookwood's Iris line and Weller's Eocean.

Group of Roseville vases of the "Pinecone" pattern. *Top row, left to right:* Brown, paper label, 7½ in. high; blue, incised mark, 4 in. high; rare pink, incised mark, 6½ in. high. *Bottom:* Blue, incised mark, 6 in. high; green, incised mark, 8 in. high; blue, paper label, 5¼ in. high. *Author's collection; Johnson photo*

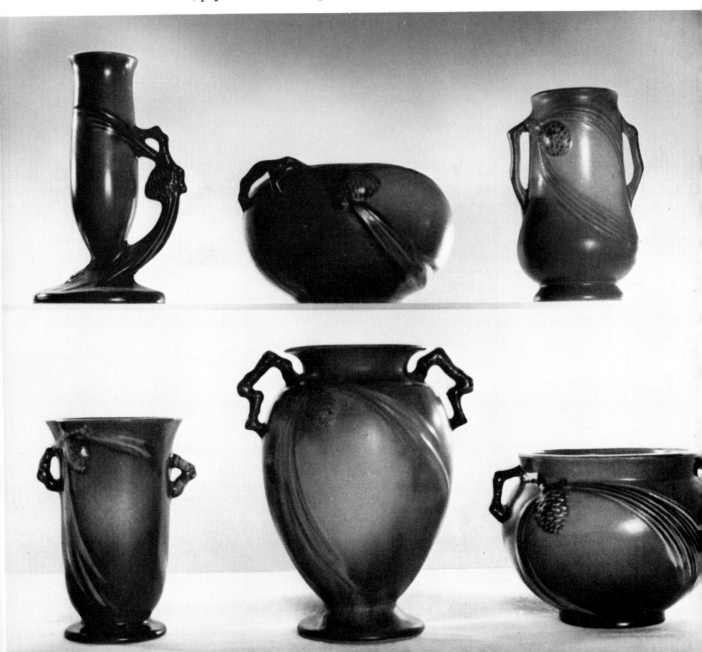

RUSSCO 1940s	Octagon shape with ribbons running up and down. Matt finish with a slight iridescence. Stacked handles. Various solid colors.
SAVONA 1924-28	Ribbed three-quarters of the way down from top. Grapes and leaves around shoulder.
SILHOUETTE 1940s	An art nouveau figure in panels. Various colors.
STEIN SETS	Tankard and six mugs. Decorated with monks, elk heads, Dutch figures, eagles, and other subjects.
SUNFLOWER 1940s	A "mum"-type sunflower on various background colors.
SYLVAN 1918	Molded owls and leaves on rough barklike background.
TEASEL 1940s	Natural floral design on various background colors.
THORN APPLE 1930s	A thistle-type bloom on one side and fruit on the other. Various background colors.
TOPEO 1934	Snaillike ear handles on two sides. Modeled background. Various colors.
TUSCANY 1924-28	Solid color grapes and leaves molded to body. Various colors.
VELMOS 1916-19	Small red moss roses and green leaves incised on light matt-finish background.
VELMOSS 1934	Three leaves molded in relief with three stripes around center. Solid color.
VOLPATO 1918-23	Similar to Donatello with band of fruits and flowers.
WATER LILY 1940s	Natural flowers. Various background colors.
WHITE ROSE 1940s	Group of small white roses on various background colors.
WINCRAFT 1940s	Various early designs, such as Pinecone and Bush Berry, included with gloss glaze.
WINDSOR 1940s	Edges impressed in box-type design with stylized flowers on sides. Various solid colors.
WISTERIA 1933	Natural flowers. Various background colors.

WOODLAND (ROZANE) Sgraffito technique with the decoration
1904 painted, with high-gloss glaze in autumn
 colors. Matt-finish background. Similar to
 Rozane Fugi. Also see text.

ZEPHYR LILY 1940s Natural floral design. Various background
 colors.

Roseville vases. *Left to right, top row:* "Ferrella," mottled tan and brown, early
black-on-black label, 6 in. high; "Rosecraft Hexagon," dark green glaze with
white decoration, marked "R" with "v," 4 in. high; "Rosecraft Vintage," black
glaze with natural color grapes, marked "R" with "v," 6 in. high; "Magnolia," tan
and brown with white flowers, embossed mark, 3 in. high by 6 in. long. *Bottom
row:* "Water Lily," blue with white flower, embossed mark, 5 in. high; "Aztec," as
pictured in catalog, blue on blue, marked "R" with "v," 4¼ in. high; "Blackberry,"
rustic colors with blackberries, early paper label, 5 in. high. *Author's collection;
Johnson photo*

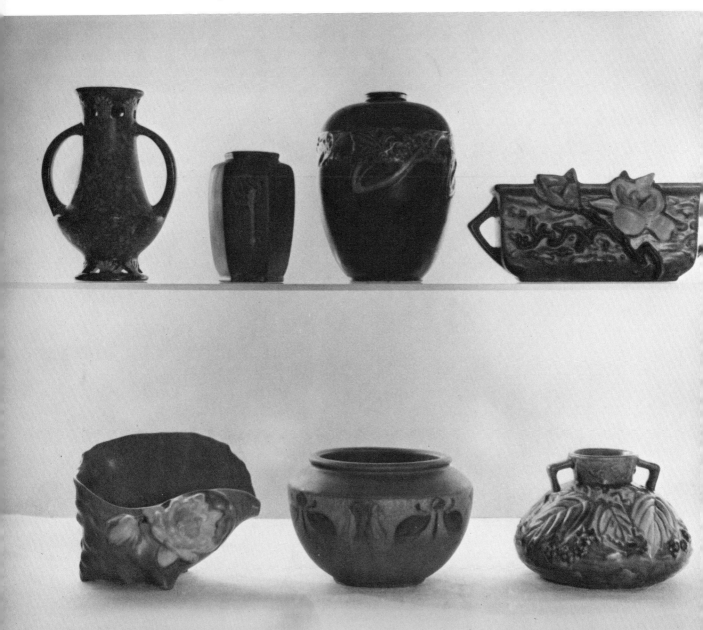

LONHUDA POTTERY
1892—1895
1898—1905

W. A. Long, a druggist in Steubenville, Ohio, had been quite interested in art pottery and in the testing of different glazes for several years. He then decided to go into the pottery business for himself. At the time, Rookwood was building a new factory in Cincinnati, and several other firms were doing quite well in this locale. Long, with two partners, organized his Pottery in 1892 at Steubenville, Ohio. The factory was named "Lonhuda," incorporating all three names, W. A. Long, W. H. Hunter, and Alfred Day. "Lonhuda" was also the name applied to the wares.

Long hired Laura Fry, who had patented the formula for making the brown ware with slip painting under the glaze while she was working at Rookwood Pottery. This was Rookwood's "standard" glaze. In 1895 the Lonhuda Pottery was purchased by S. A. Weller. With the purchase came Long and his formula for making Lonhuda. Weller renamed this particular ware "Louwelsa," since the name "Lonhuda" belonged to W. A. Long. Later, it was rumored that Weller had stolen the formula and consequently was sued by Laura Fry. The case was dropped eventually, as no concrete evidence could be shown that he had stolen it. Prior to this time Laura Fry had sued the Rookwood Pottery on this same matter and she also lost that case.

Long stayed with Weller Pottery only a few months. In 1896 he took a position with Owens, again taking his formula with him. At Owens the

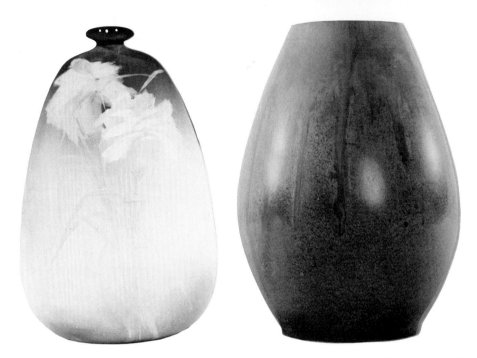

Left: Lonhuda (Denver) pottery vase. Pastel colors on brown background, matt finish, 8 in. high. *Author's collection; Orren photo. Right:* Clifton pottery vase. Green with tan, marked "Clifton," 9 in. high. *Collection of Oma and Andy Anderson; Johnson photo*

brown ware was called "Utopian." His stay with Owens was also for a short period of time.

In 1898 Long migrated to Colorado, where the clays were excellent for potting. There he organized the Denver China and Pottery Company and continued to make the Lonhuda ware. This plant closed in 1905 and Long moved to Newark, New Jersey, where he organized the Clifton Art Pottery. The art pottery made at this plant was influenced by the oriental shapes and glazes characteristic of this period. From time to time, Long introduced new artistic lines, among them being the "Crystal Patina." This ware had a dense white body with a pale green crystalline glaze which gave the effect of the patina on bronze. Later, the Crystal Patina was made in a wider range of colors where the colors would run and blend together. Still another line developed by Long was called "Clifton Indian Ware." This line was copied from native Indian forms and decorated on red clay. Each piece was always lined with a jet-black glaze, Long's Clifton Ware is always marked on the base and is occasionally dated. "Robin's Egg Blue Ware" consisted of a matt glaze in the exact shade the name suggests.

At a distance, one might mistake the matt-finish Lonhuda ware for a piece of Weller second-line Dickens Ware, as the finish closely resembles it. However, the sgraffito method was not used, only the soft

coloring. Long also used this particular method during his tenure with Owens, the finish being called "Matt Utopian." Let us mention here again that one will find similarity in different lines due to the migrating of the artists from one company to another.

Lonhuda was always marked and is of an excellent quality. It served to introduce the slip decoration under the glaze in the Zanesville area and today is considered to be quite rare. One might wonder why Long did not continue making pottery for a longer period of time. Whatever the reason may be, it is regrettable that this pottery could not have been made for several more years, as it does show very fine quality.

The names and monograms of the Lonhuda decorators:

[This list is not complete.]

Laura A. Fry Helen M. Harper

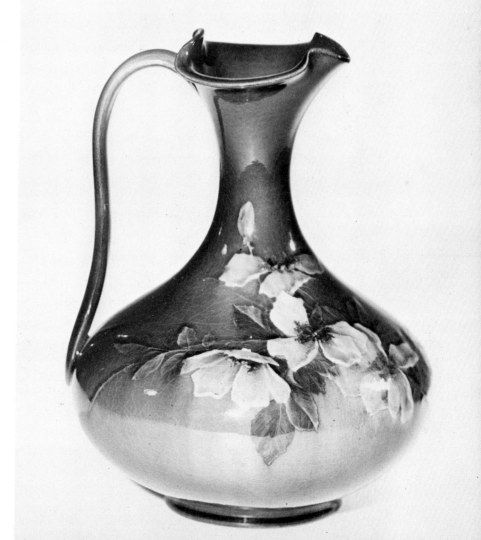

Lonhuda pottery ewer. Brown ware, signed "A.B.S."—Amelia B. Sprague, 9 in. high. *Author's collection; Orren photo*

W. A. Long

Jessie R. Spaulding

Sarah R. McLaughlin

Amelia B. Sprague **A.B.S.**

Marks to be found on Lonhuda:
 [Impressed numbers relate to the forms.]

1892-95; Ohio

1898-1905; Denver

In 1893, a new mark was developed, consisting of an Indian's head. This mark was used on very little early American Indian-type pottery.

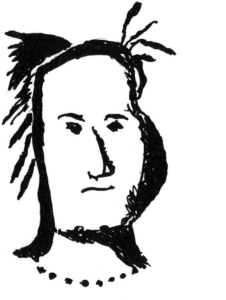

1893

1893

Clifton Art Pottery mark:

Incised

CAMBRIDGE ART POTTERY
Circa 1895

The Cambridge Art Pottery Company of Cambridge, Ohio, was one of many potteries to locate in the rich Ohio Valley, entering the ceramic field during the heyday of art pottery.

The company manufactured an art line in the faïence type of ceramics. These were made in various shaped vases, ornamental type wares as well as table service pieces. The company mark was used along with the added line name. About 1900, a line called "Terrhea" was created. This line was very similar to Weller's Louwelsa, Owens' Utopian, and Rookwood's standard brown ware. Exceedingly fine work was produced between 1900 and 1910, such as beautiful portraits and outstanding florals in slip underglaze painting. Most of these pieces were dated and signed by artists who are known to have worked at other Ohio potteries, especially in the Zanesville area.

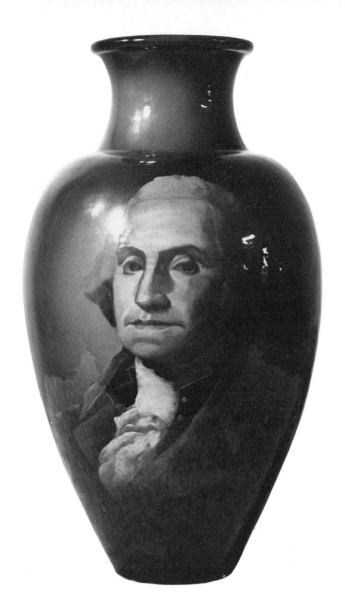

Cambridge brown ware vase. High glaze, marked "Cambridge" inside an acorn, signed by artist "A. Williams—1902," 24 in. high. *Collection of Frances and Don Hall; Fox photo*

Cambridge marks:

CAMBRIDGE

Printed

GUERNSEY

Printed

OAKWOOD

Printed

ACORN

Printed

CAMBRIDGE

105

Impressed

Stamped

TERRHEA

28

Impressed

CAMBRIDGE

Impressed

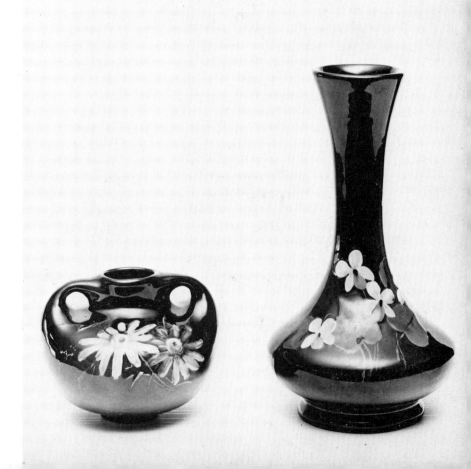

Cambridge vases. *Left:* Dark brown with yellow flowers, marked "Cambridge," 4 in. high; *right:* dark brown with yellow flowers, marked "Terrhea," 9 in. high. *Author's collection; Knight photo*

PETERS and REED
1897—1921
ZANE POTTERY
1921—1941

In the Ohio Valley, with its fine rich clays, more potteries flourished than anywhere else in the United States. New potteries sprang up every few months between 1880 and 1915. Many men who worked at the Weller, Rookwood, and other large factories in this area aspired to become industrialists rather than just ordinary workmen. Two such men were John Peters and Adam Reed. When Sam Weller stopped making flowerpots in 1897, when his art ware became popular, Peters and Reed decided to try their hand at capturing some of Weller's flowerpot business. A building was rented, with an option to buy, at the old Clark Stoneware plant on Linden Avenue in South Zanesville, Ohio. Their anticipated wealth was not accomplished over night; however, they were beginning to prosper. When the option came due, in 1898, circumstances put them in no position to buy the building, and George Young purchased it for his Roseville Pottery, where it remained until it closed in 1954.

Peters and Reed purchased another building, in the same general location—the old South Zanesville Stoneware Company. The company was incorporated in 1901, as Peters and Reed. Almost immediately they did well selling garden ware and flowerpots. Soon they were ready to invade the art-pottery field. When Frank Ferrel left Weller about 1905, Peters and Reed hired him as designer and salesman. Ferrel had designed a Pinecone pattern while at Weller which was not accepted and

the samples were destroyed. He renewed this pattern for Peters and Reed and it subsequently became a profitable seller. This new line was made of reddish brown clay with raised designs, sprayed with green paint which was then wiped from the embossings and backgrounds. It was also made in designs other than the Pinecone, and labeled "Moss Aztec." Other art lines were created and all continued to sell readily. After his short tenure of two years with Peters and Reed, Ferrel migrated to the Owens Pottery.

In 1920 Harry S. McClelland bought Peters' stock; in 1921 the name was changed to Zane Pottery Company. When Reed died, McClelland became sole owner. The factory was enlarged and more art lines were added to the production. At this time, a fine Ohio artist, C. W. Chilcote, was in charge of designing and Ernest Murray was ceramist.

The Moss Aztec line continued to sell quite well and was in production until the Zane Company changed from the reddish brown clay to white clay in 1926.

The company continued to prosper and, at peak production, the annual sales amounted to approximately one half million dollars.

When Harry S. McClelland died in 1931, his wife, Mrs. Mabel Hall McClelland, became president and she retained Zane Pottery for another decade. She then retired and sold the plant to Lawton Gonder, who operated it as Gonder Ceramic Arts from 1941 to 1957.

A group of Zane (Peters and Reed) vases. *Left to right:* "Chromal," 6 in. high; "Moss Aztec" marked "Zane," 2½ in. high; "Drip Line," 5½ in. high. *Author's collection; Johnson photo*

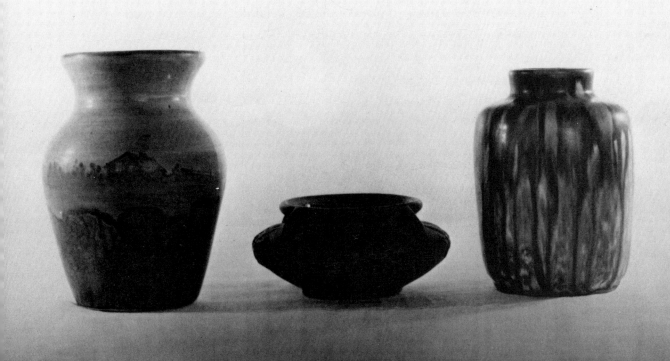

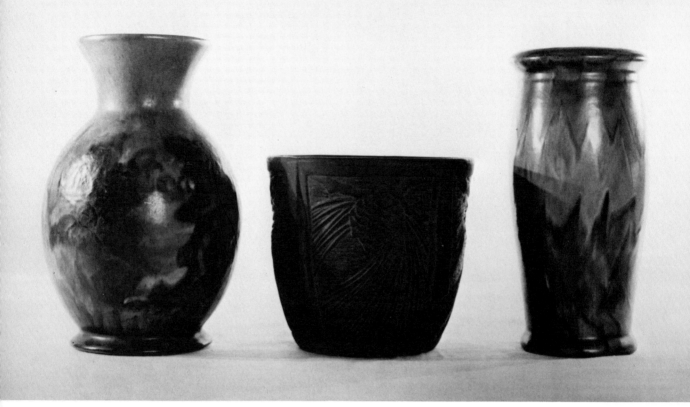

Peters and Reed pottery. *Left to right:* Three dark brown pieces with sprigged-on "Moss Aztec," brown and green, 5½ in. high; "Sheen Ware," shades of brown, gray, and green, 8 in. high. *Collection of Oma and Andy Anderson; Johnson photo*

Patterns or line names:

CHROMAL WARE	Scenic decoration in semigloss finish.
CRYSTALINE WARE	Hard semimatt glaze. Orange and green.
DRIP LINE	Covered with one glaze, with second glaze dripping irregularly from top.
GARDEN WARE	Graystone until Weller had this name copyrighted, then changed to Stonetex.
GRAYSTONE	See Garden Ware.
LANSUN	Matt finish. Sunset scenes in various colors.
MONTENE WARE	Rich copper bronze color.
MOSS AZTEC	Reddish brown clay with wiped-on green. Various designs include the Pinecone.
PERECO WARE	Solid color matt glaze in blue, green, and orange.
PERSIAN WARE	Allover stylized flowers and leaves.
POWDER BLUE LINE	Solid blue matt finish.

SHEEN WARE Four colors in matt glaze. Herringbone pattern
 and others.
STONETEX See Garden Ware.

Zane Pottery mark impressed. Most of the early ware was unmarked.

1921-1941

Peters and Reed pottery. *Left to right:* Three dark brown pieces with sprigged on
decoration covered with amber high-gloss glaze, mug 5½ in. high, vase 8½ in.
high, pitcher 15 in. high; "Moss Aztec" vase, light brown rubbed with green,
7½ in. high. *Author's collection; Knight photo*

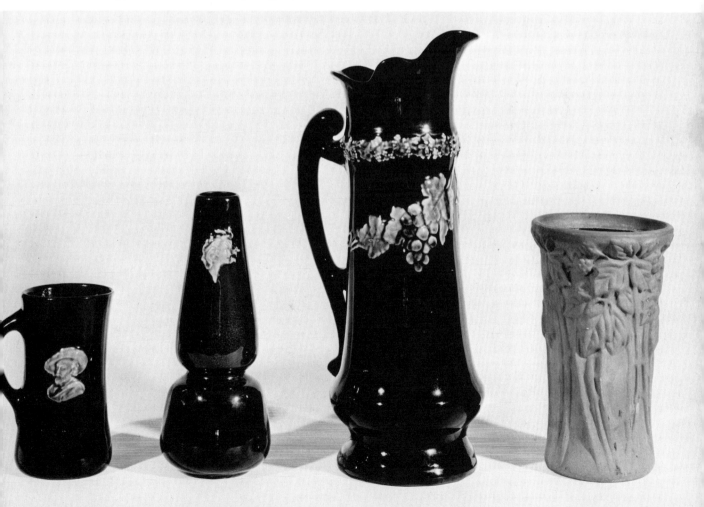

NEWCOMB POTTERY
1897–1940

The first and perhaps the most noteworthy appeal of Newcomb ware is in its artistic quality. This is reasonable, since it had its origin in a school of art. Newcomb pottery was developed in 1897 in the art department of Sophia Newcomb Memorial College for women, in New Orleans, Louisiana. Today, Newcomb is part of Tulane University.

There are few social phenomena in American history more striking than the growth of art at the turn of the twentieth century. America was just beginning to awaken to the importance of art as a part of its economy. Newcomb, under the direction of Professor Ellsworth Woodward, was among the first schools to realize it must abandon the exclusive traditional course in "fine art," which the community did not need financially, and to add courses of study that would combine art with industry and that would lead to application of art to industrial needs. To meet that need in such a way as to gain active cooperation from the general public was a problem—a problem with special difficulties when undertaken in a city which, at that time, was little more than a commercial port for a vast agricultural region. If no industry stood ready to use a trained designer there was no inducement to study. If no one saw inducement to study art, the deadlock would continue unbroken.

Education and progress demanded a change and the art school undertook an experiment with pottery as the object lesson. To keep the lessons on a going and developing basis, the workers must find it profitable, and so the college began paying for the product and shouldering the responsibility of disposing of it.

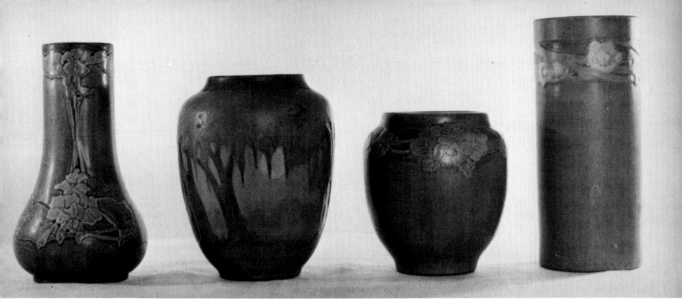

Newcomb Pottery vases. *Left to right:* Signed "C.L.," blue, 7½ in. high; moon shining through Spanish moss, attributed to Sadie Irvine, blue, 6 in. high; signed "C.L.," blue, 5 in. high; signed "S.," blue, 8 in. high. *Author's collection; Johnson photo*

The school converted an old chemistry building into a pottery shop with one kiln, potter's wheels, and all the equipment that was needed for potting. The same building housed the salesrooms where visitors were always welcome. Every process was open for inspection.

Professor Woodward engaged an artist, Mary G. Sheerer, as co-director. Since Miss Sheerer was already familiar with the Rookwood style of decoration and slip painting, this constituted no problem. She was quite devoted to ceramics as an art, and made the Newcomb art department her career. The success of Newcomb was largely due to the tireless energy of this artist.

Professor Woodward also hired Joseph Fortune Meyer as technician of the clay shop. Mr. Meyer threw all the pots on the potter's wheel, after the desired shapes were sketched by Miss Sheerer. When these were completed, the pots were turned over to the girls in the art department to be decorated. Mr. Meyer threw every piece of pottery at Newcomb until he became ill in 1925. All pieces were marked, on the base, with the JM monogram.

The artists were Southern women, educated in the Newcomb School of Art, who were making a living creating this pottery, otherwise they would probably never have been producers of art at all. The Pottery was always just a studio business and never operated as a factory. The Art School, a four-year course, was really started to train girls to decorate the pots for sale. However, generally only the most talented of the senior girls were allowed to work on the pottery.

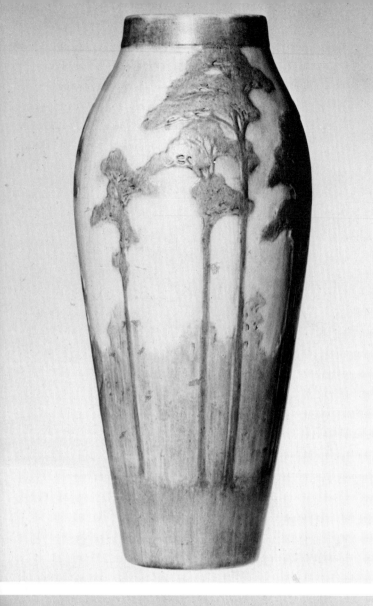

Newcomb vases. *Left:* Tall pine trees, modeled by an unidentified artist, blue, 11 in. high. *Author's collection. Below, left:* Daffodils in relief, modeled by Henrietta Bailey, blue, 5½ in. high. *Collection of Hubert and Linda Lockerd. Below, right:* Stylized magnolia-blossom form, blue, 5 in. high. *Author's collection; Orren photos*

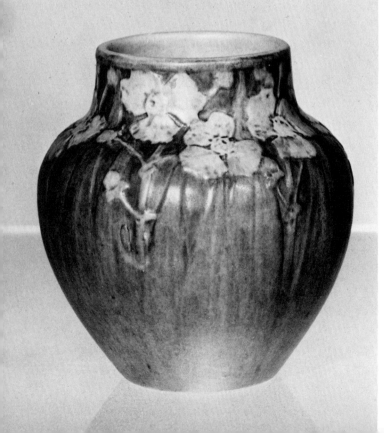

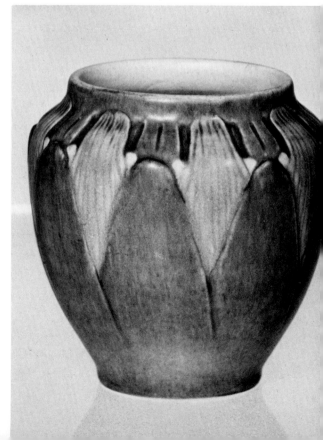

Newcomb pottery is completely indigenous. The rich cream-colored clay was found in St. Tammany Parish, Louisiana, the land of the orange and palm, the magnolia and jasmine, the bearded cypress, the noble oak, and the stately pines. All these furnished the rich material for ornamentation. The decorations are sometimes stylized and sometimes natural.

Every piece of Newcomb pottery was hand thrown; then, while the clay was still plastic, the design was drawn in with a soft pencil, then incised and molded with a tool. When finished, it gave the effect of low-relief modeling, which leads one to believe it was cast in a mold, when in fact it was completely handmade. If studied closely, you will

Newcomb vase encircled by a continuous pattern of trees. Signed by the artist, "Marie LeBlanc," the blue-green coloring is typical but the high-gloss glaze is uncommon, 5½ in. high, 3½ in. diameter. *Collection of Irma and Bill Runyon; Orren photo*

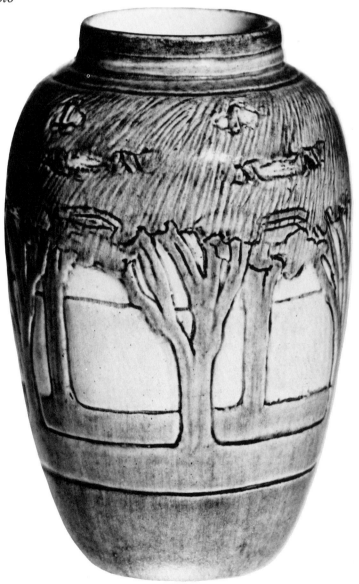

Left: Jet black vase, marked, "JM" monogram, text numbers indicate a rare trial glaze, 7½ in. high. *Collection of R. E. and F. G. O'Brien, Jr.; Knight photo. Below:* Newcomb bowl-vase with begonia-blossom decoration designed by Henrietta Bailey, blue, 5½ in. diameter. *Collection of Hubert and Linda Lockerd; Orren photo*

find the subtle fluid lines of the leaves and flowers will never be exactly the same size or thickness. Pieces were never duplicated.

The color in effect is blue. This might be called the standard recognizable color of Newcomb pottery. It is actually a combination of blue and green with contrasting touches of yellow, white, and pink. The color was brushed or sponged on, one color over the other. When held to a strong light, this is clearly visible. Most pieces are this standard color, although, on occasion, other colors—black, white, and dark blue—were used.

Prior to 1910 a high-gloss glaze was used on a minimum number of pieces. Dr. Paul Cox, hired in 1911 as a new technician, developed the standard glaze which characterizes this ware. It is a semi-transparent matt glaze, in which the underpainting appears as through a morning mist. This entailed three separate firings. Dr. Cox was graduated in 1904 from Alfred University, in Alfred, New York, one of the first schools to teach ceramics in America. Dr. Cox remained at Newcomb until 1918 and at this writing is still living in Louisiana.

The finest pieces of Newcomb pottery were made prior to 1918; and after 1920 very little of the underglaze decoration was used. A creamy matt glaze was developed and used on plain shapes, but had very little success.

The pottery was closed in 1940 and the Newcomb Guild was established. The Guild ceased operations in 1952.

Among the agencies and outlets for Newcomb art pottery were Marshall Field and William O'Brien of Chicago; Paul Elder of San Fransico; Gustaf Stickley of New York; and Arts and Crafts Association of Philadelphia. Other outlets were in Boston, Milwaukee, Washington, D.C., and Detroit.

During the period Newcomb pottery was made, it was exhibited at several International Expositions, including the 1904 Louisiana Purchase Exposition where a silver medal was won. Bronze medals were awarded at the World's Fair in Paris (1900) and at the Pan American Exposition at Buffalo, New York (1901). A silver medal was awarded at Charleston in 1902. In 1905 a bronze medal was awarded at Portland. Gold medals were won at Jamestown in 1905, Knoxville in 1915, and San Francisco in 1915.

A partial list of the artists working at Newcomb was gleaned from the college archives. The names and some monograms will be noted at the end of this chapter.

From the very beginning all Newcomb pottery was marked; the marks are found on the base of the article. These marks include the Pottery's mark, technician's mark, and the monogram of the artist.

Due to the scarcity of this fine art ware, pottery collectors may find it difficult to obtain a specimen; however, one can locate pieces on display at many fine museums, including the Metropolitan Museum of Art, Smithsonian Institution, and Museum of Fine Arts, Boston.

The important consideration, besides the beauty of this ware, which has a touch of the old South, Newcomb has proved that art and manufacture had been brought together on terms of mutual respect and interdependence.

The following are the marks to be found on Newcomb pottery:

Impressed

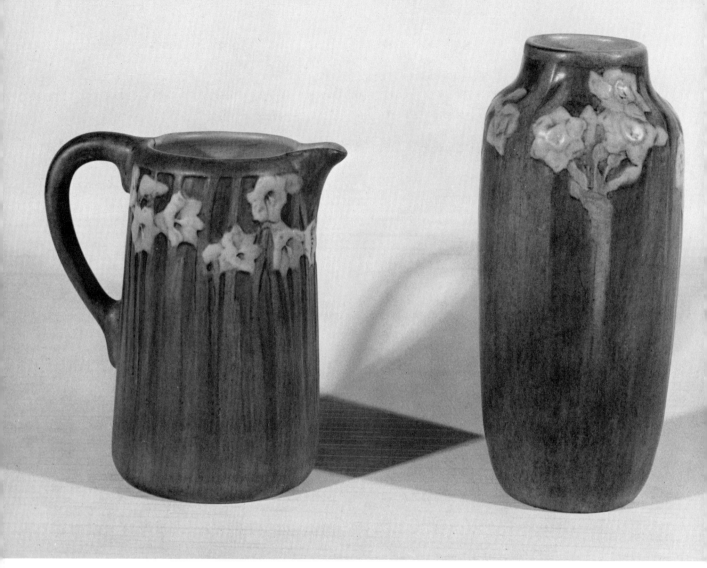

Newcomb pottery. Pitcher, blue with white flowers, marked "NC," artist monogram unknown, 6 in. high; vase, blue with white flowers, marked "NC," signed by Henrietta Bailey, 8 in. high. *Author's collection; Knight photo*

Paper labels were also used with the following data:

Newcomb Pottery, New Orleans
Designs are not duplicated
Object number and price

The names and monograms of the Newcomb decorators:
 [This list of names may not be complete, and some of the monograms were not available.]

Henrietta Bailey *HBH* Mary F. Baker

Mary W. Butler M.W.B.

Frances Jones F.J.

Frances H. Cocke FHC

Hattie Joor JH

Olive W. Dodd O W D

Irene B. Keep I.B.K.

Esther Huger Elliott EHE

Roberta Kennon RK-99

Bessie A. Ficklen 1904 B A F

Katherine Kopman HK

Selina E. B. Gregory S.E.B. G

Maria Hoe LeBlanc M.H.L. ML e B

Sarah Henderson H

Francis E. Lines E

Sally Holt

Ada Lonnegan A LN

Emily Huger #

Leona Nicholson LN

Sadie Irvine

Beverly Randolph BR

Mary W. Richardson Mazie T. Ryan

Martha Robinson Raymond A. Scudder

Elizabeth Rogers Mary Sheerer

Amalie Roman Gertrude R. Smith

Desiree Roman

The mark of the potter, which appears with the mark of the artist:

Joseph Meyer

Letters on the base denote the clay mixture.
Letters with numbers are registration marks.
One scratch through the Pottery mark denotes a "second."

VAN BRIGGLE POTTERY
1899—

The Van Briggle Pottery was established in 1899 by Artus Van Briggle in the shadow of Pikes Peak, where the colors of the beautiful sunsets and the countryside are captured in Colorado's clay. Here, in Colorado Springs, Van Briggle pottery continues to be made and sold. The company has never employed any agents, nor is its ware sold in retail stores. All purchases are made directly at the factory. Visitors are invited to make a tour of the plant and watch the artists at work, the plant being open daily except Sunday. The only process the public is not allowed to see is the glazing which, after all these years, is still a carefully guarded secret.

Artus Van Briggle was born in Felicity, Ohio, on March 21, 1869. As a lad of seventeen, he became quite interested in art pottery and, in spite of poor health, went to Cincinnati, Ohio, to study under Karl Langenbeck, of the Avon Pottery (1886). His tenure with the Avon Pottery was short and he joined Rookwood a year later (1887), when the Avon Pottery closed. By 1894 he had become quite an accomplished artist and had already been given the title of senior artist at Rookwood, and had been provided with his own private studio. The Rookwood Company, taking notice of his fine talent, sent him to Paris, France, for additional study, paying a portion of his expenses. There he met Anne Lawrence Gregory, to whom he came engaged in 1895 and whom he married in 1903.

Van Briggle returned from Europe in the summer of 1896 and remained at Rookwood for another three years. During this period his

257

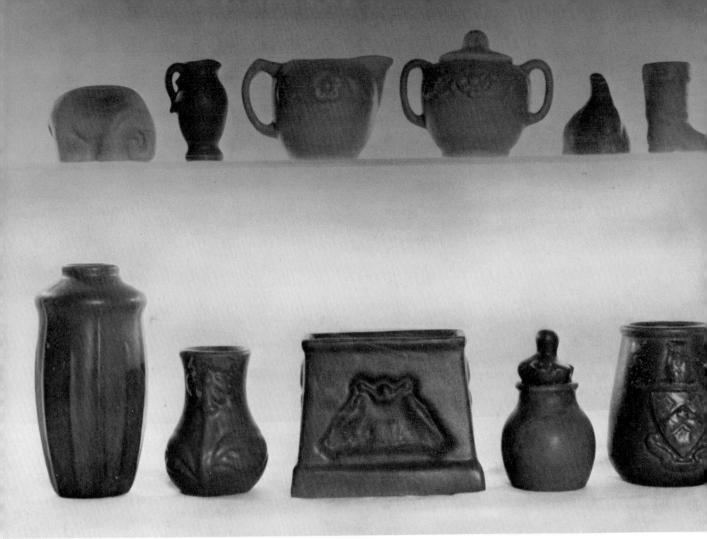

Van Briggle ware. *Top row, left to right:* "Turquoise Ming" elephant, 2¼ in. high; "Persian Rose" handled vase, 3 in. high; "Turquoise Ming" sugar and creamer, 3 in. high; rabbit, green, 2½ in. high; "Turquoise Ming" boot, 2¾ in. high. *Bottom row:* vase, brown, 6½ in. high; "Persian Rose" vase, blue flowers, 4 in. high. "Persian Rose" card holder, blue birds, dated ca. 1909, 4½ in. high; "Persian Rose" covered jar, dated 1915, 4½ in. high; handled mug, dark blue, dated 1916, 4½ in. high. *Author's collection; Johnson photo*

efforts were turned toward perfecting a matt-type finish which was adopted by Rookwood. Throughout his tenure with Rookwood he was considered one of their finest artists. However, because of ill health and on orders from his doctor, he was forced to seek a new climate.

This separation from Rookwood took Van Briggle to Colorado Springs, where he opened his own Pottery. The experience he gained while with Rookwood and in his studies abroad gave him the knowledge he needed for his own factory. Rookwood was not pleased with his departure as they had invested quite a substantial sum of money toward his education in the field of ceramics. Notwithstanding Rook-

wood's displeasure, Mrs. Storer remained his friend and advisor and contributed the necessary funds to open his first studio Pottery in 1899, with full operation commencing in 1901.

Anne Lawrence Gregory Van Briggle was born in Plattsburg, New York, on July 11, 1868. At the time she met Artus she was studying painting in the Beaux Arts in Paris. In the Pottery today hangs a portrait of Artus Van Briggle which was painted by Anne during this period. She was quite a talented artist in her own right. She worked hand-in-hand with Artus and created many of the early pieces, as well as the later Van Briggle.

Artus Van Briggle died in 1904, leaving his widow to carry on the pottery business. During the five-year period that he personally operated his own factory he took more awards than any other American potter of that era. Some of the awards that were won during these early days were at the St. Louis Exposition of 1904, at the Lewis and Clark Centennial of 1905, and at the Arts and Crafts Exhibition of Boston. It is interesting to note that Van Briggle pottery may be found among the permanent collections of the Louvre, Paris, the South Kensington Museum, London, the Smithsonian Institution, Washington, D.C., and several other important museums around the world.

As a brave young widow, Anne continued experimenting with the Colorado clays, and the Pottery progressed rapidly. In 1907 a beautiful building, designed by a Holland Dutch architect, Nicholas Van den Arend, was erected at 300 West Uintah Street. This was, indeed, a fitting memorial to Artus Van Briggle. The mammoth kilns were built at tremendous cost and were in full operation until the fall of

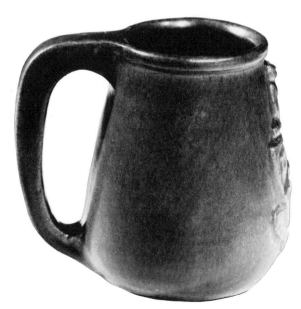

Dark blue mug, 1916, 4½ in. high.
Author's collection; Orren photo

1968, when the Uintah Street plant ceased operations. All facilities were transferred to the 21st Street plant where accessibility to the interstate highway was more advantageous.

In 1908 Anne Van Briggle was married to E. A. Ritter, a mining engineer. She remained as art director at the Pottery, always actively creating, until 1923. She died November 15, 1929.

The potters developed and introduced two new glazes as a tribute to Mrs. Ritter. One was "Jet Black" with a mirror finish. The other was "Honey Gold," also with a gloss glaze, capturing the colors of autumn leaves.

Early Chinese potters, and their secret of wonderful glazing, became famous centuries before pottery was made in the Western world. Their secrets were lost with them, to be born again in Van Briggle pottery. In China's centuries of history, the emperors selected certain colors in pottery as their favorites. For instance the Ming dynasty was the patron of a turquoise blue, whose delicate tints defied every effort of imitation for more than 500 years. This color was successfully obtained by Artus

"Turquoise Ming." Figure 9 in. high, bowl 15 by 10 in. *Author's collection; Johnson photo*

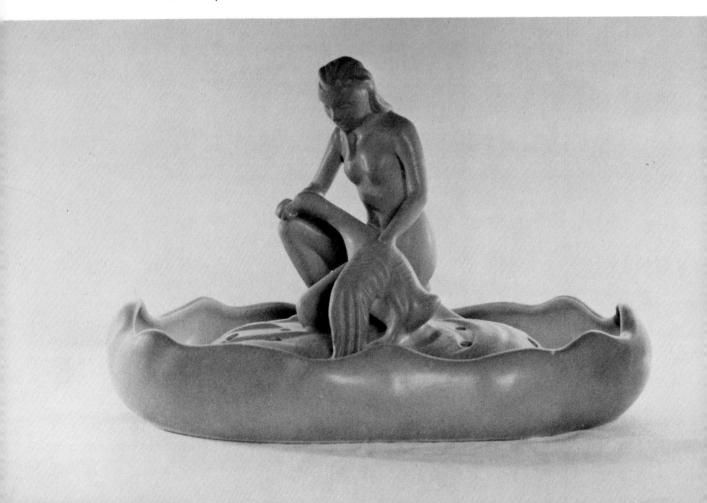

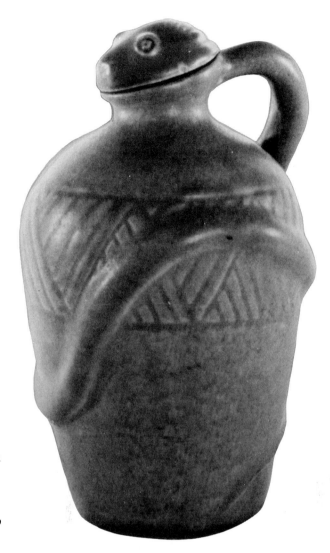

Green jug. Dated "190#" with the last digit obliterated— believed to be ca. 1902, 7 in. high. *Collection of Oma and Andy Anderson; Johnson photo*

Van Briggle. The American innovation of this finish is highlighted by spots of royal blue, brushed or sprayed on over the turquoise in beautiful shaded work. This color, known as "Turquoise Ming," is still in production. Another is the maroon red, brushed with a dark blue-green, known as "Persian Rose," which is no longer in production. This is a copy of old Persian, deep rouge-tinted pottery. Another color was a light "off-white" shade known as "Moon Glo." In the early Van Briggle, other colors will be found, such as dark blue, dark brown, dark green, yellow, and lavender, as well as the colors that are used today.

Van Briggle pottery was made in many types of vases, tableware, lamps, paperweights, bookends, and small bric-a-brac, all with molded

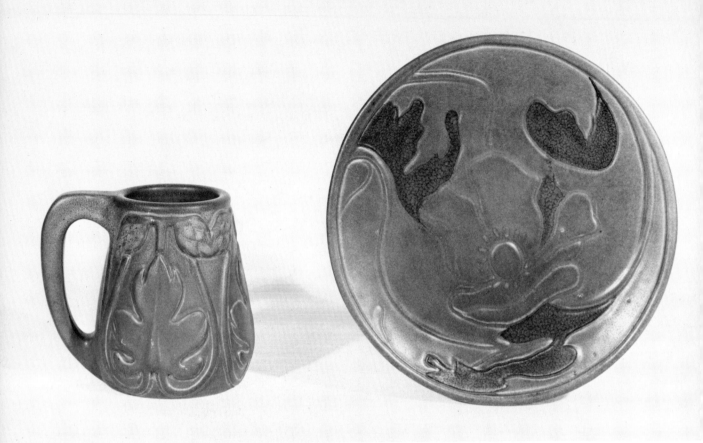

Van Briggle pottery. *Left:* Mug, shades of brown and green, marked "Van Briggle 1902," signed "III"—Artus Van Briggle, 4½ in. high. *Right:* plaque, shades of brown, green and blue, marked "Van Briggle 1903," signed "III," 8½ in. diameter. *Collection of R. E. and F. G. O'Brien, Jr.; Knight photo*

designs. However, the outstanding and most beautiful pieces are the modeled or sculptured art nouveau figures, some of which are quite large. The details of the human figures often suggest the emergence from water, the effect being very artistic. In some instances, these figures are used as "flower frogs" in large bowls. Perhaps the two most important Van Briggle figures are "Lorelei" and "Despondency," the latter being that of a man. Both figures have received recognition in the art nouveau field. Also made by the Van Briggle Pottery were the small molded animals in various colors.

From the very beginning, Van Briggle ware was marked with the double "A," the monogram standing for Artus and Anne. The pieces were sometimes dated. Complete artist signatures can be considered a rarity on Van Briggle pieces. However, some of the earliest wares were fully signed. Furthermore, a Roman numeral was designated to certain artists, to be placed on the base of each piece, to be used as their signa-

ture. It is believed that "I" can be attributed to Anne Van Briggle, "II" to Harry Bangs, and "III" to Artus Van Briggle. Although no records of these marks were kept, pieces bearing these Roman numerals would be prior to 1904. The company still declares there is no such thing as an unmarked piece of Van Briggle. There are also no "seconds" in the pottery lines. Any piece not coming up to standard was completely destroyed.

Since Artus Van Briggle was among the first Americans to think of art as a contributor to the economy of the nation, the continued importance of the Pottery he founded justifies his confidence in the financial success of industry with high artistic standards.

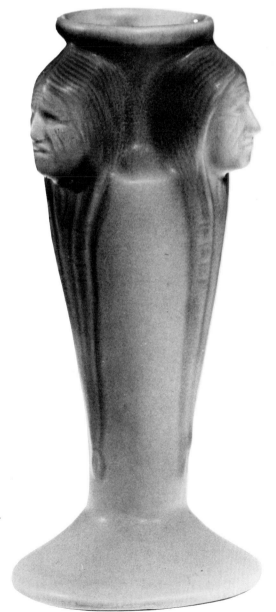

Blue vase with three Indian heads; 11½ in. high. *Author's collection; Orren photo*

The marks found on Van Briggle pottery are incised by hand on the base of each piece.

Early period, 1901-1920:

1918

VAN BRIGGLE
1902

VAN BRIggle
U.S.A.

Late period, 1920-present:

VAN BRIggle
Colo Spgs
originaL

VAN BRIGGLE
Colo. SPGS.

BUFFALO POTTERY
1903—
DELDARE
1908—1909
1924—1925

The Buffalo Pottery was organized in 1902 in Buffalo, New York, and began operations in a new building at Seneca and Hayes Streets in 1903. From the very outset, the company operated nine kilns and employed over one hundred people.

Buffalo Pottery was established by the Larkin Company, manufacturers of soap and toilet products, which had its beginning in 1875, when an enterprising soap salesman, John Durrant Larkin (1845–1926) decided to manufacture his own products. The original product was a bar of yellow laundry soap called "Sweet Home." This product was followed by a liquid soap, also called "Sweet Home" (1879) and a boxed soap powder known as "Boraxine" (1881). Tucked inside each package of Boraxine was a colored lithograph. Thus, the Larkin Company first introduced this method of merchandising to the American housewife. By 1883, fancy toilet soap, cold cream, tooth powder, and other toilet products were added to the Larkin lines. These products were packaged in fancy boxes, always including a premium.

It was Elbert Hubbard, Larkin's brother-in-law and business partner, who became the promoter and introduced the "Club Plan" of premium merchandising. The principle of this plan was that after purchasing a given amount of Larkin products a premium was received. This proved to be so successful that the Larkin Company

decided to manufacture their own premium products (among them pottery), thus capturing all the profits.

Elbert Hubbard is perhaps best remembered as the author of the famous book *A Message to Garcia,* published in 1899. Hubbard was also publisher and editor of two small magazines called *Fra* and *Philistine* and a monthly publication known as *Little Journeys.* Hubbard and his wife were lost when the English liner *Lusitania* was torpedoed and sunk, May 7, 1915, by a German submarine, off Head of Kinsale, Ireland.

Operations at the Buffalo Pottery began in 1903 with John D. Larkin as president, a post he held until his death, when he was succeeded by his son, John D. Larkin, Jr. Louis H. Bown, a native of Trenton, New Jersey, was appointed first general manager of the company. Bown brought with him several talented artists and craftsmen, including William J. Rea, who was given the position of production manager.

The first wares produced by the Buffalo Pottery were dinner sets in semivitreous china in the style of the imported French dinnerware and in a blue willow pattern that was exceptionally well executed. They also produced calendar plates and commemorative and historical pieces very similar to wares made by Doulton and other English potters. These dishes were very popular and the company began selling them to retail stores as well as using them as premiums for the Larkin Company.

In 1908 Buffalo Pottery entered the art-pottery field when Bown introduced "Deldare Ware." The development of Buffalo Deldare may be accredited to three men; Bown, Rea, and an artist named Ralph Stuart. Deldare Ware is characterized by a rich olive drab (green) clay formula developed by Rea. Pieces made on this body have been discovered dated as early as 1907 and as late as 1914. These pieces are known as "Deldare Specials" and are not marked with the Deldare mark. These were probably special order pieces or pieces made for the employee's own use. The scarcity of such pieces make them choice collectibles.

Ralph Stuart, Rea, and Bown studied such English literature as *Vicar of Wakefield* and *Cranford* for design ideas. Scenes from these books were reproduced from patterns by the Buffalo artists in mineral

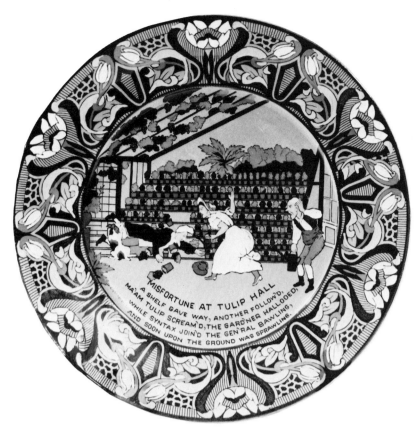

Above: Buffalo "Emerald Deldare" plate titled "Misfortune at Tulip Hall," signed "J. Gerhardt," 8¼ in. diameter. *Below:* "Deldare" plate titled "The Fallowfield Hunt. The Death," signed "L. Palmer," 8¼ in. diameter. *Author's collection; Orren photos*

colors under a fine high-gloss glaze on the regular Deldare Ware produced in 1908 and 1909 and also on the revived issues of 1924 and 1925. The patterns were stamped on the article and the artist filled in the colors as designated by the head designer. The only freehand work the artists were allowed to do was the addition of the white clouds in any manner they chose. Each piece is signed by the artist who finished it.

Many collectors have inquired as to the source of the name "Deldare." No proof has been found that accounts for its origin, although many suggestions have been given. Presently, an air of mystery continues regarding this title. No doubt the three men who developed Deldare could greatly enlighten us on the subject if they were alive today.

The regular Deldare Ware is always banded with a continuous scene, with a titled scene in the center. The borders are always matching while the center subjects change. There are two different patterns in the regular dated Deldare. The first, "The Fallowfield Hunt," has a border of hunters on horseback, racing across the countryside. The subjects in the center follow the hunt from "The Start" to "The Return." These include "Breaking Cover," "The Dash," "The Death," "The Hunt Supper," and "Breakfast at the Three Pigeons." These titles are always written on the face of the article near the bottom.

The second pattern, "Ye Olden Times," has a continuous border of old-time two-story houses with the center scenes of the local genre, both indoors and outdoors. The titles of these include "Ye Olden Days," "Ye Lion Inn," "Ye Town Crier," "Ye Village Street," "Ye Village Gossips," and numerous others. Both patterns were made in dinnerware including all sorts of accessories. "Ye Olden Times" pattern was reissued in 1924 and 1925 and was marked and dated correctly. Increased wages and the high price of materials made this ware costly to produce. Because of the exorbitant retail price, it ceased to sell readily and was discontinued again.

A calendar plate was issued in 1910 on the regular Deldare body and is considered extremely rare. This was the only year a calendar plate was produced on the Deldare body.

In 1911 the Buffalo Pottery created a new line which they named "Emerald Deldare." This ware is of the same rich olive drab clay,

"Deldare" pretzel dish. Titled "Ye Olden Times," signed "W. Foster," 6½ by 12 in.
Author's collection; Orren photo

banded with stylized flowers and geometric designs. A most popular
decoration to be found on Emerald Deldare are the scenes from "The
Tours of Dr. Syntax." However, other very popular decorations were
also used in art nouveau motifs, geometric designs, stylized flowers
and butterflies, dragonflies, peacocks, and outdoor scenes of lakes and
mountains. It might be noted here that in 1909 the Pottery produced
some pieces with Dr. Syntax scenes. However, these were done in blue
instead of the regular Deldare colors. The original caricatures in the
Dr. Syntax series were painted in water colors by Thomas Rowlandson
while William Combe wrote the verses that accompanied each one.

In 1912, a ware called "Abino" was introduced. This line is deco-
rated with rural, Dutch mill, pastoral, and natural scenes. Abino ware
apparently received its name because the designs were similar to the
picturesque scenery found at Point Abino, a resort on Lake Erie, a
few miles from Buffalo.

Other lines created about this time were "Luna Ware," a pale blue clay formula body, "Café-au-Lait," a soft tan body, and "Ivory Ware" on an ivory clay body. These lines were occasionally decorated with the identical subjects as were used on Deldare Ware.

The Buffalo Pottery, at the beginning of World War I, began producing chinaware for the government for use in the Armed Forces and, except for brief periods, has been manufacturing mostly hotel china up to and including the present day.

In 1925 the Buffalo Pottery brought out a reproduction of the famous "Portland" vase which was issued again in 1946. These were made in very limited numbers and are considered extremely rare. The vase is eight inches tall with white figures on a blue background.

In 1950 a Christmas plate was introduced by the Buffalo Pottery. These plates were not sold commercially but were made to be given as a gift to customers, employees, and friends. These plates proved so popular that they were issued yearly from 1950 through 1962, with the exception of 1961. This is one more item that is eagerly sought by collectors.

Every piece of Buffalo art ware is plainly marked and frequently includes the line name and the date.

A partial list of Deldare decorators:

Anna, L.	Gerhardt, J.	Munson, L.
Ball, H.	Gerhardt, M.	Nakolk, J.
Beatty, G.	Hall, P.	Newman, L.
Berks, L.	Harris	Palmer, L.
Biddle, H.	Hlumne, M.	Ramlin, M.
Biddle, M.	Holland, P.	Ramlus, W.
Broel, E.	Hones	Reath, G.
Broel, M.	Jentshi, A.	Robin, H.
Bron, M.	Jone, G. H.	Roth, A.
Caird, K.	Katon	Rowley, F.
Ditmars, E.	Kekola, J.	Sauter, E.
Dowman, E.	Lang, A.	Shafer, O.
Fardy	Mac, F.	Sheehan, N.
Ford, H.	Mars, Ed J.	Simpson, M.
Foster, W.	Missel, E.	Simpson, R.

Simpson, W. E.	Stuart, R.	Whitford
Sned, M. or	Tardy	Wigley, J.
Snedeker, M.	Thompson, M.	Wil, L.
Souter, O.	Vaise, R.	Wilson, M. J.
Steiner, M.	Vogt, N.	Wilton, B.
Stiller	Wade, A.	Windsor, R.
Streissel, L.	Wayson	Wit, L.

Company marks:

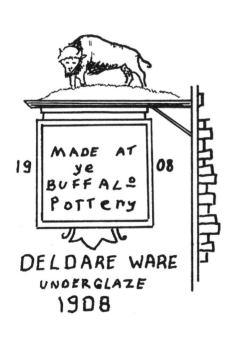

Mark for Abino ware:

ABINO WARE
BUFFALO
POTTERY
1912

GATES POTTERY
TECO WARE
1903—1915

The Gates Pottery of Terra Cotta, Illinois, introduced an art ware known as Teco Ware in 1903. The name of this ware was derived from the first two letters of Terra and Cotta, the name of the location of the Pottery.

William D. Gates, president of the Gates Pottery, had experimented with various clays and glazes for many years before developing the formula for Teco Ware. The earliest ware had a high-gloss glaze in green. About 1906 Gates introduced a matt glaze very similar to Grueby and Van Briggle ware. This ware is characterized by a velvety smooth surface in luscious shades of green on a red or cream-colored clay body.

A garden of plants, mostly aquatic, was grown on the premises especially for the use of the designers. Consequently, the forms are largely derived from natural subjects. These forms are occasionally

Teco ware. Lush green matt glaze, marked "Teco," 2 in. high, 8 in. diameter.
Collection of Oma and Andy Anderson; Knight photo

molded and other times hand thrown, according to the intricacy of the design. Teco Ware is never hand painted or decorated with other colors.

The rich clays were strictly American and came almost entirely from Brazil, Indiana. The smooth rich shades of the green glazes and the graceful simplicity of the Teco Ware are sufficient to merit the title of art pottery.

Teco Ware is always marked on the base of each article.

Teco mark, impressed:

```
T E
  C
  O
```

TIFFANY POTTERY

Circa 1907

Louis Comfort Tiffany (1848–1933) is best remembered as the highly skillful original maker of the entrancingly beautiful iridescent glass and the daring designer of leaded- and stained-glass windows and lampshades of the art nouveau period. Tiffany was a master of many arts— a painter in oils and water colors, an interior decorator, a landscape artist, a designer of textiles—and had many other talents, including the art of potting.

During the period Grueby Pottery was in operation, lamp bases and other items were purchased from that company and then further embellished with Tiffany shades and metal treatments. After Grueby ceased operations, about 1907, Tiffany began making ceramics in his Corona, New York, plant. This project was short lived since it was too costly and time consuming to produce; furthermore, pottery was not considered one of Tiffany's foremost accomplishments. Tiffany did, however, handle the better wares from other well-known American potteries. The advertising of his pottery was not given as prominent a place as was his fancy glass and leaded lamps, but his pottery did have merit and each example is unique.

Tiffany pottery was both molded and hand thrown and then decorated with natural-appearing floral designs made from the plastic clays and then applied, some in the free-flowing art nouveau style. A few specimens also bore incised designs. The earlier wares were an off-white, occasionally sponged with brown. Later, all shades of soft greens, blues, and subdued reds were commonly used. Gold luster and a bronze finish were among the most popular.

Tiffany pottery vase. Hand thrown, pale green, signed with Tiffany monogram, 5 in. high. *Collection of Irma and Bill Runyon; Johnson photo*

"Favrile" pottery vases. *Left to right:* "Gold Lustre" glaze with relief design of large leaves, signed with "L.C.T." cipher in base, 5 in. high; "Bronze Pottery," silver-plated copper exterior and mottled green glazed interior, relief decoration of flowers, leaves, and vines, impressed "L.C. Tiffany—Favrile—Bronze Pottery—B.P. 313," in copper base, signed with "L.C.T." cipher, 8¼ in. high; unglazed buff-colored vase with molded relief of flowers, leaves, and vines, signed with "L.C.T." cipher, 5⅛ in. high; buff and tan, molded relief of leaves. Signed "L.C.T.," 4¾ in. high. *Collection of Mr. and Mrs. R. L. Suppes; Brooks photo*

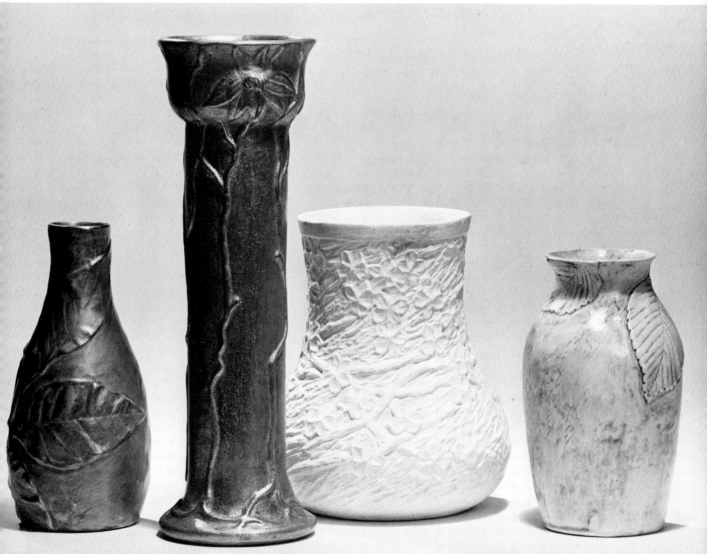

All types of glazes were employed on Tiffany pottery, including a soft matt, a rough-finished matt, a gloss finish, and the bronze and gold luster type, including the iridescent ware. The forms or shapes were very reminiscent of the Rookwood, Grueby, and other excellent wares of the same period.

Tiffany pottery is always marked with the Tiffany monogram in the base of each piece.

Tiffany Pottery marks:

[A cipher of interweaving letters was one type of monogram used by the Tiffany Studios for the signature (L. C. T.) on his pottery.]

Incised in the base

Generally when a particular metal was affixed to Tiffany pottery for the base, a full signature was impressed in the base.

MARIA POTTERY
1908—

María pottery is perhaps not in the same category as others in this book. However, it should be discussed since it had an important impact during the period of growing interest in art pottery, crafted for ornamental use only.

María pottery was created by María Montoya Martinez and her husband Julián. María was born in 1881 in San Ildefonso, New

Mexico, and was a member of the Tewa-speaking Pueblo Indian tribe. Powoge (word for "Pueblo"), translated as "The place where the waters meet," is a picturesque location of the upper Rio Grande, about twenty miles to the northwest of Santa Fe, New Mexico. A group of archaeologists under the supervision of Dr. E. L. Hewett arrived in 1907 to study the ruins of the old camping grounds of the Pueblo Indians here. Julián was one of the first Indians to be hired to dig in the old village at Puyé Canyon and the Pajarito Plateau.

While digging in the old ruins, shards of an old Indian "pot" were uncovered. María, who made some pottery, was commissioned to reproduce an exact replica of the discovery, for which she was compensated with two silver dollars. She mixed the clay and modeled the shape; in the meantime, Julián rediscovered the technique used for the painted decoration. He made a syrup of guaco, then boiled it down until it was thick enough to apply to the "pot" with a brush made of chewed yucca stems. When the bowl was fired, it became an exact replica of the design and color of the shards.

María and Julián had revived the ancient craft of the Pueblo pottery making. This pottery was cream with black and red designs, red with black and cream designs, and some in monochrome colors. In 1908 this pottery was placed on the market and sold on a small scale. Pots and vases were the most common wares; however, plates and plaques were also produced, but these proved unsatisfactory due to easy breakage and cracking.

María pottery was always fired by a primitive method. A bed was made of broken pottery and then covered with a layer of cedarwood. The "pots" were arranged on top of this pile, then covered with another layer of cedarwood. This arrangement continued until there were three rows or layers of pottery. This completed stack was then covered with cakes of dried cow dung, forming a shell-like oven with an opening at the very top through which the smoke escaped. The stack was set afire and allowed to burn until it died down. The "pots" were picked from the ashes as soon as they were cool enough to handle, being picked up with sticks.

About 1912 an important discovery was made by María and Julián. They noted that if the fires were smothered for a time with shovels of powdered sheep dung, the pots would have a black glaze. When the

"San Ildefonso Black on Black" bowl. Signed "Marie," 3½ in. high. *Author's collection; Knight photo*

vessels were removed from the ashes, and while they were still hot, they were greased with hog lard, which gave the ware a glossy finish. About 1919 Julián discovered a slip paint that would cause the part that was painted with it (before the firing) to have a matt finish. This resulted in a shiny black body with matt designs in black, a ware known as "San Ildefonso Black on Black." This is the recognizable color of the signed María pottery. This technique was a carefully guarded secret for many years and was known only by the potters of San Ildefonso. One will notice that the pottery is rather thick and heavy.

María and Julián contributed a great deal to the potting industry in this small community, which brought economic gain to them and their people. They also appeared at many important expositions, sponsored by the representatives of the United States Bureau of Indian Affairs. Almost immediately, this pottery became a national art interest.

In the earlier years María taught pottery-making and was employed to demonstrate this art, under the sponsorship of Dr. Edgar L. Hewett, at the Museum of New Mexico. It was here that the pottery was first sold to the public.

"San Ildefonso Black on Black" bowl. Signed "Marie and Julian," 5 in. high. *Author's collection; Knight photo*

The earliest pottery bore no mark at all. About 1923 María was advised by a white friend that it was customary to sign American works of art. This was agreed upon and the Americanized name of "Marie" was used for the signature in the early 1920s. A short time later, about 1925, she added the Americanized form "Julian" of her husband's name. The combination of these two names was used until Julián's death in the fall of 1943. After the death of Julián, María's daughter-in-law, Santana (wife of María's eldest son, Adam), worked with María and the pottery was signed "Marie & Santana." About 1948 María changed the spelling of her name and the wares were signed "Maria and Santana."

In 1956 María's son, Tony Martinez (Indian name, Popovi Da) became her partner. At Tony's request, María marked the ware "Maria Poveka" on the undecorated articles and "Maria & Popovi" on the decorated pieces. The wares that are being produced currently (1969) by María's son are marked "Maria & Popovi Da."

Specimens may be found of the San Ildefonso Black on Black that are signed by other artists. However, these are not the genuine María pottery, but are made in the same locale where María and Julián taught their people this art.

In the collection of the American Museum of Natural History is a plaque (black and red on cream) that is signed by María, using her Indian name Poveka. Other specimens of María pottery may be seen at the Museum of New Mexico.

Signatures to be found on María pottery:

[All signatures are incised with a polishing stone and the signatures will vary somewhat from piece to piece.]

Marie

1923-25
Pieces signed "Maria" only
are not genuine pieces

*Marie
&
Julian*

1925-43

María Pottery vases, black on black. *Left:* Signed "Marie & Julian," approximately 6½ in. high. *Collection of Joan R. Still. Right:* Signed "Marie & Santana," approximately 5½ in. high. *Collection of R. A. Royals; Knight photo*

Marie
&
Santana

1943-48

Maria
&
Santana

1948-50s

Maria Poveka

Used on undecorated pieces
from 1956 to early 1960s

Maria
&
Popovi

Used on decorated
pieces from 1956 to early 1960s

Maria
&
Popovi Da

Current (1969) mark

[All signatures are incised with a polishing stone and the signatures will vary somewhat from piece to piece.]

No. I

No. II

María pottery sketches

No. III

No. IV

No. V

PAUL REVERE POTTERY
1908—1942

Paul Revere Pottery was established in Boston, Massachusetts, in 1908 by a group of philanthropists which included Mrs. James J. Storrow, who was also a member of the Board of Managers of the North Bennett Street Industrial School of Boston's North End. These sympathetic people were endeavoring to establish better social and industrial conditions among the underprivileged young girls who were no longer compelled to go to school, but rather were forced to take up some type of work in order to survive. They felt that pleasant conditions could exist in a shop as well as in a home, and that a life of drudgery was not necessarily all these working girls had to look forward to. The art of pottery was undertaken as the object lesson, and thus began the Paul Revere Pottery.

Edith Brown, who had served as librarian at the North End Boston Library and had also supervised a group of high-school girls in an educational program, was first director and designer, assisted by Edith Guerrier. This group of underprivileged girls became known as "The Saturday Evening Girls." The small operation of pottery-making was started in the basement of an old dwelling. In 1912 Mrs. Storrow purchased, for this operation, a brick house at 18 Hull Street in Boston, under the shadow of the Old North Church, where Paul Revere's signal lanterns had been hung. This location was also opposite Copps Hill Burying Ground, where the green turf and ancient elms watch over the resting places of some of Boston's first citizens.

At this new location, the Pottery was equipped with a substantial kiln and all the other materials that were essential for production. The

club grew rapidly until the membership included some two hundred girls. This group continued to be known as "The Saturday Evening Girls."

The ware became famous and a substantial amount of it was sold both locally and abroad. However, the experiment never became really profitable. Mrs. Storrow found it necessary to continue contributing funds in order to keep the Pottery in operation.

In 1915 the plant was moved to a new building on Nottingham Hill in Brighton, Massachusetts. At this new location, thirty girls were employed regularly. The pottery continued to sell, but the financial condition remained unaltered and could not be placed on a paying basis. Edith Brown died in 1932. Without her guiding influence, the Pottery foundered and, in 1942, its doors were finally closed. Mrs. Storrow died in 1944.

Paul Revere pottery was made in all sorts of tableware and accessories, as well as "baby ware" that was very popular. Doll heads were also made but never placed on the market. The wares were mostly hand decorated in mineral colors; however, the sgraffito method along with the molded type was also used. The designs used in decorating were mostly natural, such as flowers, trees, chickens, rabbits, boats, and a galloping horse with a rider. Stylized designs were sometimes used.

The colors used on Paul Revere pottery were varied: eggshell lined with green or other colors; gunmetal gray lined with such colors as yellow, brown, red, and shades of green and blue. Articles were also finished in monochrome tints.

This ware was sold in gift shops as well as the showrooms at the Pottery. A system was devised to mark the wares, but the workers became careless and much of it was sold without markings. A paper label as well as an impressed mark was used, showing a galloping horse with a rider. The letters PRP were both impressed and painted in color on the base. Some pieces included the artist's monogram but no records were made available as to the identity of these artists.

Although this small industry was not a profitable one, it did prove that some success could be accomplished along with attractive working conditions and agreeable surroundings, which was one step ahead for the "working girl."

Paul Revere Pottery marks:

P. R.P
1940

Painted Impressed

McCOY POTTERY
1910—

The McCoy Pottery was established about 1910 in Roseville, Ohio, by Nelson McCoy, Sr. From the very outset, art pottery was produced, with patterns very similar to Weller's Louwelsa and Eocean. The dark ware was named "LOY-NEL-ART," but its quality cannot be compared with that of other fine Ohio potteries. The McCoy underglaze slip-painted ware was never made in the variety of patterns that other companies used; however, the pansy was used quite extensively. This author has never seen a piece of artist-signed McCoy pottery. Other lines were presented in molded patterns similar to those produced by Roseville in their floral ware. Varieties included vases, bowls for flower arrangements, planters in the form of frogs and other animals, and a very popular three-piece teaset in various colors. The company prospered and their wares were distributed all over the United States.

Nelson McCoy died in 1945 and was succeeded by his nephew, Nelson Melick, who had been associated with the company for twenty years.

McCoy cookie jars. Jet black glaze trimmed in gold and red, marked, late periods, 10 in. and 10½ in. high. *Author's collection; Knight photo*

During the decade 1945–54 McCoy Pottery was one of the largest manufacturers of art ware in America. Its pottery was sold in many department stores and gift shops as well as being a popular item with florists.

Mr. Melick died in 1954 and Nelson McCoy, Jr., became president. In 1967 the company was sold to the Mount Clemens Pottery Company

McCoy vases from late period. *Left to right:* Soft orchid with green leaves, marked, 9 in. high; white with green, note paper label, marked, 9 in. high; soft pink with green, marked, 9 in. high. *Author's collection; Knight photo*

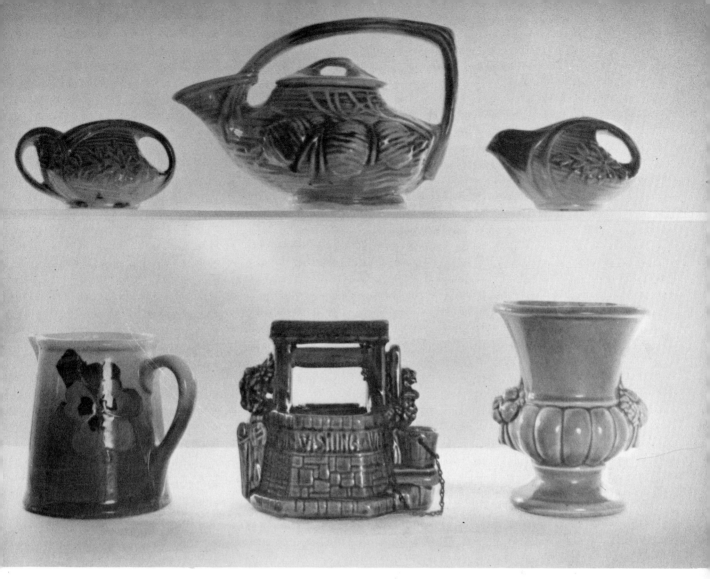

McCoy ware. *Top row:* Typical tea set, green with brown trim. *Bottom row, left to right:* Early (ca. 1910) pitcher (5½ in. high) in Weller "Eocean"-type decoration; high-glaze "Wishingwell" planter (late); typical McCoy vase (late) in turquoise blue. *Author's collection; Johnson photo*

of Mount Clemens, Michigan. The new owners retained McCoy as president, the post he continues to hold at this writing. The company's operation still includes a variety of art ware which carries the new mark of M C P on the base of each article. Much of the early McCoy pottery was distributed unmarked, which makes it rather difficult for the beginning collector to determine its true identity. The early marked McCoy pieces are swiftly disappearing into the hands of collectors, which make these pieces the ones that are most sought after. The late McCoy is being collected by young collectors and it is also fast disappearing from the scene.

McCoy vase. Dark brown shaded to green, marked "LOY-NEL-ART," 5½ in. high. *Author's collection; Knight photo*

Company marks:

Ⓜ

ROSEWOOD

LOY-NEL-ART

McCoy

Early marks, impressed

McCoy

Late mark, impressed

McCoy
USA

Late mark, embossed

AREQUIPA POTTERY
1911—1918

The name of Dr. Philip King Brown is closely bound up in the history of Arequipa Pottery. He founded the Arequipa Tuberculosis Sanatorium at Fairfax, California, in 1911. As project director, he raised the initial capital and acquired the grounds free of charge. It was located above a picturesque canyon in Marlin County. The name Arequipa means "the place of peace," and it was just such a place for the ailing girls who must while away so many long hours.

Several different projects were undertaken, such as basketweaving, loom work, typing, and other things believed to have therapeutic value. Most of these projects proved to be unsatisfactory because of high cost or the fact they were not practical for the patients to handle.

Dr. Brown, who was endeavoring to place the sanatorium on a paying basis, conceived the idea of pottery-making. Dr. Hall, of the Marblehead Pottery of Massachusetts, had established just such a project for the emotionally distressed or disturbed patients with some success. Also, a pottery had proved advantageous to "The Saturday Evening Girls," of the Paul Revere Pottery. This measure of success gave Dr. Brown the encouragement to embark on just such a project himself. Dr. Brown engaged Frederick Hurten Rhead, a ceramist who had formally worked for the Roseville Pottery in Ohio, to aid in the organization of the Arequipa Pottery. Some of the older and more capable boys were brought in from an orphanage in San Francisco to assist with the heavy chores.

From the outset, the girls were allowed to help with every operation that was not too strenuous, which included the decorating of the wares. This proved to be wondrous therapy for the patients. Unluckily, however, this adventure could not operate on a paying basis. In 1914 Rhead was replaced by Albert L. Solon, an Englishman. Even with this change in personnel it was impossible to get Arequipa on a sound financial level and it continued to lose money. Solon consequently resigned, to accept a position at what is now known as San Jose State College.

Solon was replaced by F. H. Wilde in 1916. Mr. Wilde had previous experience in organizing two successful California potteries. The Arequipa system was revised to some extent and things began to look brighter until America's entry into World War I. Production was curtailed due to rising prices, and the closing of the Pottery became compulsory.

Arequipa was made of fine local clays and the decorations, all hand done, were of the modeled and sgraffito types. The motifs were de-

Arequipa bowl. Mottled aqua and blue glaze, 2⅜ in. high, 6 in. diameter. *Courtesy of the Smithsonian Institution*

Base of Arequipa piece showing both impressed mark and paper label. *Courtesy of the Smithsonian Institution*

Arequipa vase. *Below right:* Pinkish orange luster glaze, 8¾ in. high, 5½ in. diameter. *Courtesy of the Smithsonian Institution*

Arequipa vase. *Below left:* Blue-gray glaze, 8 in. high, 6 in. diameter. *Courtesy of the Smithsonian Institution.*

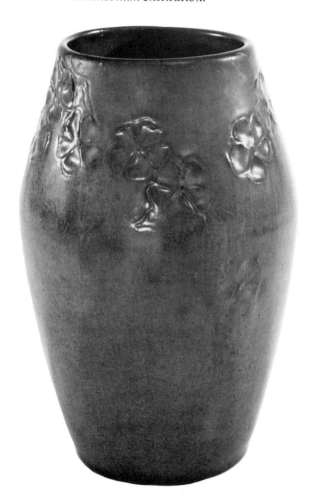

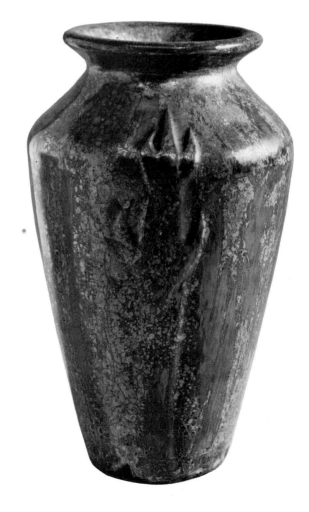

rived from the local flora. The glaze is a soft velvetlike matt glaze. The colors were especially lovely, with rich shades of color, one brushed over the other, with swirls and highlights, such as green with yellow spots. The classic forms were very reminiscent of other pottery of the period.

At the Panama Pacific Exposition in 1915, the girls were allowed to exhibit their wares and demonstrate "throwing on the potter's wheel." They were also paid a small salary, plus a percentage on what they sold. This undertaking proved to be quite successful and a gold and two bronze medals were awarded to Arequipa.

Among the agents and outlets for Arequipa pottery were John Wanamaker in New York, Bigelow, Kennerd and Company in Boston, Marshall Field in Chicago, and Dohrmann and Company and The White House in San Francisco. Arequipa is well represented in the Smithsonian Institution.

Although Arequipa Pottery proved to be a financial failure, and was practically totally dependent on individual donations, it did prove, most

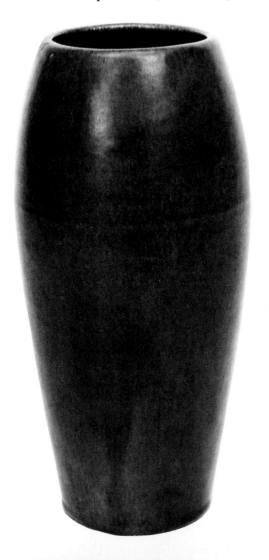

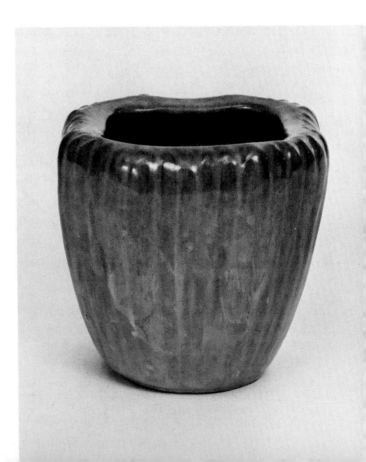

Left: Arequipa vases. Plum glaze, 10 in. high, 5½ in. diameter. *Below:* Yellow luster, 4 in. high, 4⅜ in. diameter. *Courtesy of the Smithsonian Institution*

importantly, that personal interest and craftsmanship were of marvel-
ous therapeutic value.

A regular system of marking the wares was used throughout the entire
existence of the Pottery.

Arequipa Pottery marks:

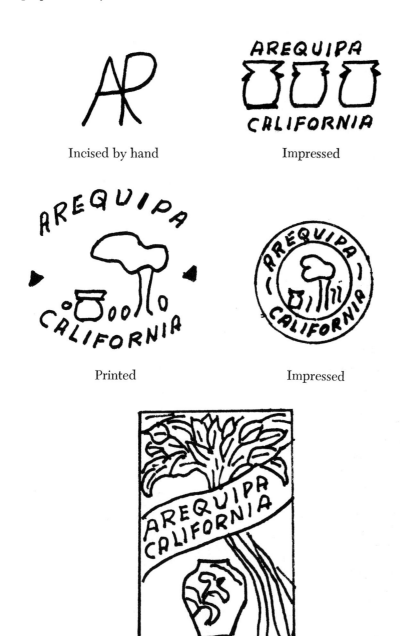

Incised by hand Impressed

Printed Impressed

Paper label. Price and number also shown at bottom of label

COWAN POTTERY

1913—1920

Cowan Pottery was founded by Guy Cowan, who came from a family of potters from East Liverpool, Ohio. He attended the New York School of Ceramics, at Alfred University in Alfred, New York. Upon graduation, he began teaching pottery in the city school system of Cleveland, Ohio.

In 1913 Cowan opened a studio in Cleveland. Here art ware was created and sold. Most of the wares made were of the sculpture type; however, some quantity of vases and other articles were also created. Professor Charles Binns, an Englishman from the Royal Worchester factory, became a guiding influence for the company. The operation was short lived and the studio was closed in 1920. These few years proved to be an unprofitable venture. During the operation of Cowan Pottery several artists were employed and each specimen is marked with the company name but seldom artist signed.

Cowan pottery. *Left to right:* Green figure, shiny, marked, 3 in. high; candlesticks, ivory, matt finish, marked, 2½ in. high; vase, light brown on red, shiny, marked, 3½ in. high. *Collection of R. C. and F. G. O'Brien, Jr.; Knight photo*

Cowan vase. Gunmetal, impressed mark, 4 in. high. *Author's collection; Johnson photo*

Partial list of artists:

Alexander Blazys Waylande Gregory
Paul Bogatay A. D. Jacobson
Thelma Frazier Margaret Postgate

Cowan Pottery marks:

COWAN COWAN POTTERY

Ink Stamped

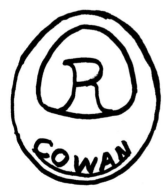

Ink Stamped
This mark enlarged
approximately four times

Impressed

JUGTOWN POTTERY
Early 1920s—

Jugtown Pottery was established in the early 1920s by Jacques and Juliana Busbee, in Jugtown, North Carolina.

Before prohibition began, some fifty potters in this area were making a living producing jugs for whiskey, along with other household wares. With the demand curtailed for the "little brown jug," most of the potters were forced to return to tilling the soil or other employment.

The Busbees realized the craft of potting was waning away in North Carolina, so they endeavored to revive interest in this dying art. They established a pottery in Moore County, near Seagrove, and recruited some of the farmer-potters to assist them in getting the new enterprise under way. These men were from the old school and would not deviate from the old customs. Ben Owen, a lad of seventeen, was soon employed by the Busbees. This young man had fresh ideas of his own and was also willing to accept advice from his employers. Ben turned all the shapes and, under the supervision of Jacques, soon learned how to test the clays and apply the glazes.

Searching for means of disposition of their wares, Juliana opened a combination tearoom and salesroom, known as the "Village Store," in Greenwich Village, in New York City. This shop was stocked with foods, folkcraft, and Jugtown pottery from Moore County. Employees were imported from North Carolina to bring the atmosphere of the "backwoods" to the Village Store, which seemed to appeal to the local patrons. Among the people that patronized the Store, were many VIPs. Jugtown was on its way and soon became internationally famous.

Although this operation was comparatively successful, Juliana soon closed the Village Store to return to Jugtown to assist with the Pottery operation.

Jacques and Juliana Busbee were forceful and dynamic personalities and seemed to greatly intrigue people. Travelers would drive miles out of their way to visit with them in their picturesque cabin and get a specimen of their Jugtown pottery. Distribution of the pottery was made in some foreign countries as well as nationwide.

From 1922 until 1947 Jugtown was produced by Ben Owen under the direct supervision of Jacques Busbee. After the death of Jacques Busbee in 1947, Juliana continued the operation of the Pottery with the assistance of Ben Owen. This proved to be too much of a burden for her and she consequently decided to sell the Pottery. She had become so confused that two separate deeds were signed to the business

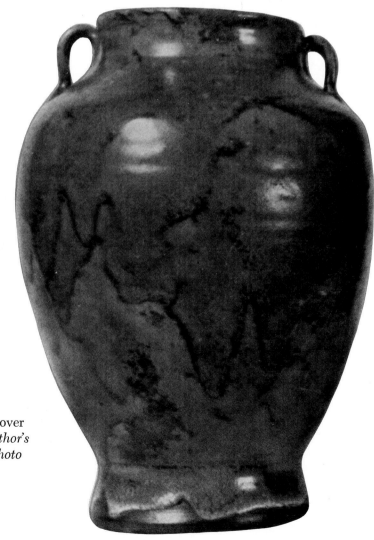

Jugtown vase. Green over yellow, 8 in. high. *Author's collection: Johnson photo*

and a lawsuit followed. The Pottery had to close its doors for a year. In 1960 it was reopened under new management. Juliana died in 1962. Ben Owen established a pottery of his own just a few miles away, using similar style forms and the same type of glazes as were used at Jugtown. These are marked "Ben Owen, Master Potter."

Jugtown was made in every type of utility ware, vases, candlesticks, flower bowls, and all sorts of table accessories. The glazes varied from the common salt glazes, to the heavy glazes of the type used by Grueby and Van Briggle, to glazes very similar to those used on Weller hand-made lines, such as Greenbriar and Coppertone.

The pottery was made from local clays in the Oriental and classic forms so often used during this period. The colors were quite varied. The most popular shade was the Chinese blue, which ranged from light blue to dark turquoise, with reddish purple splotches. Other colors were plain gray salt glaze with cobalt decoration, cream, and shades of orange ranging from pumpkin color to a dark copper tone. Also some ware was made in white, black, green, and a brownish orange splotched with black.

Specimens of Jugtown are on display at several museums in North Carolina, as well as the Smithsonian Institution and the Cleveland Museum of Art.

Jugtown Pottery is still in operation today (1969), making ware in the same shapes and same glazes as in the earlier period. Also, the same company mark is used as was used in the beginning.

Jugtown Pottery mark:

Impressed

FRANKOMA POTTERY
1933—
CHRISTMAS MEMORIAL PLATES
1965—

Nestled in the rolling hills of Oklahoma, at Sapulpa, stands the Frankoma Pottery, owned and operated by John Frank and his wife, Grace Lee Frank. Visitors are always welcome and every process is open for inspection.

John Frank came to Oklahoma from Chicago in 1927 to take a teaching position at the University of Oklahoma, at Norman, where he taught art and pottery. His work with the Geological Survey (unearthing Oklahoma clay deposits) brought together valuable information for his future venture of potting. The clay used in all Frankoma pottery today is from "Sugar Loaf Hill," close to the plant. This is a red-brown clay and, when the glazes are applied in various thickness, the clay shows through, giving beautiful shadow effects.

In 1933 the Franks established a small studio in their home, with only the bare necessities, to work with the native clays. The clay produced an excellent quality pottery, and consequently a portion of this finished product was put up for sale. Artists desiring to participate in the small enterprise were welcomed. One such artist was Sinclair

Homer, a part Cherokee Indian, who modeled a plaque of his good friend Will Rogers in 1935. The plaque was quite popular and this item was made by Frankoma for several years. Its popularity induced Homer to have the plaque copyrighted in 1935. Sculpture by Professor Joe R. Taylor is still being offered in the Frankoma line. Three pieces of sculpture by the world's most famous Indian sculptor, Willard Stone, are being reproduced. Joniece Calvert has had works represented in the line, and is working on others.

By 1936 the Pottery was beginning to prosper and Mr. Frank resigned his post as teacher to devote his entire time to creating smart lines of tableware for everyday living. The beautiful array of colors used on Frankoma pottery is somewhat different from that found on other modern-day pottery, the glaze having a soft velvety finish that is quite pleasing to the eye.

In 1938 the home studio had grown into a small factory and was moved from Norman to Sapulpa, where it continues operations today (1969). The name was coined from Mr. Frank's surname and the last three letters of Oklahoma.

Frankoma plaque of Will Rogers (1935). Signed "Sinclair Homer," green glazed edge, 5 by 5½ in. *Author's collection; Orren photo*

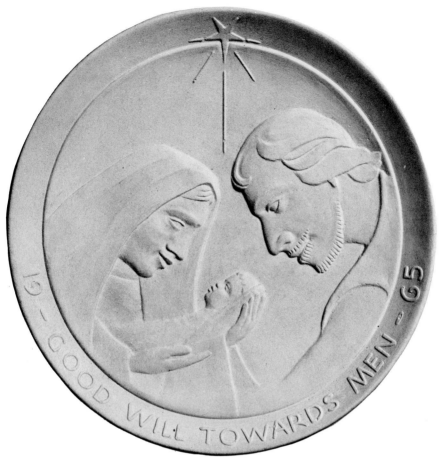

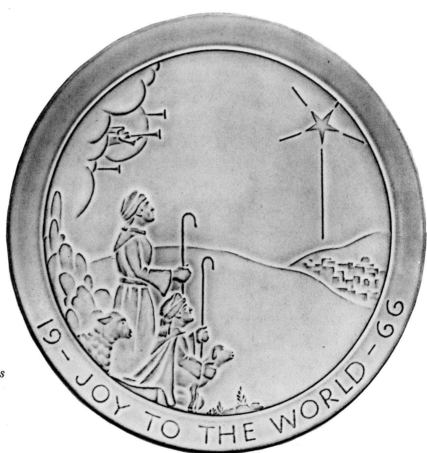

Frankoma Pottery
Christmas plates. *Cornelius
photos*

With so much emphasis being placed on Christmas plates being made abroad, Mr. Frank conceived the idea and decided to create a line of American Christmas plates. These plates were first introduced by the Franks with the thought that they would be a spiritual inspiration and a reminder of the lasting values of the Holy Scriptures, and with a hope that they would be a blessing to those who possess them. The first one was designed and issued in 1965 and is marked "First Issue," along with the other marks. John Frank has done the original modeling each year so far, and will as long as he is able. The original master mold is signed by Mr. Frank and copyrighted. Each design reflects the fine ability and artistic achievements of John Frank. The plates are

Frankoma Pottery
Christmas plates. *Cornelius
photos*

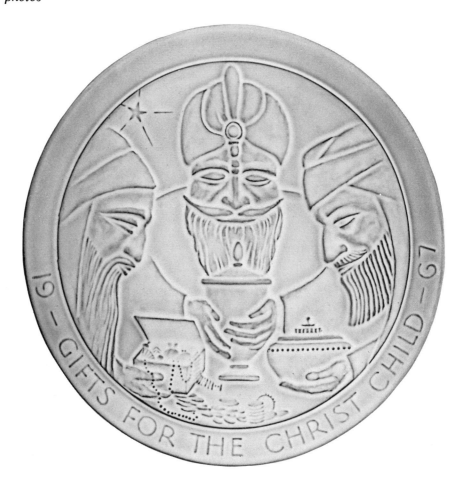

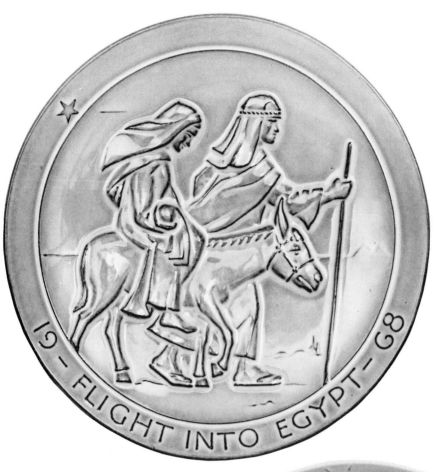

Frankoma Pottery
Christmas plates. *Cornelius
photos*

done in one color only—a white semitranslucent glaze, known as "Della Robbia" white, which was developed by Frankoma Pottery. The red clay shows through, leaving a hint of brown outlining each design.

The plates are uniform in size, being approximately eight and one-half inches in diameter, with the title around the lower portion of the rim, which also includes the date. The subjects are done in bas-relief and depict a biblical scene relative to the Christmas story, which are brought to life in a skillful manner. A leaflet accompanies each plate, giving the scriptural background for the inspiration for that year. It is Mr. Frank's intention to always keep the material on this same basis and, with the Scriptures being so full of inspirations, we are sure there will be ample material for many more beautiful American Christmas plates.

The plates are produced in limited quantity and, on Christmas Eve, a ceremony is held at the factory, at which time all the molds, including the master mold, are completely destroyed. These, being the initial American Christmas plates, promise to be as popular and important as the Royal Copenhagen, Bing and Grondahl, Rosenthal, and Bareuther porcelain plates, and those in glass introduced by Lalique of France in 1965.

POTTERY TILES

Ornamental and souvenir tiles from American factories are still preserved and collected, long after the floor and wall tiles have been destroyed. Many tile companies made gift tiles for the customers. These included commemoratives, records of important dedications and conventions, and busts of presidents or other celebrities. These tiles and plaques are eagerly sought by today's American art pottery collectors. Art tiles to decorate homes and public buildings were made in a number of styles. Groups of tiles were placed together to compose

A. E. tiles. *Above left:* Natural colors with yellow figure, titled, "There was a lady loved all swine," marked, 6 in. square. *Above, right:* Background of natural colors with brown female figure and blue boy, titled "Fortune and the Boy" marked, 6 in. square. *Right:* Delft blue, marked, 6 in. square. *Author's collection; Knight photos*

these subjects. At times, only four tiles were used for a theme; at other times several hundred had to be used to compose an entire theme.

In addition to the regular tile manufacturing companies, tiles were also made by various important potteries—Rookwood, Weller, Tiffany, and others—along with their regular lines of ware. The majority of tile companies were engaged in business in the eastern half of the United

States due to the proximity of an abundance of fine clay. In the western part of this country, especially California, only a few tile companies operated. The Western Art Tile Works started in 1905, but failed by 1910. Only two major companies were producing art tile in California in 1920. These were the Tropico Potteries and The American Encaustic Tiling Company.

AMERICAN ENCAUSTIC TILING COMPANY, LTD.

The American Encaustic Tiling Company, better known as A. E. Tile, was organized in 1875 in Zanesville, Ohio. This company is perhaps the most important tile company in the history of ceramics in the United States. According to E. Stanley Wires, architect and foremost authority on tile, A. E. was the pioneer of floor and wall tile produced in this country.

Operations, begun in an old building on Hughes Street, had progressed far enough by 1879 to warrant the move to a more suitable location on Sharon Avenue. The company continued to prosper and,

Catalog page showing the hand-painted Spanish "Peasant" series of tiles from the American Encaustic Tiling Co. *Photo courtesy E. Stanley Wires*

by 1892, were moving into a modern new plant on Linden Avenue. Dedication of the new plant, attended by several thousand people who came from all over the country, was augmented by an address by William McKinley, who was then Governor of Ohio.

Ceramic art works produced here were outstanding, and by the early 1930s A. E. Tile was the largest tile company in the entire world.

American Encaustic Tiling Co. faïence tiles. Grille tiles were designed by Leon V. Solon. *Photo courtesy E. Stanley Wires*

Furthermore the company had acquired a beautifully decorated office building in New York City at 16 East 41st Street.

Some of the most important men in the field of ceramics were engaged by A. E. Tile, including Karl Langenbeck, chemist; Herman Mueller, modeler; Benedict Fischer, a financier who contributed to the organization of A. E. Tile; Harry Lillibridge; Emil Kohler; and George Stanbury. Also employed were Paul and Leon V. Solon, who were the sons of the noted English ceramist, L. M. Solon.

A. E. manufactured all sorts of decorative tile, including intaglio, embossed, unsurpassed decalcomanias, and beautiful underglaze hand-

Early twentieth-century faïence floor designs in tiles from American Encaustic Tiling Co. *Photo courtesy E. Stanley Wires*

painted panels. All types of architectural tiles were produced as well as a large variety of novelties and souvenior plaques or tiles. Some were only two and a half to three inches in size, small enough to tuck into a pocket or purse. These souvenir pieces depicted important events, dedications, conventions or just VIPs. Large quantities of the small tiles came with various colored backgrounds, in diverse techniques, and in different glazes. The earliest dated one that has been found was distributed at the dedication of the new A. E. Tile plant in 1892.

The depression years of the 1930s took its toll, including A. E. Tile; consequently the plant ceased operations about 1936.

American Encaustic Tiling Company marks:

[Many A. E. tiles were modeled and marked by Herman C. Mueller. These are prior to 1893.]

A.E. TiLE Co.
LiMiTED

HM A.E.T. Co.

AETCO FAIENCE

Block letters, impressed

Embossed

Mosaic Tile bear. Black glaze, marked, 6 in. high. *Author's collection; Knight photo*

LOW ART TILE WORKS

The Low Art Tile Works was established at Chelsea, Massachusetts, by John Gardner Low in conjunction with his father, John Low. The first Low kiln was drawn on May 1, 1879.

John Gardner Low studied painting in Paris, France, under Thomas Couture from 1858 to 1861. On his return to the United States, he was employed by the Chelsea Keramic Art Works, where he learned the potting business from the Robertsons.

The Lows, ever progressive, were always experimenting with various techniques. They developed one technique referred to as the "natural" process of decoration. Leaves, grass, and flowers were used as the natural patterns pressed into the surface of each tile while the clay was still in plastic condition. On this impression, a sheet of thin tissue paper was applied, a second (soft) tile was laid on top with the tiles face to face, and then the whole was compressed. When the units were separated, one tile would have an embossed pattern.

Plaques, Low Art Tile Works. *Collection of E. Stanley Wires*

Examples of the work of Low Art Tile Works and the Chelsea Keramic Art Works. Designs by Hugh Robertson and Arthur Osborne. *Collection of E. Stanley Wires*

The most important tiles made by Low were the "Plastic Sketches" or "Poems in Clay" as they were called. Some of these ingenious works of art were created by a talented young artist, Arthur Osborne. A certain portion of these tiles were as much as twenty-four to thirty inches in length. These were skillfully executed subjects such as pastoral scenes, animals and, the most stunning of all, the human faces and figures. In the high-relief subjects, the undercutting was hand done, after the designs were stamped in the press. The works executed by Osborne were marked "AO" or "A" in a circle.

Low manufactured such structural tiles as mantel facings, panels, modeled plaques, and friezes, and bric-a-brac trimmed in brass, including trinket boxes, inkstands, clock cases, and paperweights.

The decorative tiles created by Low were an important innovation to the architectural industry and increased the public demand for more colorful tiles.

Low Art Tile Works marks:

[Many of these tiles bore the mark of Arthur Osborne, chief modeler prior to 1893.]

AO Ⓐ

J & JG LOW
PATENT
ART TILE WORKS
CHELSEA MASS USA
COPYRIGHT 1881 BY

J & JG LOW

"King Lear" plaque made by Cambridge Art Tile Company. *Sketched by David Thompson.*

J. and J. G. Low Art Tile plaque on display at the Smithsonian Institution. *Sketched by David Thompson.*

MOSAIC TILE COMPANY

In 1894 the Mosaic Tile Company was founded in Zanesville, Ohio, by Herman Mueller, Karl Langenbeck, and William M. Shinnick, the latter being known for his contribution to the growth of the tile industry in the United States at the turn of the century. Both Mueller and Langenbeck were well experienced in the field of ceramics and left the American Encaustic Tiling Company to organize Mosaic Tile Company.

The Mosaic Company was an immediate success and on several occasions surpassed A. E. Tile to become the largest tile company in the world. During this era, when the tile business became highly competitive, these two companies vied for this title for several years—first one at the top and then the other. Mosaic manufactured all varieties of architectural tiles as well as numerous souvenir novelty items, including figures of people and animals. Many commemorative tiles and plaques were also created, depicting famous people and important events. These tiles or plaques were made in various sizes and with all types of elegant decorations including embossed, impressed, decalcomania, and one type with molded figures "sprigged on" similar to the Wedgwood Jasperware, with blue backgrounds and white figures. The souvenir pieces were made in a variety of shapes including round, square, oval, and hexagonal.

Mosaic developed a type of decorative tile in which the designs were created by sifting the powdered clay through stencils, then pushing it into the surface with tremendous pressure which gave the effect of mosaic design.

The Mosaic Tile Company in Zanesville ceased operations in 1967.

Mosaic Tile Company. Delft blue, marked, 6 in. square. *Author's collection; Knight photo*

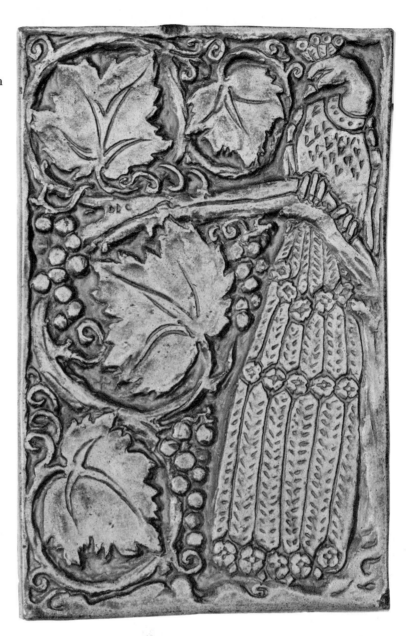

Modern tile by Batchelder-Wilson
Company, Los Angeles, Cal.
Collection of E. Stanley Wires

Mosaic Tile Company marks:

Embossed Impressed

CAMBRIDGE ART TILE COMPANY

The Cambridge Art Tile Company was established in 1887 at Covington, Kentucky. From the outset the Cambridge Company engaged some of the most talented artists available in the ceramic industry. One of these important artists was Clement J. Barnhorn, a celebrated sculptor from Cincinnati, Ohio. Also employed was Ferdinand Mersman, modeler, who had studied at the Academy of Fine Arts in Munich, Germany. Both of these outstanding artists were associated with the Rookwood Pottery at one time or another.

Items produced by the Cambridge Tile Company were handmade faïence tiles, mantel facings, friezes, modeled plaques, and garden pottery.

The company eventually merged with Wheatley to become the Cambridge-Wheatley Company, producing a very high grade interior tile ware.

Rookwood faïence tiles.
Photo courtesy E. Stanley Wires

Tiles of Mueller Mosaic Tile Company. *Photo courtesy E. Stanley Wires*

MUELLER MOSAIC TILE COMPANY

During the art nouveau period, the name of Herman C. Mueller was closely bound up in the history of American art pottery. He was one of the most talented ceramic artists in the United States during this era, having been trained in the Art School at Nuremberg, Germany.

For two decades prior to the organization of his own Pottery, Mueller had worked for several leading potteries in this country, including Matt Morgan, American Encaustic Tiling, National Tile, and Robertson Art Tile. He also assisted Karl Langenbeck in organizing the Mosaic Tile Company of Zanesville, Ohio.

In 1908 the Mueller Mosaic Tile Company was established in Trenton, New Jersey. The company produced some of the most beautiful and fascinating faïence tiles in America. Some of these were classic art nouveau figures, while others depicted the "jolly Monk," so popular at this period. The monk decor was widely used by the Weller Pottery in the second-line Dickens Ware and appeared on mugs, tankards, and all size vases. Another line of Mueller tiles depicted a variety of cunning antics by mischievous elves. Other products created were beautiful panels of faïence tile and metal worked together.

Mueller Mosaic faïence tile inserts. *Sketched by David Thompson.*

MORAVIAN POTTERY AND TILE WORKS

At the turn of the century, perhaps one of the most interesting and unique tile companies in America was the Moravian Pottery and Tile Works of Doylestown, Pennsylvania.

The guiding influence of the pottery was Dr. Henry C. Mercer who, at one time, was curator of the Museum of Archaeology at the University of Pennsylvania. He was also the author of a book on iron, entitled *The Bible in Iron,* published by the Bucks County Historical Society of Doylestown, Pennsylvania. Dr. Mercer began experimenting with art tiles about 1900, using the common red clay found in the vicinity of Doylestown. Realizing that the white uninteresting tiles were being outmoded, the Moravian Pottery produced beautiful colored tiles, some being as bright and as colorful as leaded glass windows, while others were soft matt finishes with subtle colored glazes. The designs on these tiles were reminiscent of the Pennsylvania Dutch patterns. A portion of these designs were copied from old Moravian iron-stove decorations and firebacks which were used in "Fonthill," Dr. Mercer's home in Doylestown. Still other designs were copied from a valuable collection of drawings gathered from the ruins of old English churches and presented to Dr. Mercer by Sir Hercules Read of the British Museum. Many medieval-type patterns were inspired by old designs

Mueller Mosaic faïence tile inserts. *Sketched by David Thompson.*

found in France, Italy, and other countries. The American Indian was also used on some tiles for fireplaces.

The Moravian Pottery created some of the most important symbolic decorations for churches and museums in the United States and Canada.

Moravian Pottery and Tile Works company marks:

Henry C. Mercer

OTHER TILE COMPANY MARKS

The Robertson Art Tile Company of Morrisville, Pennsylvania. Operated by George W. Robertson. Hugh C. Robertson (of Dedham fame), did some of the modeling for the embossed tile design.

 Hugh C. Robertson

Star Encaustic Tiling Company of Pittsburgh, Pennsylvania; established, 1876.

S.E.T. Co.

Tile fireplace panel made by Grueby Faïence Company. *Photo courtesy E. Stanley Wires*

IMPORTANT AMERICAN TILE COMPANIES WITH DATE AND PLACE OF ORIGIN

Alhambra Tile Company, 1892, Newport, Ky.
American Encaustic Tiling Company, 1875, Zanesville, Ohio
Architectural Tiling Company, Inc., 1911, Keyport, N.J.
Atlantic Tile and Faïence Company, 1910, Maurer, N.J.
Beaver Falls Art Tile Company, 1886, Beaver Falls, Pa.
C. Pardee Works, 1894, Perth Amboy, N.J.
Cambridge Art Tile Company, 1887, Covington, Ky.
Columbia Encaustic Tile Company, 1887, Anderson, Ind.
Enfield Pottery and Tile Works, 1906, Enfield, Pa.
Grueby Faïence Company, 1891, Boston, Mass.
J. and J. G. Low Art Tile Works, 1879, Chelsea, Mass.
Matawan Tile Company, 1902, Matawan, N.J.
Moravian Pottery and Tile Works, 1899, Doylestown, Pa.
Mosaic Tile Company, 1894, Zanesville, Ohio
Mueller Mosaic Tile Company, 1908, Trenton, N.J.
Old Bridge Enameled Brick and Tile Company, 1893, Old Bridge, N.J.
Olean Tile Company, 1913, Olean, N.Y.
Perth Amboy Tile Works, 1908, Perth Amboy, N.J.
Providential Tile Company, 1891, Trenton, N.J.

Robertson Art Tile Company, 1890, Morrisville, Pa.
Rookwood Pottery, 1880, Cincinnati, Ohio
Star Encaustic Tiling Company, 1876, Pittsburgh, Pa.
Trent Tile Company, 1882, Trenton, N.J.
United States Encaustic Tile Works, 1877, Indianapolis, Ind.
United States Quarry Tile Company, 1913, Canton, Ohio
Wenezel Tile Company, 1915, Trenton, N.J.
Wheatley Pottery Company, 1880, Cincinnati, Ohio
Wheeling Tile Company, 1913, Wheeling, W. Va.

Above: The "Rich Man and Lazarus" panel, 3 by 5 feet, Moravian Pottery and Tile Works. *Left:* Faïence tile by the Rookwood Pottery. *Photos courtesy E. Stanley Wires*

Rookwood faïence fireplace tiles. *Photo courtesy E. Stanley Wires*

Glossary

All terms listed here are not used in this text. However, they are interesting and informative. *Courtesy of Stangl Pottery; China, Glass & Tablewares Magazine.*

Backstamp	The maker's name stamped on the back of their wares. A trade mark is sometimes included along with the name. Makers' marks on antique ware are of historical interest to collectors of pottery.
Basaltware	Unglazed stoneware, usually black, with a dull gloss.
Bisque or Biscuit	Clayware that has been fired once for hardening but has not yet been glazed.
Bisque Fire	The first firing, or baking, in clayware manufacture, which hardens the clay in its final shape.
Body	The physical composition of a piece of clayware, as opposed to its glaze and decoration.
Casting	A process in which slip, or liquid clay, is poured into a mold and then allowed to set. The result is a piece of clayware duplicating the shape of the mold.
Ceramics	Articles made of so-called earth material (sand, clay, etc.) processed by firing, or baking. This includes pottery.
Coupe Shape	A contemporary plate shape without a shoulder, flat across the diameter, and rolled in slightly at the rim.
Crazing	A defect in clayware glaze consisting of a network of tiny cracks caused by the difference in the rate of contraction between body and glaze. It is almost the same in appearance as deliberately induced crackling.
Creamware	A refined cream-colored earthenware body.
Embossing	A raised or molded decoration produced either in the mold or formed separately and applied to the body of a piece before firing.
Encrustation	A decoration of precious metal (gold, silver, etc.) applied thickly in liquid and then fired.

Engobe	A type of decoration in which white or colored liquid clay (slip) is applied over the body of the ware.
Faïence	Originally a type of French-made pottery, the term is used today to refer to a fine glazed earthenware, usually with a colorful decoration.
Flatware	In dinnerware, any flat piece such as a plate.
Gadroon Edge	A popular molded dinnerware border design which resembles braided rope.
Glaze	A glossy transparent or colored coating baked onto clayware body for decorative purposes and to make it nonabsorbent and more resistant to wear.
Ground-Lay	An underglaze dinnerware decoration generally taking the form of wide borders of dark colors such as maroon, deep blue, etc. The process consists of dusting the powdered color onto an oil coating, then firing.
Hard Paste	A true porcelain having a hard, cold appearance. The enamel colors seem to set on top of the glaze and do not merge with it as they do on soft-paste porcelain.
Intaglio	Decoration in which the design is sunk beneath the surface of the piece. It is opposite of embossing.
Ironstone	A hard, heavy earthenware made to withstand heat and rough usage. Made by most manufacturers during the nineteenth century.
Jasper	A fine colored unglazed stoneware, usually blue.
Kiln	The oven in which ceramic ware is fired, or baked. The word is generally pronounced as if it were spelled without the "n."
Luster	A ceramic glaze coating, metallic in nature, which gives the finished piece an iridescent effect.
Matt Finish	A flat glaze finish without gloss.
Ovenware	Clayware that is able to withstand the heat of a kitchen oven without damage, thus permitting a homemaker to prepare oven-cooked food in it and then use it for table service. In styling, such ware is usually of casual design and features bright colors.
Overglaze Decoration	Design applied to clayware after it has been fired and glazed. Because they are not subject to high temperatures, the colors in such decoration tend to be more vivid than those in underglaze designs.
Parian	A white generally unglazed body used in the making of various intricately shaped articles such as figures, vases, jugs, etc.
Pin Marks	Small, irregular rough patches without glaze, where the ware in glaze firing was supported on pins. These marks are smoothed down and polished in the finishing and are hardly visible.

Potter's Wheel	A round platform rotated either mechanically or manually upon which the potter throws, or forms, a circular shape.
Reject	A piece of ware which, because of an imperfection, does not meet certain quality standards and is therefore withheld from sale or shipment.
Rockingham Type Wares	A name given to earthenware decorated with a rich purple-brown glaze.
Run of Kiln	A grading term indicating a run of ware most of which appears perfect after manufacture but which may not be completely perfect on close inspection.
Selects	Near perfect pieces as determined by selection and rejection of imperfect pieces.
Sgraffito	A type of ceramic decoration produced by coating a piece with a layer of colored slip, or liquid clay, then incising a design in that layer to let the original body color show through.
Shoulder	The raised rim of the traditionally shaped plate.
Slip	A mixture of clay and water with a creamlike consistency. It is used both for producing ceramic body and for ceramic decoration.
Soft Paste	An artificial type of porcelain made but not fired to as high a temperature as other true or hard-paste porcelains.
Stoneware	A hard, highly fired variety of earthenware, normally holding water without the need for glazing.
Studio Pottery or Studio Potters	Handmade pottery produced by one potter or by a small team. These wares express modern taste and creative talents better than mass-produced factory wares.
Terra Cotta	Red unglazed earthenwares. This type, being porous, is not very suited to useful wares.
Texture Glaze	A colored glaze in which dripping, running, eruption, or some other controlled disturbance is introduced to heighten the decoration effect.
Throwing	Forming clay manually by shaping it as it is rotated on a potter's wheel, or revolving platform.
Underglaze Decoration	A ceramic decoration that is applied directly to the bisquit, or unglazed body, and then covered with a protective gloss coating that makes it highly resistant to wear.

Index of Lines and Patterns

A complete listing of names of lines and patterns with the manufacturer's name in parentheses. Titles of plaques and the names of various important decorations are also listed. Italic numbers refer to illustrations.

General Index

This Index includes the names of all artists listed in the text, all places mentioned, persons to whom illustrations are credited, and all Potteries as well as processes, important colors, glazes, and items made in the various wares. Italic numbers refer to pages on which there are illustrations.

Rehm, Wilhelmina, 170
reproductions, of Radford Jasperware, 206
 of Rookwood, 154, 157
Rettig, Martin, 170
Revere Pottery, Paul, 283-285, 289
Revi, A. C., *151, 155*
Rhead, Frederick Alfred, *51, 52,* 211
Rhead, Frederick Hurton, 210, 222, 289-290
Rhead, G. W., 52
Rhead, Harry W., 210, 213, 214
Rhead, Lois, 222
Richardson, Mary W., 256
Ritter, E. A., 260
Roberts, Eugene, *98,* 121
Robertson, Alexander W., 24, 25
Robertson, George W., 319
Robertson, Hugh Cornwell, 24, 25-26, 27, *32,*
 310, *311, 319*
Robertson, James, 24, 25
Robertson, J. Milton, 27
Robertson, William, 27
Robertson Art Tile Company, 25, 317, 319,
 321
Robin, H., 270
Robinson, Mrs. Adelaide Alsop, 197
Robinson, Harry, 190
Robinson, Martha, 256
Rockingham pottery, 15
Rogers, Elizabeth, 256
Rogers, Will, plaque of, 300, *300*
Roman, Amalie, 256
Roman, Desiree, 256
Rookwood Pottery, 54, 129-174, *130-160,* 174,
 179, 182, 208, 237, 241, 244, 257, 258,
 276, 305, 316, *316,* 321, *321, 322*
Roseville, Ohio, 184, 207, 285
Roseville Pottery, 50, 187, 205, 207-236,
 208-217, 223-234, 236, 244, 285, 289
Ross, Hattie M., 190
Roth, A., 270
Roth, Frederick G. R., 195
Rothenbush, Fred, 170
Rowlandson, Thomas, 269
Rowley, F., 270
Royal Academy of Art (Denmark), 210
Royals, R. A., *280*
Runyon, Irma & Bill, *25, 181, 196, 251, 275*
Ryan, Mazie T., 256
Rydings, Mr. & Mrs. George M., *175*

S & H Green Stamps, 217
Sacksteder, Jane, 170
saggers, defined, 12
Saint John the Divine, Cathedral of, 195
Saint Louis Exposition, 24, 139, 196, 209, 259
Saint Tammany Parish, La., 251
salt glaze, 12, 15
Samson, Thorwald, 175
San Francisco, Cal., 253
San Francisco World's Fair, 24
San Ildefonso, N. Mex., 276-278
San Jose (Cal.) State College, 290
Santana (signature on Maria), 279, *280,* 280
Sapulpa, Okla., 299
Saturday Evening Girls, The, 283-284, 289
Sauter, E., 270
Sax, Sarah, *150, 151,* 170
Schmidt, Carl, 172
Schwerber, Aloysius J., 55
scratching of designs, 69
Scudder, Raymond A., 256
Seagrove, N.C., 296
Seaman, Marie, 198
Sehon, Adeliza, 172
sgraffito, 38, *41,* 54, 83, 139, 158, 192, 211,

212, 236, 238, 325
Shafer, O., 270
Sheehan, N., 270
Sheerer, Mary G., 249, 256
Shinnick, William M., 313
Shirayamadani, Kataro, 133, 135, 145, 146,
 156, 172
Shoemaker, R. Lillian, 190
Sicard, Jacques, 45, 50
silver deposit, Rookwood, 145
 Roseville, 230
 Weller, 36
silver overlay, Rookwood, 145
 Roseville, *209,* 209
 Weller, *title,* 36, 37
Simpson, M., 270
Simpson, R., 270
Simpson, W. E., 271
size, indication of, 154
sketches, of Maria pottery, *281-282*
slip, defined, 325
slip painting, 12
Smalley, Marion H., 172
smear glaze, 12
Smith, Bill G., *183*
Smith, Gertrude R., 256
Smith, Helen, 222
Smith, Irvin, 74
Smith, Joseph L., 26
Smithsonian Institution, 253, 259, *290, 291,*
 292, 298
Sned (or Snedeker), M., 271
Solon, Albert L., 290
Solon, L. M., 307
Solon, Leon V., *307,* 307
Souter, O., 271
South Kensington Museum, London, 259
South Zanesville, Ohio, 244
South Zanesville Stoneware Company, 244
Spanish influence on Morgan pottery, 179
Spaulding, Jessie R., 240
special pieces (Rookwood), 153
Sprague, Amelia B., *130, 131,* 172, *239,* 240
sprigging, of cameo-type decoration, 202, 203,
 314
Staffordshire Pots and Potters, 52
Stallmacher Teplitz, 193
Stanbury, George, 307
Stangl, J. M., 18
Stangl Pottery, 15-23, *16-23*
Stanwood, Gertrude, 198
Star Encaustic Tiling Company, *320,* 321
Starksville, Miss., 148
Steel, F., 222
Steele, Ida, 190
Steele, Tot, 121, 222
Stegner, Carolyn, 172
Steiner, M., 271
Steinle, Carrie, 137, *140,* 146, 172
Stemm, Will H., 190
Stemm, William, 121
Steubenville, Ohio, 33, 237
Stevens, Mary Fauntleroy, 190
Stickley, Gustav (retailer), 253
Still, Joan R., *71, 111, 280*
Stiller, —, 271
stilts, defined, 49
Stone, Williard, 300
Storer, Bellamy, 135
Storer, Maria Longworth Nichols, *see*
 Longworth, Maria
Storrow, Mrs. James J., 283, 284
Strafer, Harriet R., 172
Streissel, L., 271
Stuart, Ralph, 266, 271